D1459895

Better Type

Better Type

BETTY BINNS

with typeset examples
by Kathie Brown of U.S. Litho

A ROUNDTABLE PRESS BOOK

WATSON-GUPTILL PUBLICATIONS/NEW YORK

A Roundtable Press Book
Directors: Marsha Melnick, Susan E. Meyer
Associate Editor: Marguerite Ross

Published by Watson-Guptill Publications
a division of Billboard Publications, Inc.
1515 Broadway, New York, NY 10036

Copyright © 1989 by Betty Binns and Roundtable Press, Inc.

All rights reserved. No part of this book may be reproduced or utilized
in any form or by any means, electronic or mechanical, including
photocopying, recording, or by any information storage and retrieval
system without permission in writing from the publisher.

Library of Congress Cataloging-in-Publication Data

Binns, Betty, 1929–
 Better type.

"A Roundtable Press book."
Includes index.
1. Printing, Practical—Layout. 2. Type and type-
founding. 3. Printing—Specimens. I. Title
Z246.B55 1989 686.2'24 88-37849
ISBN 0-8230-0484-8

Printed in the United States of America
First printing, 1989

1 2 3 4 5 6 7 8 9 10 / 94 93 92 91 90 89

This book is dedicated to Lynne, Mike, Carol, Brad, Fred, Joe, Jim, and all the other typesetters who have all these years put up with my fussy specifications and illegible handwriting.

ACKNOWLEDGMENTS

The help I have received from Kathie Brown has been
inestimable. Without her skill, taste, kindness, and tact
this book could never have been done. Susan Meyer of
Roundtable Press not only cajoled me into this undertaking,
but nursed me through it with good humor beyond
the call of duty. In addition I want to thank the many
designers and typesetters from whom I have learned
over the years. I have tried to pass on their knowledge.

CONTENTS

INTRODUCTION 8

1 **WORKING VOCABULARY 10**

2 **LEGIBILITY AND READABILITY 16**

3 **LETTER DESIGN AND TYPE COLOR 33**

4 **LINE SPACING AND TYPE COLOR 48**

5 **WORD SPACING AND TYPE COLOR 110**

6 **CHARACTER SPACING AND TYPE COLOR 126**

7 **UNJUSTIFIED SETTING 146**

8 **CHARACTER ALTERATION 163**

9 **DETAILS 179**

BIBLIOGRAPHY 188

INDEX 189

Good typography demands that the designer perceive very small differences in the way letters and spaces relate to each other. This book introduces these subtleties and presents visual examples of the way they affect the appearance of type on the page, a kind of eye-training device designed to sharpen your skills in identifying the elements that distinguish fine text typesetting. Music schools routinely give ear-training courses to teach their students fine shades of pitch discrimination so that even those not genetically blessed with absolute pitch can sharpen their skills of perception. I don't know what the equivalent of absolute pitch would be in typography, but I believe that by learning what the subtle details are and by learning to pay close attention to them, any designer concerned with typography can learn to use type in ways that are more readable, more beautiful, and, most importantly, more expressive of their graphic intent.

As used in this book, the adjectives *readable*, *beautiful*, and *expressive* are not really separable. Although we have all seen visually striking pages of type that are nearly impossible to read, and although such uses of type are legitimate in some contexts, this book is concerned exclusively with type that is intended to be read. At the very outset, therefore, the book demonstrates the way in which type size, line width, and interlinear space all affect readability.

Type color is the key to both readable and expressive type, and subsequent chapters demonstrate how type color is determined by the design of the typeface itself and by line spacing, word spacing, and letterspacing. Each of these chapters presents examples of text type set in a vari-

INTRODUCTION

ety of ways and in a variety of typefaces and sizes. The accompanying captions call attention to how these subtle changes affect the overall appearance of the type on the page.

In contemporary typesetting, characters can be altered, and this, too, has a great bearing on the readability of the type, as does the choice of justifying or not justifying the column. Two chapters provide many settings and typefaces to illustrate what happens. Even the small details of punctuation and numbered lists are presented to illustrate how they affect the appearance of type.

If this book accomplishes its goal, you should acquire a clear idea of what elements will give you the look you want to achieve. You should also be able to communicate those ideas to the typesetter, to establish a common language between yourself and the compositor. Largely because of the rapidly changing technology in typesetting, designers often use terms that no longer apply to the current technology or terms that have a slightly different meaning from the intended definition. The classic example of this, of course, is *leading*, a term used to describe the space between lines. This term had meaning when there was lead between lines of metal type, but I doubt that many people setting computer type today have ever even seen lead. The more precise the language for type specification, the easier it is to arrive at the exact results you want. For this reason, Chapter 1 presents the technical terminology used throughout the book. While I emphatically do not recommend that designers tell typesetters how to do their job, I do believe that knowing a little of how the job is done helps in clearly expressing what you want.

Finally, there is a practical intention in this book. A basic understanding of how type is produced, as well as some knowledge of the particular capabilities of your typesetter, will help you make appropriate decisions for particular jobs. While almost any degree of refinement in typography is possible with some computer systems, not all refinements are equally practical. Since both cost and time are factors in almost all the work you do, it is important to understand the relative difficulty of achieving what you want so that you can evaluate this in terms of the overall project. Some things can be accomplished easily and at little or no cost, and others may be expensive and time-consuming.

As you will see, I offer almost no hard-and-fast rules of the ''always'' and ''never'' kind. Each typeface, each size and measure, and every method of typesetting presents different challenges, and your individual taste as a designer will, and should, condition your particular solution. However, there are broad criteria for legibility, readability, and consistency of color that should always be kept in mind. If type is meant to be read, it must be readable. The ultimate goal is to have readable type that is also beautiful and expressive.

Typography employs its own specific vocabulary. Since we will be relying on this language throughout this book, it's important to be familiar with the terms being used. Some of the terms explained here may already be familiar to you, and others may not. All of them are designed to provide the language that communicates creative ideas.

LETTERFORMS

Figure 1 shows a typeset word with its typographic parts identified. Our alphabet uses uppercase, or capital letters (caps) and small, or lowercase, letters (lc). If we think of a lowercase letter as sitting on a baseline and draw another line along the top of the body of the letter, the distance between the two lines is the x-height of the letter. The parts of the lowercase letters that rise above this line are called ascenders; the parts that fall below the baseline are called descenders.

The stroke refers to any linear element that makes up a letterform. The thickness of the line with which the letter is drawn is called its stroke weight. Typically this line varies in weight within the letterform. Heavy strokes are called thicks, and light strokes are called thins. The amount of variation between them is referred to as the thick/thin contrast.

The space entirely or partially enclosed within a letter is called the counter; the part of the letter enclosing the counter is called the bowl. The upright stroke of a letter is called the stem. The terminal strokes are called serifs. When the stem curves into the serif, this curve is called a bracket. Not all serifs are bracketed. Typefaces that do not have serifs

WORKING VOCABULARY

are called sans serif faces. (The French word *sans* means "without.") All other faces are called serif faces. Although the exact design of a serif differs in every typeface, serifs tend to fall into some basic categories, as shown in Figure 2.

In all good typographic design, subtle visual considerations modify mechanical geometric ones. For example, we tend to think that the ascender is the same height as the cap letter, but this is not always the case. It's also true that horizontal strokes tend to be slightly thinner than vertical strokes. Curved letters are often slightly wider than squared letters of the same size. And round letters tend to fall slightly below the baseline. All of these subtle variations are designed to give the *illusion* of mathematical precision.

TYPEFACES

A typeface is an alphabet designed with consistent visual characteristics. A font of type is a set of characters, in the same size, comprising all the letters of the alphabet in both upper- and lowercase and all the figures and marks of punctuation. A consistent design is the mark of a unified typeface. Even very small design variations make one typeface different from another and have surprisingly large consequences in the overall appearance of a type page.

There are many new typefaces that are based on old models and are often called by the names of their original models, like Garamond or

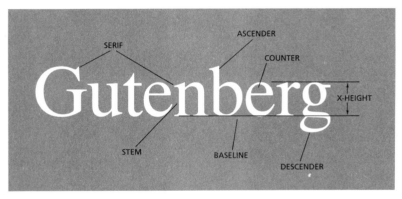

FIGURE 1

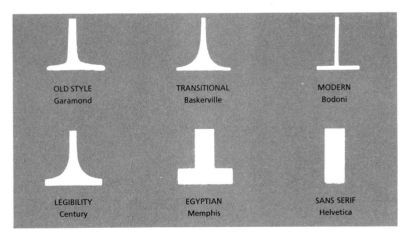

FIGURE 2

This is Gill Sans Light

This is Gill Sans

This is Gill Sans Bold

This is Gill Sans Extra Bold

This is Gill Sans Ultra bold

FIGURE 3

This is Torino, a condensed face

This is Baskerville, a normal face

This is Clarendon, an expanded face

FIGURE 4

Caslon. These typefaces not only differ substantially from their models, they also differ from each other. Because different typesetting systems require adjustments of design to fit their technical requirements, even the same basic designs can differ somewhat when set on different equipment. Linotype Garamond, for example, will be slightly different from Compugraphic Garamond. The reason for this difference of the typeface will become clearer when we discuss unit systems.

Typefaces fall into not only the broad categories typified by their serifs, as shown in Figure 2, but also into groupings defined by their basic stroke weight, the variations between thick and thin strokes, the proportion of x-height to stroke width, and the ratio of x-height to the ascenders and descenders. Figure 3 shows what is called a family of type, that is, a group of typefaces with the same basic design but with differing stroke weights. The most common weights are light, normal (or book), semi-bold, bold, and extra bold.

Faces that are taller than usual in proportion to their width are called condensed faces, and those that are wider in proportion to their height are called extended or expanded faces (Figure 4).

ABSOLUTE MEASUREMENTS

Most measurements in typography are specified in picas and points. A pica is an absolute measurement, like an inch or a centimeter; it is always fixed in size. There are 6 picas to an inch and 12 points in a pica, which means there are 72 points in 1 inch. Figure 5 compares inches and centimeters to picas and points.

The length of a typeset line—its measurement from left to right—is always given in picas and is called either the measure, length, or pica width of the line. When we speak of a line being "by" 24 picas, we are referring to its measure. The arithmetical multiplication sign (x) is often used to mark a given measure; for example, "x 24" means by, or set on, a 24-pica line measure.

The amount of space we perceive between lines is most commonly and most accurately given as the measurement in points from the baseline of one line of type to the baseline of the next. As a holdover from the metal technology previously used to set type, some people and even some equipment manufacturers use the word *lead* or *leading* because there actually was lead between the lines. Nowadays line spacing, interlinear space, and base-to-base spacing are all preferable terms. When we speak of type being "on 13," we mean that it measures 13 points from baseline to baseline. The abbreviation *b/b* is often used in specifying this space for headings and display lines. The most common expression, however, is as a fraction such as 9/11, in which the denominator (11) is the base-to-base measurement and the numerator (9) is the designated type size. Thus the expression "9/11 x 24" means 9-point type set with 11-point line spacing on a 24-pica line. It is read as "9 on 11 by 24."

Type size itself is a rather elusive concept. We refer to the size of type in points—for example, 10-point Helvetica or 12-point Bodoni. This refers to the measurement, in points, from the top of the ascender to the bottom of the descender (Figure 6). Your eye, however, determines type size by assessing the lowercase height (x-height) and other aspects of the design of the face, such as the size of the counters. For example, 10-point Helvetica is substantially larger than 12-point Bodoni in every way except in the ascender-to-descender measurement. The most useful way of judging the appropriate size of type for a given use is to know how many characters of that size, on the average, will set in the width of 1 pica. This is known as the characters per pica, or cpp, of the type.

RELATIVE MEASUREMENTS

While many of the measurements used by designers are absolute, some measurements are relative, which means they vary from type size to type size. Typical examples of relative measurements are em spaces, en spaces, and thin spaces. An em (M) space is understood to be a space equal in

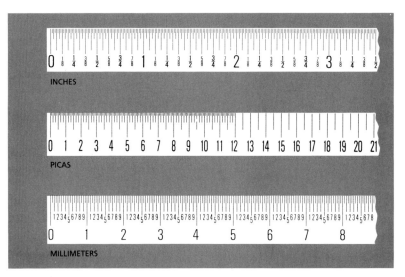

FIGURE 5

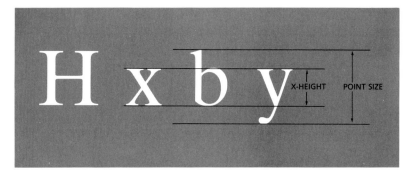

FIGURE 6

13

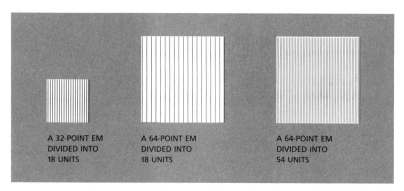

A 32-POINT EM
DIVIDED INTO
18 UNITS

A 64-POINT EM
DIVIDED INTO
18 UNITS

A 64-POINT EM
DIVIDED INTO
54 UNITS

FIGURE 7

width to the size of type designated; an en space (N) is half that width, and a thin space is a quarter of an em. In 10-point type, for example, an em space is 10 points, an en space is 5 points, and a thin space is 2.5 points. Indentations of various kinds and spaces around display elements are often specified with ems, ens, and thin spaces. These relative spaces refer always and only to horizontal space—the space within the type line. Vertical space is always given in absolute points or fractions of points.

Other relative measurements are associated with computer typesetting. Typesetting programs use a system in which the units of measurement—actually referred to as units—are proportional to the width of the particular face and size of the type being set. This system subdivides the width of the uppercase *M* of a given font and size into either 18 or 54 (or sometimes 144) units. Thus, as we see in Figure 7, 1 unit of 32-point Bookman is half the actual size of 1 unit of 64-point Bookman. Although it is unlikely the designer will ever use units in specifying type, it is important to understand how very small spaces—like those between characters and words—are adjusted by the typesetter. Being familiar with the terminology permits you to communicate your corrections to the typesetter.

Each character in a font is designed to fit exactly a given number of units. Type designs must sometimes be altered so that the characters fit into even units, depending on the system of unit measurements used by a typesetter. Variations in the number of units into which a typesetting system subdivides a character account for many of the subtle differences we see in typefaces that may have the same name but have been designed for different systems.

The unit measurement of each character includes a small amount of space on each side of the letter. The space constitutes the normal space between characters in a font. In a process called kerning (see Chapter 5), this predetermined space can be altered. In an 18-unit system, spaces as small as 1/8 unit can be added or removed. (In a 54-unit system the equivalent would be 3/8 unit.) Word spacing (see Chapter 4) is also manipulated using unit spaces.

This book was set on an 18-unit system. In the discussions on word spacing, remember that when we specify 4 to 7 units on an 18-unit system, for example, the equivalent would be 12 to 21 units on a 54-unit system.

TYPESETTING PROCEDURES

Every typesetting house has its own internal procedures and divisions of responsibility, making it impossible to chart the exact course of copy from the time it leaves a designer's hands to the time a proof arrives. Nevertheless, there are certain basic processes that copy must go through, and these stages employ their own vocabulary as well.

"Copy" refers to the words that are to be set. Copy may be in the form of manuscript, called hard copy, which is produced by a typewriter or word processor. Copy may also come in an electronic form, as a disk or diskette. This copy is accompanied by instructions from the designer on how the type is to be set, instructions called specifications, or specs. Before the copy is entered into the typesetting system, the specs are translated into alphanumeric codes. The copy and the codes are then entered into the system, a process called input.

Although there are some keyboarding systems that are highly interactive, in which the operator can intervene at any time to control spacing and line endings, such systems are rare. In fact, since they require expensive operator time, these systems are becoming even more rare for setting running text. In most text setting, the copy and codes are input, and all the specific typesetting decisions are made by the computer, rather than by the operator. With careful programming and coding, such systems can produce refined and precise typesetting without line-by-line operator intervention.

After the copy is input and processed by the computer, it is output by the actual typesetting mechanism. Normally a positive photographic image on paper, the output can also be a film positive. In a good composition house, output is proofread in house. Good proofreading involves checking to see that all the typesetting instructions have been followed and carefully examining the quality of the typesetting itself. If the type is set from hard copy, the accuracy of the input is also checked for typographic errors. Bad line breaks, excessive hyphenation, unequal word spacing, and actual input errors should all be corrected before the proof is returned to the customer, although the fact that proof is read by the typesetter in no way excuses the designer from checking it meticulously.

If you have reviewed the working vocabulary presented here, you can tackle any of the discussions in the following chapters. The technical language gives you the tools needed for communicating your visual ideas.

A minimum requirement for text type meant to be read is that it be legible. Legible type is large enough and distinct enough for a reader to discriminate individual words and/or letters. If type is too small to focus on, or if letters are insufficiently distinct from each other to be easily recognized, then type is illegible. If you can't distinguish an *l* from an *i*, for example, the text is not legible. Readability takes legibility a step further. Text may be legible but not readable if the reader is unable to read easily and smoothly and becomes quickly tired and bored. Readability is the quality that makes the page easy to read, inviting, and pleasurable to the eye.

In recent years specialists in psychology and communications theory have discovered a good deal about the process of reading, and some of them have come up with recommendations for ideally legible text. (Not unexpectedly, these recommendations conform to what good typographers have been doing naturally since Gutenberg.) Nevertheless, these generalized recommendations cannot take into consideration the design of individual faces and the subtleties of word and character spacing, nor the nature of the material and the subjective circumstances of reading. The findings of this research should be taken not as a final authority but as a starting point in designing readable text.

The major factors affecting readability relate to the relative proportions of line width, type size, and spaces between lines, words, and letters. How this works becomes clear when we understand the process of reading. Psychologists have found that we read in a series of eye fixations; that is, we read a group of words within one eye span and then shift our eyes, in what is called a saccadic movement, along the line to another group of words. At normal reading distance a normal eye span is between 12 and 15 picas wide. If a column of text type is set too wide—any more than two-and-a-little eye spans—we must move our heads as well as our eyes. This makes for both tiring and inefficient reading. The upper limit, then, for the length of a line meant for continuous reading is about 27 picas. A column of type a single eye span wide (about 13 picas) is the standard measure of many magazine and newspaper columns, which are designed for quick reading.

The width of a line is not, however, the only factor that determines readability. Within the upper and lower limits, two elements make for good and readable composition: the proportion of type size to line width, and the horizontal flow conditioned by the white space between the lines. If the size of the type is too great for the measure, very few words will fit on the line, and word spacing will become very uneven. Many of the line endings will be hyphenated, causing reading rhythm to be broken. If the size of the type is too small for the measure, the reader will have to focus more closely, reducing the eye span and increasing the number of saccadic movements to the end of the line. This leads quickly to fatigue. However, the most common mistake nonprofessionals make is specifying type too large for the measure rather than too small.

There are certain rules of thumb about the proportion of line width to type size. For example, the width of the line specified should be equal to between 1.5 and 2.5 times the length of the typeset alphabet, or lines should average 8 to 10 words. These rules are a good place to start, but

LEGIBILITY AND READABILITY

they should be taken as guidelines only. The design of the face and the nature of the material must be taken into consideration.

The proportion and distribution of white space between lines, words, and characters are also major factors in determining readability. Although these elements and their refinements will be discussed extensively in later chapters, it is important here to realize that they are crucial to even the most basic discussion of readability. There must be enough space between the lines so that the eye can easily move in a horizontal direction, enough space between words so that they can be perceived as units, and enough space between letters so that they can be distinguished. On the other hand, there must not be so much space that the eye fails to make the transition from the end of one line to the beginning of the next easily, so that words do not flow easily into each other, or so that letters do not compose visually into words.

Psychologists and reading experts have also discovered that once we have mastered reading, we largely recognize words by their outlines, rather than by their individual letters. This tells us that long passages of all capital letters are difficult to read, since words composed of all capitals have basically rectangular outlines and lack ascenders and descenders. In fact, reading speed is slowed by about 10 percent in text that is made up of all capital letters. Text made up of typefaces with very large x-heights tends to exhibit some of the same problems. Like words in all caps, words in faces with large x-heights do not have very characteristic visual outlines. As x-height increases, ascender and descender height necessarily decreases; this can lead to poor differentiation of certain letter pairs, such as lowercase *n* and lowercase *h*. The larger x-height also reduces the channel of white space between the lines.

Experts continue to debate whether or not sans serif typefaces are less legible and/or readable than serif faces. Since serif faces tend to move the eye along the horizontal direction of reading, we would expect serif faces to be more readable than sans serif ones. And since the serifs themselves are an additional means of differentiating letters from one another, we would expect serif typefaces to be more legible than sans serif ones. However, according to several experiments, sans serifs do not seem to have decreased legibility. Nevertheless, many people do find that reading long passages in sans serif type can be tiring. My belief is that the overall even color of some sans serif pages tends not to offer enough visual interest to sustain attention and so may decrease readability.

Right justification, or rather the lack of it, has also been investigated as a factor in readability. Since an uneven line ending creates a pattern of broken eye movement, you might expect that justified type would be easier to read. Again, reading experiments do not confirm this. It may be that the additional white space provided by unjustified type compensates for the less easy eye movement pattern. Unjustified left margins, however, force the reader to search for the beginning of each line and should be avoided except for special effects.

The key relationships for readability, however, are those between visual type size (characters per pica), line length, and line spacing. The following pages show some examples of how these interact.

READABILITY ON NARROW MEASURES

On a minimum measure, like 9 picas, small and even very small sizes of type are far more readable than large sizes. The characters-per-pica (cpp) in unjustified setting of the faces shown here range from 3.69 for the 7 point to 2.15 for the 12 point. In the 9-pica measure the 8 (3, 4) and even the 7 point (1, 2) read fluently, while the 9 point (5), which sets 2.87 characters per pica, begins to look too large for the width of line. The larger sizes are impossibly clumsy on the narrow measure. A measure as narrow as this would seldom be used for consecutive reading.

Examples 8–18 are set unjustified on a 12-pica measure. Measures of 12 to 15 picas are common in magazine setting, where they are often set justified. When the measure is increased to 12 picas, the 7 point (8, 9) begins to seem hard to read but the 8 point, especially with 2 points of line spacing (11), would work well in many contexts. However, at this line width most people would be more comfortable with the 9 point (12, 13) for prolonged reading. The 10 point and larger sizes are too large for this measure also.

The next morning, in the printing office, Edwin came upon Big James giving a lesson in composing to the younger apprentice, who in theory had 'learned his cases'. Big James held the composing stick in his great left hand, like a match-box, and with his great right thumb and index

1 7/8 TIMES ROMAN BY 9

The next morning, in the printing office, Edwin came upon Big James giving a lesson in composing to the younger apprentice, who in theory had 'learned his cases'. Big James held the composing stick in his great left hand, like a match-box, and with his great right thumb and index

2 7/9 TIMES ROMAN BY 9

The next morning, in the printing office, Edwin came upon Big James giving a lesson in composing to the younger apprentice, who in theory had 'learned his cases'. Big James held the composing stick in his great left hand, like a match-

3 8/9 TIMES ROMAN BY 9

The next morning, in the printing office, Edwin came upon Big James giving a lesson in composing to the younger apprentice, who in theory had 'learned his cases'. Big James held the composing stick in his great left hand, like a match-

4 8/10 TIMES ROMAN BY 9

The next morning, in the printing office, Edwin came upon Big James giving a lesson in composing to the younger apprentice, who in theory had 'learned his cases'. Big James held the composing stick in his great left hand, like a match-box,

5 9/11 TIMES ROMAN BY 9

The next morning, in the printing office, Edwin came upon Big James giving a lesson in composing to the younger apprentice, who in theory had 'learned his cases'. Big James held the composing stick in his great

6 10/12 TIMES ROMAN BY 9

The next morning, in the printing office, Edwin came upon Big James giving a lesson in composing to the younger apprentice, who in theory had 'learned his cases'. Big James

7 12/14 TIMES ROMAN BY 9

The next morning, in the printing office, Edwin came upon Big James giving a lesson in composing to the younger apprentice, who in theory had 'learned his cases'. Big James held the composing stick in his great left hand, like a match-box, and with his great right thumb and index picked letter after letter from the case, very slowly in order to display the movement,

8 7/8 TIMES ROMAN BY 12

The next morning, in the printing office, Edwin came upon Big James giving a lesson in composing to the younger apprentice, who in theory had 'learned his cases'. Big James held the composing stick in his great left hand, like a match-box, and with his great right thumb and index picked letter after letter from the case, very slowly in order to display the movement,

9 7/9 TIMES ROMAN BY 12

The next morning, in the printing office, Edwin came upon Big James giving a lesson in composing to the younger apprentice, who in theory had 'learned his cases'. Big James held the composing stick in his great left hand, like a match-box, and with his great right thumb and index picked letter after letter from the case,

10 8/9 TIMES ROMAN BY 12

The next morning, in the printing office, Edwin came upon Big James giving a lesson in composing to the younger apprentice, who in theory had 'learned his cases'. Big James held the composing stick in his great left hand, like a match-box, and with his great right thumb and index very slowly in order to display the move-

11 8/10 TIMES ROMAN BY 12

The next morning, in the printing office, Edwin came upon Big James giving a lesson in composing to the younger apprentice, who in theory had 'learned his cases'. Big James held the composing stick in his great left hand, like a match-box, and with

12 9/10 TIMES ROMAN BY 12

The next morning, in the printing office, Edwin came upon Big James giving a lesson in composing to the younger apprentice, who in theory had 'learned his cases'. Big James held the composing stick in his great left hand, like a match-box, and with

13 9/11 TIMES ROMAN BY 12

The next morning, in the printing office, Edwin came upon Big James giving a lesson in composing to the younger apprentice, who in theory had 'learned his cases'. Big James held the composing stick in his great left hand,

14 10/11 TIMES ROMAN BY 12

The next morning, in the printing office, Edwin came upon Big James giving a lesson in composing to the younger apprentice, who in theory had 'learned his cases'. Big James held the composing stick in his great left hand,

15 10/12 TIMES ROMAN BY 12

The next morning, in the printing office, Edwin came upon Big James giving a lesson in composing to the younger apprentice, who in theory had 'learned his cases'. Big James held the composing stick in his great left hand, like a match-box, and with his great

16 11/12 TIMES ROMAN BY 12

The next morning, in the printing office, Edwin came upon Big James giving a lesson in composing to the younger apprentice, who in theory had 'learned his cases'. Big James held the composing stick in his great left hand, like a match-box, and with his great

17 11/13 TIMES ROMAN BY 12

The next morning, in the printing office, Edwin came upon Big James giving a lesson in composing to the younger apprentice, who in theory had 'learned his cases'. Big James held the composing stick in his great left hand, like a match-box,

18 12/13 TIMES ROMAN BY 12

READABILITY ON INTERMEDIATE MEASURES

The examples on this spread and the next are set on an 18-pica measure. Measures from 15 to 20 picas are often used in two-column book and magazine formats. Mass-market paperback books are usually set 19 or 20 picas wide. The characters-per-pica in this justified setting range from 3.35 for the 8 point to 1.91 for the 14 point. In this measure the 8 point (1, 2) looks forbiddingly small and dense. Example 3, 9/10, also looks very dense since the increased width of the line requires more space between lines to help the horizontal flow. The 9/11 sample shows how the additional line space helps. The additional line space is even more important for the two 10-point examples (5, 6).

Examples 7 and 8 show the relation of size, measure, and line space even more dramatically. Although the 11-point type (2.49 cpp) would normally be too large for an 18-pica measure, adding an unusually great amount of space between the lines changes the overall effect. No amount of line spacing, however, can make faces which set 2.23 cpp (9) or 1.91 cpp (10) useful for text setting on an 18-pica measure.

The next morning, in the printing office, Edwin came upon Big James giving a lesson in composing to the younger apprentice, who in theory had 'learned his cases'. Big James held the composing stick in his great left hand, like a match-box, and with his great right thumb and index picked letter after letter from the case, very slowly in order to display the movement, and dropped them into the stick. In his mild, resonant tones he explained that each letter must be picked up unfalteringly in a particular way, so that it would drop face upward into the stick without any intermediate manipulation. And he explained also that the left hand must be held so that the right hand would have to travel to and fro as little as possible. He was revealing the basic mysteries of his craft, and was happy, making the while the broad series of stock pleasantries which have probably been current in composing rooms since printing was invented. Then he was silent, working more and more quickly, till his right hand could scarcely be followed in its twinklings, and the face of the apprentice duly spread in marvel. When the line was finished he drew out the rule, clapped it down on the top of the last row

1 8/9 TIMES ROMAN BY 18

The next morning, in the printing office, Edwin came upon Big James giving a lesson in composing to the younger apprentice, who in theory had 'learned his cases'. Big James held the composing stick in his great left hand, like a match-box, and with his great right thumb and index picked letter after letter from the case, very slowly in order to display the movement, and dropped them into the stick. In his mild, resonant tones he explained that each letter must be picked up unfalteringly in a particular way, so that it would drop face upward into the stick without any intermediate manipulation. And he explained also that the left hand must be held so that the right hand would have to travel to and fro as little as possible. He was revealing the basic mysteries of his craft, and was happy, making the while the broad series of stock pleasantries which have probably been current in composing rooms since printing was invented. Then he was silent, working more and more quickly, till his right hand could scarcely be followed in its twinklings, and the face of the apprentice duly spread in marvel. When the line was finished he drew out the rule, clapped it down on the top of the last row

2 8/10 TIMES ROMAN BY 18

The next morning, in the printing office, Edwin came upon Big James giving a lesson in composing to the younger apprentice, who in theory had 'learned his cases'. Big James held the composing stick in his great left hand, like a match-box, and with his great right thumb and index picked letter after letter from the case, very slowly in order to display the movement, and dropped them into the stick. In his mild, resonant tones he explained that each letter must be picked up unfalteringly in a particular way, so that it would drop face upward into the stick without any intermediate manipulation. And he explained also that the left hand must be held so that the right hand would have to travel to and fro as little as possible. He was revealing the basic mysteries of his craft, and was happy, making the while the broad series of stock pleasantries which have probably been current in composing rooms since printing was invented. Then he

3 9/10 TIMES ROMAN BY 18

The next morning, in the printing office, Edwin came upon Big James giving a lesson in composing to the younger apprentice, who in theory had 'learned his cases'. Big James held the composing stick in his great left hand, like a match-box, and with his great right thumb and index picked letter after letter from the case, very slowly in order to display the movement, and dropped them into the stick. In his mild, resonant tones he explained that each letter must be picked up unfalteringly in a particular way, so that it would drop face upward into the stick without any intermediate manipulation. And he explained also that the left hand must be held so that the right hand would have to travel to and fro as little as possible. He was revealing the basic mysteries of his craft, and was happy, making the while the broad series of stock pleasantries which have probably been current in composing rooms since printing was invented. Then he

4 9/11 TIMES ROMAN BY 18

The next morning, in the printing office, Edwin came upon Big James giving a lesson in composing to the younger apprentice, who in theory had 'learned his cases'. Big James held the composing stick in his great left hand, like a match-box, and with his great right thumb and index picked letter after letter from the case, very slowly in order to display the movement, and dropped them into the stick. In his mild, resonant tones he explained that each letter must be picked up unfalteringly in a particular way, so that it would drop face upward into the stick without any intermediate manipulation. And he explained also that the left hand must be held so that the right hand would have to travel to and fro as little as possible. He was revealing the basic mysteries of his craft, and was happy, making

5 10/11 TIMES ROMAN BY 18

The next morning, in the printing office, Edwin came upon Big James giving a lesson in composing to the younger apprentice, who in theory had 'learned his cases'. Big James held the composing stick in his great left hand, like a match-box, and with his great right thumb and index picked letter after letter from the case, very slowly in order to display the movement, and dropped them into the stick. In his mild, resonant tones he explained that each letter must be picked up unfalteringly in a particular way, so that it would drop face upward into the stick without any intermediate manipulation. And he explained also that the left hand must be held so that the right hand would have to travel to and fro as little as possible. He was revealing the basic mysteries of his craft, and was happy, making

6 10/12 TIMES ROMAN BY 18

The next morning, in the printing office, Edwin came upon Big James giving a lesson in composing to the younger apprentice, who in theory had 'learned his cases'. Big James held the composing stick in his great left hand, like a match-box, and with his great right thumb and index picked letter after letter from the case, very slowly in order to display the movement, and dropped them into the stick. In his mild, resonant tones he explained that each letter must be picked up unfalteringly in a particular way, so that it would drop face upward into the stick without any intermediate manipulation. And he explained also that the left hand must be held so that the right hand would have to travel to and fro as little as possible. He was revealing the basic mysteries of his craft, and was happy, making the while the broad series of stock pleasantries which have probably been current in composing rooms since printing was invented. Then he was silent, working more and more quickly, till his right hand could scarcely be followed in its twinklings, and the face of the apprentice duly spread in marvel. When the line was finished he drew out the rule, clapped it down on the top of the last row of letters, and gave the composing stick to the apprentice to essay.

The apprentice began to compose with his feet, his shoulders, his mouth, his eyebrows —with all his body except his hands, which nevertheless travelled spaciously far and wide.

'It's not in seven year, nor in seventy, as you'll learn, young sun of a gun!' said Big James.

The next morning, in the printing office, Edwin came upon Big James giving a lesson in composing to the younger apprentice, who in theory had 'learned his cases'. Big James held the composing stick in his great left hand, like a match-box, and with his great right thumb and index picked letter after letter from the case, very slowly in order to display the movement, and dropped them into the stick. In his mild, resonant tones he explained that each letter must be picked up unfalteringly in a particular way, so that it would drop face upward into the stick without any intermediate manipulation. And he explained also that the left hand must be held so that the right hand would have to travel to and fro as little as possible. He was revealing the basic mysteries of his craft, and was happy, making the while the broad series of stock pleasantries which have probably been current in composing rooms since printing was invented. Then he was silent, working more and more quickly, till his right hand could scarcely be followed in its twinklings, and the face of the apprentice duly spread in marvel. When the line was finished he drew out the rule, clapped it down on the top of the last row of letters, and gave the composing stick to the apprentice to essay.

The apprentice began to compose with his feet, his shoulders, his mouth, his eyebrows—

The next morning, in the printing office, Edwin came upon Big James giving a lesson in composing to the younger apprentice, who in theory had 'learned his cases'. Big James held the composing stick in his great left hand, like a match-box, and with his great right thumb and index picked letter after letter from the case, very slowly in order to display the movement, and dropped them into the stick. In his mild, resonant tones he explained that each letter must be picked up unfalteringly in a particular way, so that it would drop face upward into the stick without any intermediate manipulation. And he explained also that the left hand must be held so that the right hand would have to travel to and fro as little as possible. He was revealing the basic mysteries of his craft, and was happy, making the while the broad series of stock pleasantries which have probably been current in composing rooms since printing was invented. Then he was silent, working more and more quickly, till his right hand could scarcely be followed in its twinklings, and the face of the apprentice duly spread in marvel. When the line was finished he drew out the rule, clapped it down on the top of the last row of letters, and gave the composing stick to the apprentice

The next morning, in the printing office, Edwin came upon Big James giving a lesson in composing to the younger apprentice, who in theory had 'learned his cases'. Big James held the composing stick in his great left hand, like a match-box, and with his great right thumb and index picked letter after letter from the case, very slowly in order to display the movement, and dropped them into the stick. In his mild, resonant tones he explained that each letter must be picked up unfalteringly in a particular way, so that it would drop face upward into the stick without any intermediate manipulation. And he explained also that the left hand must be held so that the right hand would have to travel to and fro as little as possible. He was revealing the basic mysteries of his craft, and was happy, making the while the broad series of stock pleasantries which have probably been current in composing rooms since printing was invented. Then he

These examples are set justified on a 24-pica measure, a measure that is common in book setting. The 9/11 setting (1), which worked very well on an 18-pica measure, looks somewhat small on a 24-pica measure and might be tiring for prolonged reading. These lines average over 70 characters and exceed the 2½ alphabets-per-line prescribed by our rule of thumb. Nevertheless, this makes an attractive page. Example 2, 10/12, would be the most normal choice for this measure. If you turn back to page 18 and compare the 10-point type on a 9-pica measure with the way it looks here, you will have a very clear idea of how size and measure interact visually. For my taste example 3 is too large, although with an average of 58.5 characters per line it is well within the rule-of-thumb guidelines. More line spacing would greatly improve the appearance.

The next morning, in the printing office, Edwin came upon Big James giving a lesson in composing to the younger apprentice, who in theory had 'learned his cases'. Big James held the composing stick in his great left hand, like a match-box, and with his great right thumb and index picked letter after letter from the case, very slowly in order to display the movement, and dropped them into the stick. In his mild, resonant tones he explained that each letter must be picked up unfalteringly in a particular way, so that it would drop face upward into the stick without any intermediate manipulation. And he explained also that the left hand must be held so that the right hand would have to travel to and fro as little as possible. He was revealing the basic mysteries of his craft, and was happy, making the while the broad series of stock pleasantries which have probably been current in composing rooms since printing was invented. Then he was silent, working more and more quickly, till his right hand could scarcely be followed in its twinklings, and the face of the apprentice duly spread in marvel. When the line was finished he drew out the rule, clapped it down on the top of the last row of letters, and gave the composing stick to the apprentice to essay.

The apprentice began to compose with his feet, his shoulders, his mouth, his eyebrows—with all his body except his hands, which nevertheless travelled spaciously far and wide.

'It's not in seven year, nor in seventy, as you'll learn, young sun of a gun!' said Big James.

And, having unsettled the youth to his foundations with a bland thwack across the head, he resumed the composing stick and began again the exposition of the unique smooth movement which is the root of rapid typesetting.

'Here!' said Big James, when the apprentice had behaved worse than ever. 'Us'll ask Mr Edwin to have a go. 'Us'll see what *he*'ll do.'

And Edwin, sheepish, had to comply. He was in pride bound to surpass the apprentice, and did so.

'There!' said Big James. 'What did I tell ye?' He seemed to imply a prophecy that, because Edwin had saved the printing office from destruction two days previously, he would prove to be a born compositor.

The next morning, in the printing office, Edwin came upon Big James giving a lesson in composing to the younger apprentice, who in theory had 'learned his cases'. Big James held the composing stick in his great left hand, like a match-box, and with his great right thumb and index picked

The next morning, in the printing office, Edwin came upon Big James giving a lesson in composing to the younger apprentice, who in theory had 'learned his cases'. Big James held the composing stick in his great left hand, like a match-box, and with his great right thumb and index picked letter after letter from the case, very slowly in order to display the movement, and dropped them into the stick. In his mild, resonant tones he explained that each letter must be picked up unfalteringly in a particular way, so that it would drop face upward into the stick without any intermediate manipulation. And he explained also that the left hand must be held so that the right hand would have to travel to and fro as little as possible. He was revealing the basic mysteries of his craft, and was happy, making the while the broad series of stock pleasantries which have probably been current in composing rooms since printing was invented. Then he was silent, working more and more quickly, till his right hand could scarcely be followed in its twinklings, and the face of the apprentice duly spread in marvel. When the line was finished he drew out the rule, clapped it down on the top of the last row of letters, and gave the composing stick to the apprentice to essay.

The apprentice began to compose with his feet, his shoulders, his mouth, his eyebrows—with all his body except his hands, which nevertheless travelled spaciously far and wide.

'It's not in seven year, nor in seventy, as you'll learn, young sun of a gun!' said Big James.

And, having unsettled the youth to his foundations with a bland thwack across the head, he resumed the composing stick and began again the exposition of the unique smooth movement which is the root of rapid typesetting.

'Here!' said Big James, when the apprentice had behaved worse than ever. 'Us'll ask Mr Edwin to have a go. 'Us'll see what *he*'ll do.'

And Edwin, sheepish, had to comply. He was in pride bound to surpass the apprentice, and did so.

'There!' said Big James. 'What did I tell ye?' He seemed to imply a prophecy that, because Edwin had saved the printing office from

The next morning, in the printing office, Edwin came upon Big James giving a lesson in composing to the younger apprentice, who in theory had 'learned his cases'. Big James held the composing stick in his great left hand, like a match-box, and with his great right thumb and index picked letter after letter from the case, very slowly in order to display the movement, and dropped them into the stick. In his mild, resonant tones he explained that each letter must be picked up unfalteringly in a particular way, so that it would drop face upward into the stick without any intermediate manipulation. And he explained also that the left hand must be held so that the right hand would have to travel to and fro as little as possible. He was revealing the basic mysteries of his craft, and was happy, making the while the broad series of stock pleasantries which have probably been current in composing rooms since printing was invented. Then he was silent, working more and more quickly, till his right hand could scarcely be followed in its twinklings, and the face of the apprentice duly spread in marvel. When the line was finished he drew out the rule, clapped it down on the top of the last row of letters, and gave the composing stick to the apprentice to essay.

The apprentice began to compose with his feet, his shoulders, his mouth, his eyebrows—with all his body except his hands, which nevertheless travelled spaciously far and wide.

'It's not in seven year, nor in seventy, as you'll learn, young sun of a gun!' said Big James.

And, having unsettled the youth to his foundations with a bland thwack across the head, he resumed the composing stick and began again the exposition of the unique smooth movement which is the root of rapid typesetting.

'Here!' said Big James, when the apprentice had behaved worse than ever. 'Us'll ask Mr Edwin to have a go. 'Us'll see what *he*'ll do.'

And Edwin, sheepish, had to comply. He was in pride bound to surpass the apprentice, and did so.

READABILITY ON AVERAGE MEASURES / 2

These examples are also set on a 24-pica measure. Example 1, which is set 12/13, is clearly too large and too dense a page for comfortable reading. However, by increasing the line spacing to 12/15 (2) the density of the effect is relieved, making this a possible setting in a context like a children's book. Notice that the additional line space has the effect here of making the type look smaller. Compare this with the effect of adding line space in example 4 on page 20, where the effect was visually opposite, making the type look larger. The type in example 3 is clearly too large for the measure.

The next morning, in the printing office, Edwin came upon Big James giving a lesson in composing to the younger apprentice, who in theory had 'learned his cases'. Big James held the composing stick in his great left hand, like a match-box, and with his great right thumb and index picked letter after letter from the case, very slowly in order to display the movement, and dropped them into the stick. In his mild, resonant tones he explained that each letter must be picked up unfalteringly in a particular way, so that it would drop face upward into the stick without any intermediate manipulation. And he explained also that the left hand must be held so that the right hand would have to travel to and fro as little as possible. He was revealing the basic mysteries of his craft, and was happy, making the while the broad series of stock pleasantries which have probably been current in composing rooms since printing was invented. Then he was silent, working more and more quickly, till his right hand could scarcely be followed in its twinklings, and the face of the apprentice duly spread in marvel. When the line was finished he drew out the rule, clapped it down on the top of the last row of letters, and gave the composing stick to the apprentice to essay.

The apprentice began to compose with his feet, his shoulders, his mouth, his eyebrows—with all his body except his hands, which nevertheless travelled spaciously far and wide.

'It's not in seven year, nor in seventy, as you'll learn, young sun of a gun!' said Big James.

And, having unsettled the youth to his foundations with a bland thwack across the head, he resumed the composing stick and began again the exposition of the unique

1 12/13 TIMES ROMAN BY 24

The next morning, in the printing office, Edwin came upon Big James giving a lesson in composing to the younger apprentice, who in theory had 'learned his cases'. Big James held the composing stick in his great left hand, like a match-box, and with his great right thumb and index picked letter after letter from the case, very slowly in order to display the movement, and dropped them into the stick. In his mild, resonant tones he explained that each letter must be picked up unfalteringly in a particular way, so that it would drop face upward into the stick without any intermediate manipulation. And he explained also that the left hand must be held so that the right hand would have to travel to and fro as little as possible. He was revealing the basic mysteries of his craft, and was happy, making the while the broad series of stock pleasantries which have probably been current in composing rooms since printing was invented. Then he was silent, working more and more quickly, till his right hand could scarcely be followed in its twinklings, and the face of the apprentice duly spread in marvel. When the line was finished he drew out the rule, clapped it down on the top of the last row of letters, and gave the composing stick to the apprentice to essay.

The apprentice began to compose with his feet, his shoulders, his mouth, his eyebrows—with all his body except his hands, which nevertheless travelled spaciously far and wide.

'It's not in seven year, nor in seventy, as you'll learn,

2 12/15 TIMES ROMAN BY 24

The next morning, in the printing office, Edwin came upon Big James giving a lesson in composing to the younger apprentice, who in theory had 'learned his cases'. Big James held the composing stick in his great left hand, like a match-box, and with his great right thumb and index picked letter after letter from the case, very slowly in order to display the movement, and dropped them into the stick. In his mild, resonant tones he explained that each letter must be picked up unfalteringly in a particular way, so that it would drop face upward into the stick without any intermediate manipulation. And he explained also that the left hand must be held so that the right hand would have to travel to and fro as little as possible. He was revealing the basic mysteries of his craft, and was happy, making the while the broad series of stock pleasantries which have probably been current in composing rooms since printing was invented. Then he was silent, working more and more quickly, till his right hand could scarcely be followed in its twinklings, and the face of the apprentice duly spread in marvel. When the line was finished he drew out the rule, clapped it down on the top of the last row of letters, and gave the composing stick to the apprentice to essay.

3 14/16 TIMES ROMAN BY 24

27

READABILITY ON WIDE MEASURES

Examples 1–5 on this and the next spread are set on a 27-pica measure, the maximum that should be used for prolonged reading since it is somewhat more than two normal eye fixations. On this measure, 10/12 (1) looks very small. Adding one point of line spacing (2) greatly helps the horizontal eye movement. As both the measure and the type size get larger, the amount of line spacing needed grows proportionally. In the 11/13 example (3), although the size of the type is larger, readability is not improved since the line spacing is insufficient. Given a choice between examples 2 and 3 for readability, I would choose 2 even though the type size is smaller. Adding a point of line spacing (4) changes this. Although my preference would still be for example 2 from an aesthetic point of view, I think most people would be more comfortable reading example 4.

In example 5, 12/14 × 27, the size is again clearly too big for the measure. However, compare this with example 6. The type size and line spacing are identical, but the measure has been increased to 34 picas. Although the occasions for using such a wide measure in text setting are infrequent, bear this in mind for such occasions: type that would look awkward and ugly on narrower measures tends to look handsome and readable on wide measures.

The next morning, in the printing office, Edwin came upon Big James giving a lesson in composing to the younger apprentice, who in theory had 'learned his cases'. Big James held the composing stick in his great left hand, like a match-box, and with his great right thumb and index picked letter after letter from the case, very slowly in order to display the movement, and dropped them into the stick. In his mild, resonant tones he explained that each letter must be picked up unfalteringly in a particular way, so that it would drop face upward into the stick without any intermediate manipulation. And he explained also that the left hand must be held so that the right hand would have to travel to and fro as little as possible. He was revealing the basic mysteries of his craft, and was happy, making the while the broad series of stock pleasantries which have probably been current in composing rooms since printing was invented. Then he was silent, working more and more quickly, till his right hand could scarcely be followed in its twinklings, and the face of the apprentice duly spread in marvel. When the line was finished he drew out the rule, clapped it down on the top of the last row of letters, and gave the composing stick to the apprentice to essay.

The apprentice began to compose with his feet, his shoulders, his mouth, his eyebrows—with all his body except his hands, which nevertheless travelled spaciously far and wide.

'It's not in seven year, nor in seventy, as you'll learn, young sun of a gun!' said Big James.

And, having unsettled the youth to his foundations with a bland thwack across the head, he resumed the composing stick and began again the exposition of the unique smooth movement which is the root of rapid typesetting.

'Here!' said Big James, when the apprentice had behaved worse than ever. 'Us'll ask Mr Edwin to have a go. 'Us'll see what *he*'ll do.'

And Edwin, sheepish, had to comply. He was in pride bound to surpass the apprentice, and did so.

'There!' said Big James. 'What did I tell ye?' He seemed to imply a prophecy that, because Edwin had saved the printing office from destruction two days previously, he would prove to be a born compositor.

The next morning, in the printing office, Edwin came upon Big James giving a lesson in composing to the younger apprentice, who in theory had 'learned his cases'. Big James held the composing stick in his great left hand,

1 10/12 TIMES ROMAN BY 27

The next morning, in the printing office, Edwin came upon Big James giving a lesson in composing to the younger apprentice, who in theory had 'learned his cases'. Big James held the composing stick in his great left hand, like a match-box, and with his great right thumb and index picked letter after letter from the case, very slowly in order to display the movement, and dropped them into the stick. In his mild, resonant tones he explained that each letter must be picked up unfalteringly in a particular way, so that it would drop face upward into the stick without any intermediate manipulation. And he explained also that the left hand must be held so that the right hand would have to travel to and fro as little as possible. He was revealing the basic mysteries of his craft, and was happy, making the while the broad series of stock pleasantries which have probably been current in composing rooms since printing was invented. Then he was silent, working more and more quickly, till his right hand could scarcely be followed in its twinklings, and the face of the apprentice duly spread in marvel. When the line was finished he drew out the rule, clapped it down on the top of the last row of letters, and gave the composing stick to the apprentice to essay.

The apprentice began to compose with his feet, his shoulders, his mouth, his eyebrows—with all his body except his hands, which nevertheless travelled spaciously far and wide.

'It's not in seven year, nor in seventy, as you'll learn, young sun of a gun!' said Big James.

And, having unsettled the youth to his foundations with a bland thwack across the head, he resumed the composing stick and began again the exposition of the unique smooth movement which is the root of rapid typesetting.

'Here!' said Big James, when the apprentice had behaved worse than ever. 'Us'll ask Mr Edwin to have a go. 'Us'll see what *he*'ll do.'

And Edwin, sheepish, had to comply. He was in pride bound to surpass the apprentice, and did so.

'There!' said Big James. 'What did I tell ye?' He seemed to imply a prophecy that, because Edwin had saved the printing office from destruction two days previously, he would prove to be a born compositor.

The next morning, in the printing office, Edwin came upon Big James giving a lesson in composing to the younger apprentice, who in theory had 'learned his cases'. Big James held the composing stick in his great left hand, like a match-box, and with his great right thumb and index picked letter after letter from the case, very slowly in order to display the movement, and dropped them into the stick. In his mild, resonant tones he explained that each letter must be picked up unfalteringly in a particular way, so that it would drop face upward into the stick without any intermediate manipulation. And he explained also that the left hand must be held so that the right hand would have to travel to and fro as little as possible. He was revealing the basic mysteries of his craft, and was happy, making the while the broad series of stock pleasantries which have probably been current in composing rooms since printing was invented. Then he was silent, working more and more quickly, till his right hand could scarcely be followed in its twinklings, and the face of the apprentice duly spread in marvel. When the line was finished he drew out the rule, clapped it down on the top of the last row of letters, and gave the composing stick to the apprentice to essay.

The apprentice began to compose with his feet, his shoulders, his mouth, his eyebrows—with all his body except his hands, which nevertheless travelled spaciously far and wide.

'It's not in seven year, nor in seventy, as you'll learn, young sun of a gun!' said Big James.

And, having unsettled the youth to his foundations with a bland thwack across the head, he resumed the composing stick and began again the exposition of the unique smooth movement which is the root of rapid typesetting.

'Here!' said Big James, when the apprentice had behaved worse than ever. 'Us'll ask Mr Edwin to have a go. 'Us'll see what *he*'ll do.'

And Edwin, sheepish, had to comply. He was in pride bound to surpass the apprentice, and did so.

'There!' said Big James. 'What did I tell ye?' He seemed to imply

The next morning, in the printing office, Edwin came upon Big James giving a lesson in composing to the younger apprentice, who in theory had 'learned his cases'. Big James held the composing stick in his great left hand, like a match-box, and with his great right thumb and index picked letter after letter from the case, very slowly in order to display the movement, and dropped them into the stick. In his mild, resonant tones he explained that each letter must be picked up unfalteringly in a particular way, so that it would drop face upward into the stick without any intermediate manipulation. And he explained also that the left hand must be held so that the right hand would have to travel to and fro as little as possible. He was revealing the basic mysteries of his craft, and was happy, making the while the broad series of stock pleasantries which have probably been current in composing rooms since printing was invented. Then he was silent, working more and more quickly, till his right hand could scarcely be followed in its twinklings, and the face of the apprentice duly spread in marvel. When the line was finished he drew out the rule, clapped it down on the top of the last row of letters, and gave the composing stick to the apprentice to essay.

The apprentice began to compose with his feet, his shoulders, his mouth, his eyebrows—with all his body except his hands, which nevertheless travelled spaciously far and wide.

'It's not in seven year, nor in seventy, as you'll learn, young sun of a gun!' said Big James.

And, having unsettled the youth to his foundations with a bland thwack across the head, he resumed the composing stick and began again the exposition of the unique smooth movement which is the root of rapid typesetting.

'Here!' said Big James, when the apprentice had behaved worse than ever. 'Us'll ask Mr Edwin to have a go. 'Us'll see what *he*'ll do.'

The next morning, in the printing office, Edwin came upon Big James giving a lesson in composing to the younger apprentice, who in theory had 'learned his cases'. Big James held the composing stick in his great left hand, like a match-box, and with his great right thumb and index picked letter after letter from the case, very slowly in order to display the movement, and dropped them into the stick. In his mild, resonant tones he explained that each letter must be picked up unfalteringly in a particular way, so that it would drop face upward into the stick without any intermediate manipulation. And he explained also that the left hand must be held so that the right hand would have to travel to and fro as little as possible. He was revealing the basic mysteries of his craft, and was happy, making the while the broad series of stock pleasantries which have probably been current in composing rooms since printing was invented. Then he was silent, working more and more quickly, till his right hand could scarcely be followed in its twinklings, and the face of the apprentice duly spread in marvel. When the line was finished he drew out the rule, clapped it down on the top of the last row of letters, and gave the composing stick to the apprentice to essay.

The apprentice began to compose with his feet, his shoulders, his mouth, his eyebrows—with all his body except his hands, which nevertheless travelled spaciously far and wide.

'It's not in seven year, nor in seventy, as you'll learn, young sun of a gun!' said Big James

And, having unsettled the youth to his foundations with a bland thwack across the head, he resumed the composing stick and began again the exposition of the unique smooth movement which is the root of rapid typesetting.

The next morning, in the printing office, Edwin came upon Big James giving a lesson in composing to the younger apprentice, who in theory had 'learned his cases'. Big James held the composing stick in his great left hand, like a match-box, and with his great right thumb and index picked letter after letter from the case, very slowly in order to display the movement, and dropped them into the stick. In his mild, resonant tones he explained that each letter must be picked up unfalteringly in a particular way, so that it would drop face upward into the stick without any intermediate manipulation. And he explained also that the left hand must be held so that the right hand would have to travel to and fro as little as possible. He was revealing the basic mysteries of his craft, and was happy, making the while the broad series of stock pleasantries which have probably been current

6 12/14 TIMES ROMAN BY 34

The next morning, in the printing office, Edwin came upon Big James giving a lesson in composing to the younger apprentice, who in theory had 'learned his cases'. Big James held the composing stick in his great left hand, like a match-box, and with his great right thumb and index picked letter after letter from the case, very slowly in order to display the movement, and dropped them into the stick. In his mild, resonant tones he explained that each letter must be picked up unfalteringly in a particular way, so that it would drop face upward into the stick without any intermediate manipulation. And he explained also that the left hand must be held so that the right hand would have to travel to and fro as little as possible. He was revealing the basic mysteries of his craft, and

7 14/16 TIMES ROMAN BY 34

LETTER DESIGN AND
TYPE COLOR

When a designer chooses a typeface and makes all the decisions related to its setting, it is largely with the goal of achieving the ideal type color. *Color* may seem an odd word to apply to something that is essentially black and white, but designers commonly use this term to describe the appearance of a mass of type on the page, the precise shade of gray that is created by the visual mixture of black type and white paper, and the visual *texture* of that mass. Perhaps the easiest way to think about type color is to compare it to various kinds of gray fabric: some light and dark, some smoothly woven, and others rough textured. Imagine, for example, a gray silk woven of evenly dyed strands, then compare this first silk to a fabric of a different gray shade and then to a tweed fabric woven with irregular threads of black and white. The visual effects of these color and textural differences are similar to the effects of type color.

The basic feature of good typesetting is consistent color. This consistency is largely determined by the evenness of the spacing between lines, words, and letters. These spaces, and how they can be controlled, will be discussed in the next three chapters. Here we will examine the ways the design of the typeface itself affects its color.

Every aspect of the font design affects its color. Of course, the thickness of the basic stroke weight itself is the primary factor that determines the lightness or darkness of the type mass. If the stroke weight of a typeface is very thin, the overall appearance of the mass will be light gray. A typeface with a heavy stroke weight, such as a bold face, produces a very dark mass.

The evenness of the stroke, that is, the degree of contrast between the thickest and thinnest parts of the letter, affects how active the overall texture may be. A typeface with an even stroke weight and even distribution of internal spaces will produce a smooth, "silky" texture, while a face with a strong thick/thin contrast will produce a texture analogous to the rough tweed fabric. (Smooth textures are sometimes referred to as "even" or "flat"; rough textures as "dazzling" or "busy." These terms tend to be judgmental, so I refer to the variations in texture as being more or less "active.")

Other aspects of the font design are also very important in their effect on color. The distribution of the internal and external spaces within the letterform is crucial in determining the evenness of the texture. The proportion of x-height to ascender and descender also influences the lightness or darkness of the color.

These design features, subtle as they may seem, have an obvious visual effect on the type color, as the examples on the following pages will clearly reveal.

EVEN STROKE WEIGHTS

Faces with even stroke weights, like Egyptian 505, create a smooth overall gray. Where the stroke weight is thin, as in Egyptian 505 Light (1), the shade of gray is quite pale. As the stroke weight becomes heavier, as in Egyptian 505 Medium (2) and Bold (3), the gray becomes much darker but the mass remains fairly even in texture.

Evenness of stroke weight alone does not produce an entirely flat texture. An entirely flat texture is the result of absolutely even distribution of white space within and around letters. In Egyptian, because the internal and external spaces are not quite equal, the overall texture is not entirely flat. Notice, for example, the large enclosed space (called the counter) within the *g* in relation to the much smaller open space (called the bowl) within the descender. This factor, along with slighter differences in the spaces inside and outside the counters of the *a* and *e*, gives some slight activity to the texture despite the evenness of the stroke.

The next morning, in the printing office, Edwin came upon Big James giving a lesson in composing to the younger apprentice, who in theory had 'learned his cases'. Big James held the composing stick in his great left hand, like a match-box, and with his great right thumb and index picked letter after letter from the case, very slowly in order to display the movement, and dropped them into the stick. In his mild, resonant tones he explained that each letter must be picked up unfalteringly in a particular way so that it would drop face upward into the stick without any intermediate manipulation. And he explained also that the left hand must be held so that the right hand would have to travel to and fro as little as possible. He was revealing the basic mysteries of his craft, and was happy, making the while the broad series of stock pleasantries which have probably been current in composing rooms since printing was invented. Then he was silent, working more and more quickly, till his right hand could scarcely be followed in its twinklings, and the face of the apprentice duly spread in marvel. When the line was finished he drew out the rule, clapped it down on the top of the last row of letters, and gave the composing stick to the apprentice to essay.

The apprentice began to compose with his feet, his shoulders, his mouth, his eyebrows—with all his body except his hands, which nevertheless travelled spaciously far and wide.

'It's not in seven year, nor in seventy, as you'll learn, young sun of a gun!' said Big James.

And, having unsettled the youth to his foundations with a bland thwack across the head, he resumed the composing stick and began again the exposition of the

The next morning, in the printing office, Edwin came upon Big James giving a lesson in composing to the younger apprentice, who in theory had 'learned his cases'. Big James held the composing stick in his great left hand, like a match-box, and with his great right thumb and index picked letter after letter from the case, very slowly in order to display the movement, and dropped them into the stick. In his mild, resonant tones he explained that each letter must be picked up unfalteringly in a particular way, so that it would drop face upward into the stick without any intermediate manipulation. And he explained also that the left hand must be held so that the right hand would have to travel to and fro as little as possible. He was revealing the basic mysteries of his craft, and was happy, making the while the broad series of stock pleasantries which have probably been current in composing rooms since printing was invented. Then he was silent, working more and more quickly, till his right hand could scarcely be followed in its twinklings, and the face of the apprentice duly spread in marvel. When the line was finished he drew out the rule, clapped it down on the top of the last row of letters, and gave the composing stick to the apprentice to essay.

The apprentice began to compose with his feet, his shoulders, his mouth, his eyebrows—with all his body except his hands, which nevertheless travelled spaciously far and wide.

'It's not in seven year, nor in seventy, as you'll learn, young sun of a gun!' said Big James.

And, having unsettled the youth to his foundations with a bland thwack across the head, he resumed the composing stick and began again the exposition of the

The next morning, in the printing office, Edwin came upon Big James giving a lesson in composing to the younger apprentice, who in theory had 'learned his cases'. Big James held the composing stick in his great left hand, like a match-box, and with his great right thumb and index picked letter after letter from the case, very slowly in order to display the movement, and dropped them into the stick. In his mild, resonant tones he explained that each letter must be picked up unfalteringly in a particular way, so that it would drop face upward into the stick without any intermediate manipulation. And he explained also that the left hand must be held so that the right hand would have to travel to and fro as little as possible. He was revealing the basic mysteries of his craft, and was happy, making the while the broad series of stock pleasantries which have probably been current in composing rooms since printing was invented. Then he was silent, working more and more quickly, till his right hand could scarcely be followed in its twinklings, and the face of the apprentice duly spread in marvel. When the line was finished he drew out the rule, clapped it down on the top of the last row of letters, and gave the composing stick to the apprentice to essay.

The apprentice began to compose with his feet, his shoulders, his mouth, his eyebrows—with all his body except his hands, which nevertheless travelled spaciously far and wide.

'It's not in seven year, nor in seventy, as you'll learn, young sun of a gun!' said Big James.

And, having unsettled the youth to his foundations with a bland thwack across the head, he resumed the composing stick and began again the exposition of the

HIGHLY CONTRASTING STROKE WEIGHTS

Typefaces with strong thick/thin contrasts in stroke weight —like Bauer Bodoni—create a very active texture on the page. Although the overall shade of gray in Bodoni Regular (1) is about the same as that of the Egyptian Medium on the preceding page, the effect is entirely different. In the heavier weights of faces with strong thick/thin contrasts, like Bodoni, the thick strokes tend to get heavier while the thin strokes remain fairly constant, so that the heavier weights are not only darker but even more contrasty and active.

In addition, the internal and external spaces are not evenly distributed, which makes the contrast even more pronounced. Notice the extremely small counter in the *e*, as well as the relatively large bowl of the *g*.

The next morning, in the printing office, Edwin came upon Big James giving a lesson in composing to the younger apprentice, who in theory had 'learned his cases'. Big James held the composing stick in his great left hand, like a match-box, and with his great right thumb and index picked letter after letter from the case, very slowly in order to display the movement, and dropped them into the stick. In his mild, resonant tones he explained that each letter must be picked up unfalteringly in a particular way, so that it would drop face upward into the stick without any intermediate manipulation. And he explained also that the left hand must be held so that the right hand would have to travel to and fro as little as possible. He was revealing the basic mysteries of his craft, and was happy, making the while the broad series of stock pleasantries which have probably been current in composing rooms since printing was invented. Then he was silent, working more and more quickly, till his right hand could scarcely be followed in its twinklings, and the face of the apprentice duly spread in marvel. When the line was finished he drew out the rule, clapped it down on the top of the last row of letters, and gave the composing stick to the apprentice to essay.

The apprentice began to compose with his feet, his shoulders, his mouth, his eyebrows—with all his body except his hands, which nevertheless travelled spaciously far and wide.

'It's not in seven year, nor in seventy, as you'll learn, young sun of a gun!' said Big James.

And, having unsettled the youth to his foundations with a bland thwack across the head, he resumed the composing stick and began again the exposition of the unique

The next morning, in the printing office, Edwin came upon Big James giving a lesson in composing to the younger apprentice, who in theory had 'learned his cases'. Big James held the composing stick in his great left hand, like a match-box, and with his great right thumb and index picked letter after letter from the case, very slowly in order to display the movement, and dropped them into the stick. In his mild, resonant tones he explained that each letter must be picked up unfalteringly in a particular way, so that it would drop face upward into the stick without any intermediate manipulation. And he explained also that the left hand must be held so that the right hand would have to travel to and fro as little as possible. He was revealing the basic mysteries of his craft, and was happy, making the while the broad series of stock pleasantries which have probably been current in composing rooms since printing was invented. Then he was silent, working more and more quickly, till his right hand could scarcely be followed in its twinklings, and the face of the apprentice duly spread in marvel. When the line was finished he drew out the rule, clapped it down on the top of the last row of letters, and gave the composing stick to the apprentice to essay.

The apprentice began to compose with his feet, his shoulders, his mouth, his eyebrows—with all his body except his hands, which nevertheless travelled spaciously far and wide.

'It's not in seven year, nor in seventy, as you'll learn, young sun of a gun!' said Big James.

And, having unsettled the youth to his foundations with a bland thwack across the head, he resumed the composing stick and began again the exposition of the unique smooth movement which is the root of rapid typesetting.

The next morning, in the printing office, Edwin came upon Big James giving a lesson in composing to the younger apprentice, who in theory had 'learned his cases'. Big James held the composing stick in his great left hand, like a match-box, and with his great right thumb and index picked letter after letter from the case, very slowly in order to display the movement, and dropped them into the stick. In his mild, resonant tones he explained that each letter must be picked up unfalteringly in a particular way, so that it would drop face upward into the stick without any intermediate manipulation. And he explained also that the left hand must be held so that the right hand would have to travel to and fro as little as possible. He was revealing the basic mysteries of his craft, and was happy, making the while the broad series of stock pleasantries which have probably been current in composing rooms since printing was invented. Then he was silent, working more and more quickly, till his right hand could scarcely be followed in its twinklings, and the face of the apprentice duly spread in marvel. When the line was finished he drew out the rule, clapped it down on the top of the last row of letters, and gave the composing stick to the apprentice to essay.

The apprentice began to compose with his feet, his shoulders, his mouth, his eyebrows—with all his body except his hands, which nevertheless travelled spaciously far and wide.

'It's not in seven year, nor in seventy, as you'll learn, young sun of a gun!' said Big James.

And, having unsettled the youth to his foundations with a bland thwack across the head, he resumed the

SIMILAR COLOR WITH DIFFERING TEXTURES / 1

These three examples have about the same gray value, but they differ in overall texture. Times Roman (1) has a moderate amount of thick/thin contrast in the stroke and a fairly even distribution of white space within the letters. Raleigh Medium (2) also has a fairly even distribution of space and a more even stroke weight. Bauer Bodoni Medium (3) has a lot of thick/thin contrast and a less even distribution of space. All three faces are well within the range of overall color and texture appropriate for continuous reading, but the differing line weight contrasts give each face a distinctive texture.

The next morning, in the printing office, Edwin came upon Big James giving a lesson in composing to the younger apprentice, who in theory had 'learned his cases'. Big James held the composing stick in his great left hand, like a match-box, and with his great right thumb and index picked letter after letter from the case, very slowly in order to display the movement, and dropped them into the stick. In his mild, resonant tones he explained that each letter must be picked up unfalteringly in a particular way, so that it would drop face upward into the stick without any intermediate manipulation. And he explained also that the left hand must be held so that the right hand would have to travel to and fro as little as possible. He was revealing the basic mysteries of his craft, and was happy, making the while the broad series of stock pleasantries which have probably been current in composing rooms since printing was invented. Then he was silent, working more and more quickly, till his right hand could scarcely be followed in its twinklings, and the face of the apprentice duly spread in marvel. When the line was finished he drew out the rule, clapped it down on the top of the last row of letters, and gave the composing stick to the apprentice to essay.

The apprentice began to compose with his feet, his shoulders, his mouth, his eyebrows—with all his body except his hands, which nevertheless travelled spaciously far and wide.

'It's not in seven year, nor in seventy, as you'll learn, young sun of a gun!' said Big James.

And, having unsettled the youth to his foundations with a bland thwack across the head, he resumed the composing stick and began again the exposition of the

1 10/12 TIMES ROMAN

The next morning, in the printing office, Edwin came upon Big James giving a lesson in composing to the younger apprentice, who in theory had 'learned his cases'. Big James held the composing stick in his great left hand, like a match-box, and with his great right thumb and index picked letter after letter from the case, very slowly in order to display the movement, and dropped them into the stick. In his mild, resonant tones he explained that each letter must be picked up unfalteringly in a particular way, so that it would drop face upward into the stick without any intermediate manipulation. And he explained also that the left hand must be held so that the right hand would have to travel to and fro as little as possible. He was revealing the basic mysteries of his craft, and was happy, making the while the broad series of stock pleasantries which have probably been current in composing rooms since printing was invented. Then he was silent, working more and more quickly, till his right hand could scarcely be followed in its twinklings, and the face of the apprentice duly spread in marvel. When the line was finished he drew out the rule, clapped it down on the top of the last row of letters, and gave the composing stick to the apprentice to essay.

The apprentice began to compose with his feet, his shoulders, his mouth, his eyebrows—with all his body except his hands, which travelled spaciously far and wide.

'It's not in seven year, nor in seventy, as you'll learn, young sun of a gun!' said Big James.

And, having unsettled the youth to his foundations with a bland thwack across the head, he resumed the composing stick and began again the exposition of the unique smooth movement which is the root of rapid typesetting.

'Here!' said Big James, when the apprentice had behaved

2 10/12 RALEIGH MEDIUM

The next morning, in the printing office, Edwin came upon Big James giving a lesson in composing to the younger apprentice, who in theory had 'learned his cases'. Big James held the composing stick in his great left hand, like a match-box, and with his great right thumb and index picked letter after letter from the case, very slowly in order to display the movement, and dropped them into the stick. In his mild, resonant tones he explained that each letter must be picked up unfalteringly in a particular way, so that it would drop face upward into the stick without any intermediate manipulation. And he explained also that the left hand must be held so that the right hand would have to travel to and fro as little as possible. He was revealing the basic mysteries of his craft, and was happy, making the while the broad series of stock pleasantries which have probably been current in composing rooms since printing was invented. Then he was silent, working more and more quickly, till his right hand could scarcely be followed in its twinklings, and the face of the apprentice duly spread in marvel. When the line was finished he drew out the rule, clapped it down on the top of the last row of letters, and gave the composing stick to the apprentice to essay.

The apprentice began to compose with his feet, his shoulders, his mouth, his eyebrows—with all his body except his hands, which nevertheless travelled spaciously far and wide.

'It's not in seven year, nor in seventy, as you'll learn, young sun of a gun!' said Big James.

And, having unsettled the youth to his foundations with a bland thwack across the head, he resumed the composing stick and began again the exposition of the unique

3 10/12 BAUER BODONI MEDIUM

Using Times Roman (1) as a norm, look at Souvenir (2) and Americana (3) as extreme examples of passive and active textures. Souvenir has an even line weight as well as a very even distribution of internal space, which creates an unusually flat texture despite the eccentricity of some letterforms. Americana (3) creates an unusually active texture due to a combination of design factors. Although the thick strokes are not particularly heavy, the thin strokes are very thin. Because of the great x-height and expanded letterform design, the space enclosed within the round letters, like o and p, is disproportionately large in relation to the apparent space between the lines. In addition, the counter of the e is very small and that of the a very large.

These extremes of active and passive textures need to be used carefully. Souvenir could become tiring for long reading because it lacks visual variety. On the other hand, Americana is so active that unless it is very carefully handled, with added space within and around the page, the reader could be dazzled by it. (Notice that there is 1 point more line space in the Americana than in the other examples here.)

The next morning, in the printing office, Edwin came upon Big James giving a lesson in composing to the younger apprentice, who in theory had 'learned his cases'. Big James held the composing stick in his great left hand, like a match-box, and with his great right thumb and index picked letter after letter from the case, very slowly in order to display the movement, and dropped them into the stick. In his mild, resonant tones he explained that each letter must be picked up unfalteringly in a particular way, so that it would drop face upward into the stick without any intermediate manipulation. And he explained also that the left hand must be held so that the right hand would have to travel to and fro as little as possible. He was revealing the basic mysteries of his craft, and was happy, making the while the broad series of stock pleasantries which have probably been current in composing rooms since printing was invented. Then he was silent, working more and more quickly, till his right hand could scarcely be followed in its twinklings, and the face of the apprentice duly spread in marvel. When the line was finished he drew out the rule, clapped it down on the top of the last row of letters, and gave the composing stick to the apprentice to essay.

The apprentice began to compose with his feet, his shoulders, his mouth, his eyebrows—with all his body except his hands, which nevertheless travelled spaciously far and wide.

'It's not in seven year, nor in seventy, as you'll learn, young sun of a gun!' said Big James.

And, having unsettled the youth to his foundations with a bland thwack across the head, he resumed the composing stick and began again the exposition of the

1 10/12 TIMES ROMAN

The next morning, in the printing office, Edwin came upon Big James giving a lesson in composing to the younger apprentice, who in theory had 'learned his cases'. Big James held the composing stick in his great left hand, like a match-box, and with his great right thumb and index picked letter after letter from the case, very slowly in order to display the movement, and dropped them into the stick. In his mild, resonant tones he explained that each letter must be picked up unfalteringly in a particular way, so that it would drop face upward into the stick without any intermediate manipulation. And he explained also that the left hand must be held so that the right hand would have to travel to and fro as little as possible. He was revealing the basic mysteries of his craft, and was happy, making the while the broad series of stock pleasantries which have probably been current in composing rooms since printing was invented. Then he was silent, working more and more quickly, till his right hand could scarcely be followed in its twinklings, and the face of the apprentice duly spread in marvel. When the line was finished he drew out the rule, clapped it down on the top of the last row of letters, and gave the composing stick to the apprentice to essay.

The apprentice began to compose with his feet, his shoulders, his mouth, his eyebrows—with all his body except his hands, which nevertheless travelled spaciously far and wide.

'It's not in seven year, nor in seventy, as you'll learn, young sun of a gun!' said Big James.

And, having unsettled the youth to his foundations with a bland thwack across the head, he resumed the composing stick and began again the exposition of the unique smooth movement which is the root of rapid typesetting.

The next morning, in the printing office, Edwin came upon Big James giving a lesson in composing to the younger apprentice, who in theory had 'learned his cases'. Big James held the composing stick in his great left hand, like a match-box, and with his great right thumb and index picked letter after letter from the case, very slowly in order to display the movement, and dropped them into the stick. In his mild, resonant tones he explained that each letter must be picked up unfalteringly in a particular way, so that it would drop face upward into the stick without any intermediate manipulation. And he explained also that the left hand must be held so that the right hand would have to travel to and fro as little as possible. He was revealing the basic mysteries of his craft, and was happy, making the while the broad series of stock pleasantries which have probably been current in composing rooms since printing was invented. Then he was silent, working more and more quickly, till his right hand could scarcely be followed in its twinklings, and the face of the apprentice duly spread in marvel. When the line was finished he drew out the rule, clapped it down on the top of the last row of letters, and gave the composing stick to the apprentice to essay.

The apprentice began to compose with his feet, his shoulders, his mouth, his eyebrows—with all his body except his hands, which nevertheless travelled spaciously far and wide.

'It's not in seven year, nor in seventy, as you'll learn, young sun of a gun!' said Big James.

And, having unsettled the youth to his foundations with a bland thwack across the head, he resumed the

Again using Times Roman as the norm, compare the different textures of Helvetica (2) and Avant Garde (3). Although both faces have even line weights (and large x-heights), the visual effect of these faces is different. The overall impression in 2 is one of great evenness and in 3 of extreme activity. Helvetica, like Souvenir, distributes its white space evenly. This factor, combined with the lack of contrast in the stroke weight, makes a very even (even boring) overall effect. At the other extreme, the rounded design of Avant Garde, combined with its very large x-height, means that the round letters contain a great deal of white space. This makes the narrow, upright letters like the *i*, *l*, and *t*—which in a sans serif face have no built-in space holding them apart—appear very close to each other. For example, compare a letter combination like *il*, which creates a dense group, with *ga*, which creates an open one. The overall effect is extremely active, even though there is no thick/thin contrast in the stroke weight.

The next morning, in the printing office, Edwin came upon Big James giving a lesson in composing to the younger apprentice, who in theory had 'learned his cases'. Big James held the composing stick in his great left hand, like a match-box, and with his great right thumb and index picked letter after letter from the case, very slowly in order to display the movement, and dropped them into the stick. In his mild, resonant tones he explained that each letter must be picked up unfalteringly in a particular way, so that it would drop face upward into the stick without any intermediate manipulation. And he explained also that the left hand must be held so that the right hand would have to travel to and fro as little as possible. He was revealing the basic mysteries of his craft, and was happy, making the while the broad series of stock pleasantries which have probably been current in composing rooms since printing was invented. Then he was silent, working more and more quickly, till his right hand could scarcely be followed in its twinklings, and the face of the apprentice duly spread in marvel. When the line was finished he drew out the rule, clapped it down on the top of the last row of letters, and gave the composing stick to the apprentice to essay.

The apprentice began to compose with his feet, his shoulders, his mouth, his eyebrows—with all his body except his hands, which nevertheless travelled spaciously far and wide.

'It's not in seven year, nor in seventy, as you'll learn, young sun of a gun!' said Big James.

And, having unsettled the youth to his foundations with a bland thwack across the head, he resumed the composing stick and began again the exposition of the

1 10/12 TIMES ROMAN

The next morning, in the printing office, Edwin came upon Big James giving a lesson in composing to the younger apprentice, who in theory had 'learned his cases'. Big James held the composing stick in his great left hand, like a match-box, and with his great right thumb and index picked letter after letter from the case, very slowly in order to display the movement, and dropped them into the stick. In his mild, resonant tones he explained that each letter must be picked up unfalteringly in a particular way, so that it would drop face upward into the stick without any intermediate manipulation. And he explained also that the left hand must be held so that the right hand would have to travel to and fro as little as possible. He was revealing the basic mysteries of his craft, and was happy, making the while the broad series of stock pleasantries which have probably been current in composing rooms since printing was invented. Then he was silent, working more and more quickly, till his right hand could scarcely be followed in its twinklings, and the face of the apprentice duly spread in marvel. When the line was finished he drew out the rule, clapped it down on the top of the last row of letters, and gave the composing stick to the apprentice to essay.

The apprentice began to compose with his feet, his shoulders, his mouth, his eyebrows—with all his body except his hands, which nevertheless travelled spaciously far and wide.

'It's not in seven year, nor in seventy, as you'll learn, young sun of a gun!' said Big James.

And, having unsettled the youth to his foundations with a bland thwack across the head, he resumed the

The next morning, in the printing office, Edwin came upon Big James giving a lesson in composing to the younger apprentice, who in theory had 'learned his cases'. Big James held the composing stick in his great left hand, like a match-box, and with his great right thumb and index picked letter after letter from the case, very slowly in order to display the movement, and dropped them into the stick. In his mild, resonant tones he explained that each letter must be picked up unfalteringly in a particular way, so that it would drop face upward into the stick without any intermediate manipulation. And he explained also that the left hand must be held so that the right hand would have to travel to and fro as little as possible. He was revealing the basic mysteries of his craft, and was happy, making the while the broad series of stock pleasantries which have probably been current in composing rooms since printing was invented. Then he was silent, working more and more quickly, till his right hand could scarcely be followed in its twinklings, and the face of the apprentice duly spread in marvel. When the line was finished he drew out the rule, clapped it down on the top of the last row of letters, and gave the composing stick to the apprentice to essay.

The apprentice began to compose with his feet, his shoulders, his mouth, his eyebrows—with all his body except his hands, which nevertheless travelled spaciously far and wide.

'It's not in seven year, nor in seventy, as you'll learn, young sun of a gun!' said Big James.

And, having unsettled the youth to his foundations

Faces based on early type design models tend to have small counters and small x-heights. This is especially true of the true Garamonds, such as the example shown in 2. (Some recently redesigned typefaces *called* Garamond have fairly large counters and x-heights.) Small counters and small x-heights tend to produce activity on the page. However, the amount of activity is modified by the low thick/thin contrast characteristic of these faces. Gill Sans Medium (3) is another face that creates a moderately active texture without stroke weight contrast. The slight unevenness of the counter space gives this face a distinctive texture. Both of these faces have fairly distinctive color and, like Times Roman, are in the middle ground, somewhere between too active and too passive.

The next morning, in the printing office, Edwin came upon Big James giving a lesson in composing to the younger apprentice, who in theory had 'learned his cases'. Big James held the composing stick in his great left hand, like a match-box, and with his great right thumb and index picked letter after letter from the case, very slowly in order to display the movement, and dropped them into the stick. In his mild, resonant tones he explained that each letter must be picked up unfalteringly in a particular way, so that it would drop face upward into the stick without any intermediate manipulation. And he explained also that the left hand must be held so that the right hand would have to travel to and fro as little as possible. He was revealing the basic mysteries of his craft, and was happy, making the while the broad series of stock pleasantries which have probably been current in composing rooms since printing was invented. Then he was silent, working more and more quickly, till his right hand could scarcely be followed in its twinklings, and the face of the apprentice duly spread in marvel. When the line was finished he drew out the rule, clapped it down on the top of the last row of letters, and gave the composing stick to the apprentice to essay.

The apprentice began to compose with his feet, his shoulders, his mouth, his eyebrows—with all his body except his hands, which nevertheless travelled spaciously far and wide.

'It's not in seven year, nor in seventy, as you'll learn, young sun of a gun!' said Big James

And, having unsettled the youth to his foundations with a bland thwack across the head, he resumed the composing stick and began again the exposition of the

1 10/12 TIMES ROMAN

The next morning, in the printing office, Edwin came upon Big James giving a lesson in composing to the younger apprentice, who in theory had 'learned his cases'. Big James held the composing stick in his great left hand, like a match-box, and with his great right thumb and index picked letter after letter from the case, very slowly in order to display the movement, and dropped them into the stick. In his mild, resonant tones he explained that each letter must be picked up unfalteringly in a particular way, so that it would drop face upward into the stick without any intermediate manipulation. And he explained also that the left hand must be held so that the right hand would have to travel to and fro as little as possible. He was revealing the basic mysteries of his craft, and was happy, making the while the broad series of stock pleasantries which have probably been current in composing rooms since printing was invented. Then he was silent, working more and more quickly, till his right hand could scarcely be followed in its twinklings, and the face of the apprentice duly spread in marvel. When the line was finished he drew out the rule, clapped it down on the top of the last row of letters, and gave the composing stick to the apprentice to essay.

The apprentice began to compose with his feet, his shoulders, his mouth, his eyebrows—with all his body except his hands, which nevertheless travelled spaciously far and wide.

'It's not in seven year, nor in seventy, as you'll learn, young sun of a gun!' said Big James.

And, having unsettled the youth to his foundations with a bland thwack across the head, he resumed the composing stick and began again the exposition of the unique smooth movement which is the root of rapid typesetting.

'Here!' said Big James, when the apprentice had behaved worse than ever. 'Us'll ask Mr Edwin to have a go. 'Us'll see

The next morning, in the printing office, Edwin came upon Big James giving a lesson in composing to the younger apprentice, who in theory had 'learned his cases'. Big James held the composing stick in his great left hand, like a match-box, and with his great right thumb and index picked letter after letter from the case, very slowly in order to display the movement, and dropped them into the stick. In his mild, resonant tones he explained that each letter must be picked up unfalteringly in a particular way, so that it would drop face upward into the stick without any intermediate manipulation. And he explained also that the left hand must be held so that the right hand would have to travel to and fro as little as possible. He was revealing the basic mysteries of his craft, and was happy, making the while the broad series of stock pleasantries which have probably been current in composing rooms since printing was invented. Then he was silent, working more and more quickly, till his right hand could scarcely be followed in its twinklings, and the face of the apprentice duly spread in marvel. When the line was finished he drew out the rule, clapped it down on the top of the last row of letters, and gave the composing stick to the apprentice to essay.

The apprentice began to compose with his feet, his shoulders, his mouth, his eyebrows—with all his body except his hands, which nevertheless travelled spaciously far and wide.

'It's not in seven year, nor in seventy, as you'll learn, young sun of a gun!' said Big James.

And, having unsettled the youth to his foundations with a bland thwack across the head, he resumed the composing stick and began again the exposition of the unique smooth movement which is the root of rapid typesetting.

'Here!' said Big James, when the apprentice had behaved

LETTER PROPORTIONS

These examples demonstrate how relative proportions of x-height, ascender, and descender affect the overall texture of the page. Again using Times Roman as the norm, notice the extreme vertical pull and nervous texture of a face like Bernhard Modern (2), in which the ascenders are more than twice the x-height. Compare this to the lack of movement in Lubalin Graph (3), in which the ascenders and descenders are about half the x-height.

Both extremes present difficulties for reading: the strong vertical pull of 2 discourages the horizontality of reading, and the dense texture created by the great x-height of 3 discourages natural eye movement in either direction. Both of these textures are interesting in themselves but a poor choice for sustained reading.

The next morning, in the printing office, Edwin came upon Big James giving a lesson in composing to the younger apprentice, who in theory had 'learned his cases'. Big James held the composing stick in his great left hand, like a match-box, and with his great right thumb and index picked letter after letter from the case, very slowly in order to display the movement, and dropped them into the stick. In his mild, resonant tones he explained that each letter must be picked up unfalteringly in a particular way, so that it would drop face upward into the stick without any intermediate manipulation. And he explained also that the left hand must be held so that the right hand would have to travel to and fro as little as possible. He was revealing the basic mysteries of his craft, and was happy, making the while the broad series of stock pleasantries which have probably been current in composing rooms since printing was invented. Then he was silent, working more and more quickly, till his right hand could scarcely be followed in its twinklings, and the face of the apprentice duly spread in marvel. When the line was finished he drew out the rule, clapped it down on the top of the last row of letters, and gave the composing stick to the apprentice to essay.

The apprentice began to compose with his feet, his shoulders, his mouth, his eyebrows—with all his body except his hands, which nevertheless travelled spaciously far and wide.

'It's not in seven year, nor in seventy, as you'll learn, young sun of a gun!' said Big James.

And, having unsettled the youth to his foundations with a bland thwack across the head, he resumed the composing stick and began again the exposition of the

1 10/12 TIMES ROMAN

The next morning, in the printing office, Edwin came upon Big James giving a lesson in composing to the younger apprentice, who in theory had 'learned his cases'. Big James held the composing stick in his great left hand, like a match-box, and with his great right thumb and index picked letter after letter from the case, very slowly in order to display the movement, and dropped them into the stick. In his mild, resonant tones he explained that each letter must be picked up unfalteringly in a particular way, so that it would drop face upward into the stick without any intermediate manipulation. And he explained also that the left hand must be held so that the right hand would have to travel to and fro as little as possible. He was revealing the basic mysteries of his craft, and was happy, making the while the broad series of stock pleasantries which have probably been current in composing rooms since printing was invented. Then he was silent, working more and more quickly, till his right hand could scarcely be followed in its twinklings, and the face of the apprentice duly spread in marvel. When the line was finished he drew out the rule, clapped it down on the top of the last row of letters, and gave the composing stick to the apprentice to essay.

The apprentice began to compose with his feet, his shoulders, his mouth, his eyebrows—with all his body except his hands, which nevertheless travelled spaciously far and wide.

'It's not in seven year, nor in seventy, as you'll learn, young sun of a gun!' said Big James.

And, having unsettled the youth to his foundations with a bland thwack across the head, he resumed the composing stick and began again the exposition of the unique smooth movement which is the root of rapid typesetting.

'Here!' said Big James, when the apprentice had behaved

The next morning, in the printing office, Edwin came upon Big James giving a lesson in composing to the younger apprentice, who in theory had 'learned his cases'. Big James held the composing stick in his great left hand, like a match-box, and with his great right thumb and index picked letter after letter from the case, very slowly in order to display the movement, and dropped them into the stick. In his mild, resonant tones he explained that each letter must be picked up unfalteringly in a particular way, so that it would drop face upward into the stick without any intermediate manipulation. And he explained also that the left hand must be held so that the right hand would have to travel to and fro as little as possible. He was revealing the basic mysteries of his craft, and was happy, making the while the broad series of stock pleasantries which have probably been current in composing rooms since printing was invented. Then he was silent, working more and more quickly, till his right hand could scarcely be followed in its twinklings, and the face of the apprentice duly spread in marvel. When the line was finished he drew out the rule, clapped it down on the top of the last row of letters, and gave the composing stick to the apprentice to essay.

The apprentice began to compose with his feet, his shoulders, his mouth, his eyebrows—with all his body except his hands, which nevertheless travelled spaciously far and wide.

'It's not in seven year, nor in seventy, as you'll learn, young sun of a gun!' said Big James.

And, having unsettled the youth to his founda-

We have already seen to what extent the design of a type font can affect type color. Color is also greatly influenced by the spaces between the lines, between the words, and between the characters of a typeface. Here we will examine the first of these.

The space inserted between the lines is called line spacing or interlinear spacing. (It is also sometimes called leading, an obsolete term referring to the lead between lines of type set in metal.)

The most accurate and convenient method of defining line spacing is as the measurement in points between the baseline of one line of text and the baseline of the next. When we speak of type being set 11/13, we mean that we can measure 13 points from the baseline of one line to the baseline of the next. Whether we set 9/13 or 12/13, the base-to-base measurement is the same.

Legibility is strongly affected by line spacing. The direction of reading may be horizontal, but the predominance of vertical strokes in our alphabet tends to pull the eye in a vertical direction. A clear horizontal channel between the lines helps to direct the eye from right to left. When we reach the end of a line, the eye must return to the next line at

LINE SPACING AND TYPE COLOR

the left. Excessive space between the lines can make the next line hard to find.

The length of the line is another factor influencing the optimum line space for legibility: the longer the line, the more the eye needs help not only in getting across it but also in getting back to the right place. Longer lines therefore generally need more space between them. Also, bigger type, which you are likely to use on a longer line, contains more internal space, which means that more external space is needed to balance it. Between too little and too much space for legibility there is a good deal of room for decisions based on considerations of appearance.

When changing the space between the lines, we are changing the proportion of black ink to white space on the page, and since the eye perceives the type block as a whole, the overall color of the page is affected. It works something like mixing white and black paint to make a gray. Although as a general rule the overall page will become lighter as more space is added between the lines, the effects of line spacing differ greatly according to the design of individual typefaces. Faces with small x-heights, for example, already seem to have space built in; the differ-

ence in height between the lowercase letters and the caps is perceived as line spacing. Faces with very large x-heights lack this built-in space. Faces with small x-heights and those with both long ascenders and descenders present still another problem. Faces with heavy stroke weights appear much less black when a good deal of space is inserted between the lines. Very contrasty faces look less "active" when they are well spaced.

Line spacing should also be considered in relation to the other spaces on the page, particularly the margins. The effect of a dense and heavy mass of type surrounded by a great deal of white space is very different from the same mass of type with very small margins. Word spacing that is slightly too loose (see Chapter 5) is exaggerated by tight line spacing, while additional line spacing might actually correct the appearance of excessive or unequal word spacing.

On the following pages we will look at a variety of typefaces with varying amounts of line spacing in order to see how this affects the overall appearance of the type.

LINE SPACING FOR A FACE WITH NORMAL PROPORTIONS AND X-HEIGHT

The effects of different amounts of line space are shown in Times Roman settings in 10, 8, 9, 12, and 14 point. Look at the pages from a little beyond reading distance and you will see how the overall gray gets lighter and lighter as the line space increases. Then read a few lines of each example. The examples that are set solid have such a dense texture that they present real difficulty for reading. Note, however, that the density appears less intense in the 8/8 and 9/9 examples than it appears in the 12/12. This is because the line space in the smaller sizes is greater in proportion to the x-height of the face. Compare the effects of 1 point of line spacing in 3, 9, and 17; 8/9 looks considerably less dense than 10/11, and 10/11 looks less dense than 12/13.

Larger sizes demand more line space. The 2 points of line space that are right for 9 or 10 point are insufficient for 12 point (18). Four points, which creates a very open texture for the 9-point setting (15), looks quite normal with the 12-point. If you are using larger than normal type on wider than normal measures, line space should be greater to compensate. Compare examples 20 and 21.

Both 9- and 10-point Times set 20 picas wide have a good relation of type size to measure for extensive reading. For these settings, 2 or 3 points of line space would be normal, with 1 point the choice only if you needed to save space.

Although the 8 point is a little small for the measure, note how much more legible it becomes with 3 or even 4 points of line space (10, 11). In this measure 8/11 (10) is quite legible, while 8/12 (11) looks too open.

The next morning, in the printing office, Edwin came upon Big James giving a lesson in composing to the younger apprentice, who in theory had 'learned his cases'. Big James held the composing stick in his great left hand, like a match-box, and with his great right thumb and index picked letter after letter from the case, very slowly in order to display the movement, and dropped them into the stick. In his mild, resonant tones he explained that each letter must be picked up unfalteringly in a particular way, so that it would drop face upward into the stick without any intermediate manipulation. And he explained also that the left hand must be held so that the right hand would have to travel to and fro as little as possible. He was revealing the basic mysteries of his craft, and was happy, making the while the broad series of stock pleasantries which have probably been current in composing rooms since printing was invented. Then he was silent, working more and more quickly, till his right hand could scarcely be followed in its twinklings, and the face of the apprentice duly spread in marvel. When the line was finished he drew out the rule, clapped it down on the top of the last row of letters, and gave the composing stick to the apprentice to essay.

The apprentice began to compose with his feet, his shoulders, his mouth, his eyebrows—with all his body except his hands, which nevertheless travelled spaciously far and wide.

'It's not in seven year, nor in seventy, as you'll learn, young sun of a gun!' said Big James.

And, having unsettled the youth to his foundations with a bland thwack across the head, he resumed the composing stick and began again the exposition of the unique smooth movement which is the root of rapid typesetting.

'Here!' said Big James, when the apprentice had behaved worse than ever. 'Us'll ask Mr Edwin to have a go. 'Us'll see what *he*'ll do.'

And Edwin, sheepish, had to comply. He was in pride

1 10/10 TIMES ROMAN

The next morning, in the printing office, Edwin came upon Big James giving a lesson in composing to the younger apprentice, who in theory had 'learned his cases'. Big James held the composing stick in his great left hand, like a match-box, and with his great right thumb and index picked letter after letter from the case, very slowly in order to display the movement, and dropped them into the stick. In his mild, resonant tones he explained that each letter must be picked up unfalteringly in a particular way, so that it would drop face upward into the stick without any intermediate manipulation. And he explained also that the left hand must be held so that the right hand would have to travel to and fro as little as possible. He was revealing the basic mysteries of his craft, and was happy, making the while the broad series of stock pleasantries which have probably been current in composing rooms since printing was invented. Then he was silent, working more and more quickly, till his right hand could scarcely be followed in its twinklings, and the face of the apprentice duly spread in marvel. When the line was finished he drew out the rule, clapped it down on the top of the last row of letters, and gave the composing stick to the apprentice to essay.

The apprentice began to compose with his feet, his shoulders, his mouth, his eyebrows—with all his body except his hands, which nevertheless travelled spaciously far and wide.

'It's not in seven year, nor in seventy, as you'll learn, young sun of a gun!' said Big James.

And, having unsettled the youth to his foundations with a bland thwack across the head, he resumed the composing stick and began again the exposition of the unique smooth movement which is the root of rapid typesetting.

'Here!' said Big James, when the apprentice had behaved worse than ever. 'Us'll ask Mr Edwin to have a

The next morning, in the printing office, Edwin came upon Big James giving a lesson in composing to the younger apprentice, who in theory had 'learned his cases'. Big James held the composing stick in his great left hand, like a match-box, and with his great right thumb and index picked letter after letter from the case, very slowly in order to display the movement, and dropped them into the stick. In his mild, resonant tones he explained that each letter must be picked up unfalteringly in a particular way, so that it would drop face upward into the stick without any intermediate manipulation. And he explained also that the left hand must be held so that the right hand would have to travel to and fro as little as possible. He was revealing the basic mysteries of his craft, and was happy, making the while the broad series of stock pleasantries which have probably been current in composing rooms since printing was invented. Then he was silent, working more and more quickly, till his right hand could scarcely be followed in its twinklings, and the face of the apprentice duly spread in marvel. When the line was finished he drew out the rule, clapped it down on the top of the last row of letters, and gave the composing stick to the apprentice to essay.

The apprentice began to compose with his feet, his shoulders, his mouth, his eyebrows—with all his body except his hands, which nevertheless travelled spaciously far and wide.

'It's not in seven year, nor in seventy, as you'll learn, young sun of a gun!' said Big James.

And, having unsettled the youth to his foundations with a bland thwack across the head, he resumed the composing stick and began again the exposition of the unique smooth movement which is the root of rapid typesetting.

'Here!' said Big James, when the apprentice had behaved worse than ever. 'Us'll ask Mr Edwin to have a

The next morning, in the printing office, Edwin came upon Big James giving a lesson in composing to the younger apprentice, who in theory had 'learned his cases'. Big James held the composing stick in his great left hand, like a match-box, and with his great right thumb and index picked letter after letter from the case, very slowly in order to display the movement, and dropped them into the stick. In his mild, resonant tones he explained that each letter must be picked up unfalteringly in a particular way, so that it would drop face upward into the stick without any intermediate manipulation. And he explained also that the left hand must be held so that the right hand would have to travel to and fro as little as possible. He was revealing the basic mysteries of his craft, and was happy, making the while the broad series of stock pleasantries which have probably been current in composing rooms since printing was invented. Then he was silent, working more and more quickly, till his right hand could scarcely be followed in its twinklings, and the face of the apprentice duly spread in marvel. When the line was finished he drew out the rule, clapped it down on the top of the last row of letters, and gave the composing stick to the apprentice to essay.

The apprentice began to compose with his feet, his shoulders, his mouth, his eyebrows—with all his body except his hands, which nevertheless travelled spaciously far and wide.

'It's not in seven year, nor in seventy, as you'll learn, young sun of a gun!' said Big James.

And, having unsettled the youth to his foundations with a bland thwack across the head, he resumed the composing stick and began again the exposition of the

The next morning, in the printing office, Edwin came upon Big James giving a lesson in composing to the younger apprentice, who in theory had 'learned his cases'. Big James held the composing stick in his great left hand, like a match-box, and with his great right thumb and index picked letter after letter from the case, very slowly in order to display the movement, and dropped them into the stick. In his mild, resonant tones he explained that each letter must be picked up unfalteringly in a particular way, so that it would drop face upward into the stick without any intermediate manipulation. And he explained also that the left hand must be held so that the right hand would have to travel to and fro as little as possible. He was revealing the basic mysteries of his craft, and was happy, making the while the broad series of stock pleasantries which have probably been current in composing rooms since printing was invented. Then he was silent, working more and more quickly, till his right hand could scarcely be followed in its twinklings, and the face of the apprentice duly spread in marvel. When the line was finished he drew out the rule, clapped it down on the top of the last row of letters. and gave the composing stick to the apprentice to essay.

The apprentice began to compose with his feet, his shoulders, his mouth, his eyebrows—with all his body except his hands, which nevertheless travelled spaciously far and wide.

'It's not in seven year, nor in seventy, as you'll learn, young sun of a gun!' said Big James.

The next morning, in the printing office, Edwin came upon Big James giving a lesson in composing to the younger apprentice, who in theory had 'learned his cases'. Big James held the composing stick in his great left hand, like a match-box, and with his great right thumb and index picked letter after letter from the case, very slowly in order to display the movement, and dropped them into the stick. In his mild, resonant tones he explained that each letter must be picked up unfalteringly in a particular way, so that it would drop face upward into the stick without any intermediate manipulation. And he explained also that the left hand must be held so that the right hand would have to travel to and fro as little as possible. He was revealing the basic mysteries of his craft, and was happy, making the while the broad series of stock pleasantries which have probably been current in composing rooms since printing was invented. Then he was silent, working more and more quickly, till his right hand could scarcely be followed in its twinklings, and the face of the apprentice duly spread in marvel. When the line was finished he drew out the rule, clapped it down on the top of the last row of letters, and gave the composing stick to the apprentice to essay.

The apprentice began to compose with his feet, his shoulders, his mouth, his eyebrows—with all his body except his hands, which nevertheless travelled spaciously far and wide.

The next morning, in the printing office, Edwin came upon Big James giving a lesson in composing to the younger apprentice, who in theory had 'learned his cases'. Big James held the composing stick in his great left hand, like a match-box, and with his great right thumb and index picked letter after letter from the case, very slowly in order to display the movement, and dropped them into the stick. In his mild, resonant tones he explained that each letter must be picked up unfalteringly in a particular way, so that it would drop face upward into the stick without any intermediate manipulation. And he explained also that the left hand must be held so that the right hand would have to travel to and fro as little as possible. He was revealing the basic mysteries of his craft, and was happy, making the while the broad series of stock pleasantries which have probably been current in composing rooms since printing was invented. Then he was silent, working more and more quickly, till his right hand could scarcely be followed in its twinklings, and the face of the apprentice duly spread in marvel. When the line was finished he drew out the rule, clapped it down on the top of the last row of letters, and gave the composing stick to the apprentice to essay.

The apprentice began to compose with his feet, his

The next morning, in the printing office, Edwin came upon Big James giving a lesson in composing to the younger apprentice, who in theory had 'learned his cases'. Big James held the composing stick in his great left hand, like a match-box, and with his great right thumb and index picked letter after letter from the case, very slowly in order to display the movement, and dropped them into the stick. In his mild, resonant tones he explained that each letter must be picked up unfalteringly in a particular way, so that it would drop face upward into the stick without any intermediate manipulation. And he explained also that the left hand must be held so that the right hand would have to travel to and fro as little as possible. He was revealing the basic mysteries of his craft, and was happy, making the while the broad series of stock pleasantries which have probably been current in composing rooms since printing was invented. Then he was silent, working more and more quickly, till his right hand could scarcely be followed in its twinklings, and the face of the apprentice duly spread in marvel. When the line was finished he drew out the rule, clapped it down on the top of the last row of letters, and gave the composing stick to the apprentice to essay.

The apprentice began to compose with his feet, his shoulders, his mouth, his eyebrows—with all his body except his hands, which nevertheless travelled spaciously far and wide.

'It's not in seven year, nor in seventy, as you'll learn, young sun of a gun!' said Big James.

And, having unsettled the youth to his foundations with a bland thwack across the head, he resumed the composing stick and began again the exposition of the unique smooth movement which is the root of rapid typesetting.

'Here!' said Big James, when the apprentice had behaved worse than ever. 'Us'll ask Mr Edwin to have a go. 'Us'll see what *he*'ll do.'

And Edwin, sheepish, had to comply. He was in pride bound to surpass the apprentice, and did so.

'There!' said Big James. 'What did I tell ye?' He seemed to imply a prophecy that, because Edwin had saved the printing office from destruction two days previously, he would prove to be a born compositor.

The next morning, in the printing office, Edwin came upon Big James giving a lesson in composing to the younger apprentice, who in theory had 'learned his cases'. Big James held the composing stick in his great left hand, like a match-box, and with his great right thumb and index picked letter after letter from the case, very slowly in order to display the movement, and dropped them into the stick. In his mild, resonant tones he explained that each letter must be picked up unfalteringly in a particular way, so that it would drop face upward into the stick without any intermediate manipulation. And he explained also that the left hand must be held so that the right hand would have to travel to and fro as little as possible. He was revealing the basic mysteries of his craft, and was happy, making the while the broad series of stock pleasantries which have probably been current in composing

The next morning, in the printing office, Edwin came upon Big James giving a lesson in composing to the younger apprentice, who in theory had 'learned his cases'. Big James held the composing stick in his great left hand, like a match-box, and with his great right thumb and index picked letter after letter from the case, very slowly in order to display the movement, and dropped them into the stick. In his mild, resonant tones he explained that each letter must be picked up unfalteringly in a particular way, so that it would drop face upward into the stick without any intermediate manipulation. And he explained also that the left hand must be held so that the right hand would have to travel to and fro as little as possible. He was revealing the basic mysteries of his craft, and was happy, making the while the broad series of stock pleasantries which have probably been current in composing rooms since printing was invented. Then he was silent, working more and more quickly, till his right hand could scarcely be followed in its twinklings, and the face of the apprentice duly spread in marvel. When the line was finished he drew out the rule, clapped it down on the top of the last row of letters, and gave the composing stick to the apprentice to essay.

The apprentice began to compose with his feet, his shoulders, his mouth, his eyebrows—with all his body except his hands, which nevertheless travelled spaciously far and wide.

'It's not in seven year, nor in seventy, as you'll learn, young sun of a gun!' said Big James.

And, having unsettled the youth to his foundations with a bland thwack across the head, he resumed the composing stick and began again the exposition of the unique smooth movement which is the root of rapid typesetting.

'Here!' said Big James, when the apprentice had behaved worse than ever. 'Us'll ask Mr Edwin to have a go. 'Us'll see what *he*'ll do.'

And Edwin, sheepish, had to comply. He was in pride bound to surpass the apprentice, and did so.

'There!' said Big James. 'What did I tell ye?' He seemed to imply a prophecy that, because Edwin had saved the printing office from destruction two days previously, he would prove to be a born compositor.

The next morning, in the printing office, Edwin came upon Big James giving a lesson in composing to the younger apprentice, who in theory had 'learned his cases'. Big James held the composing stick in his great left hand, like a match box, and with his great right thumb and index picked letter after letter from the case, very slowly in order to display the movement, and dropped them into the stick. In his mild, resonant tones he explained that each letter must be picked up unfal-

The next morning, in the printing office, Edwin came upon Big James giving a lesson in composing to the younger apprentice, who in theory had 'learned his cases'. Big James held the composing stick in his great left hand, like a match-box, and with his great right thumb and index picked letter after letter from the case, very slowly in order to display the movement, and dropped them into the stick. In his mild, resonant tones he explained that each letter must be picked up unfalteringly in a particular way, so that it would drop face upward into the stick without any intermediate manipulation. And he explained also that the left hand must be held so that the right hand would have to travel to and fro as little as possible. He was revealing the basic mysteries of his craft, and was happy, making the while the broad series of stock pleasantries which have probably been current in composing rooms since printing was invented. Then he was silent, working more and more quickly, till his right hand could scarcely be followed in its twinklings, and the face of the apprentice duly spread in marvel. When the line was finished he drew out the rule, clapped it down on the top of the last row of letters, and gave the composing stick to the apprentice to essay.

The apprentice began to compose with his feet, his shoulders, his mouth, his eyebrows—with all his body except his hands, which nevertheless travelled spaciously far and wide.

'It's not in seven year, nor in seventy, as you'll learn, young sun of a gun!' said Big James.

And, having unsettled the youth to his foundations with a bland thwack across the head, he resumed the composing stick and began again the exposition of the unique smooth movement which is the root of rapid typesetting.

'Here!' said Big James, when the apprentice had behaved worse than ever. 'Us'll ask Mr Edwin to have a go. 'Us'll see what *he*'ll do.'

And Edwin, sheepish, had to comply. He was in pride bound to surpass the apprentice, and did so.

'There!' said Big James. 'What did I tell ye?' He seemed to imply a prophecy that, because Edwin had saved the printing office from destruction two days previously, he would necessarily prove to be a born

The next morning, in the printing office, Edwin came upon Big James giving a lesson in composing to the younger apprentice, who in theory had 'learned his cases'. Big James held the composing stick in his great left hand, like a match-box, and with his great right thumb and index picked letter after letter from the case, very slowly in order to display the movement, and dropped them into the stick. In his mild, resonant tones he explained that each letter must be picked up unfalteringly in a particular way, so that it would drop face upward into the stick without any intermediate manipulation. And he explained also that the left hand must be held so that the right hand would have to travel to and fro as little as possible. He was revealing the basic mysteries of his craft, and was happy, making the while the broad series of stock pleasantries which have probably been current in composing rooms since printing was invented. Then he was silent, working more and more quickly, till his right hand could scarcely be followed in its twinklings, and the face of the apprentice duly spread in marvel. When the line was finished he drew out the rule, clapped it down on the top of the last row of letters, and gave the composing stick to the apprentice to essay.

The apprentice began to compose with his feet, his shoulders, his mouth, his eyebrows—with all his body except his hands, which nevertheless travelled spaciously far and wide.

'It's not in seven year, nor in seventy, as you'll learn, young sun of a gun!' said Big James.

And, having unsettled the youth to his foundations with a bland thwack across the head, he resumed the composing stick and began again the exposition of the unique smooth movement which is the root of rapid typesetting.

'Here!' said Big James, when the apprentice had behaved worse than ever. 'Us'll ask Mr Edwin to have a go. 'Us'll see what *he*'ll do.'

And Edwin, sheepish, had to comply. He was in pride bound to surpass the apprentice, and did so.

The next morning, in the printing office, Edwin came upon Big James giving a lesson in composing to the younger apprentice, who in theory had 'learned his cases'. Big James held the composing stick in his great left hand, like a match-box, and with his great right thumb and index picked letter after letter from the case, very slowly in order to display the movement, and dropped them into the stick. In his mild, resonant tones he explained that each letter must be picked up unfalteringly in a particular way, so that it would drop face upward into the stick without any intermediate manipulation. And he explained also that the left hand must be held so that the right hand would have to travel to and fro as little as possible. He was revealing the basic mysteries of his craft, and was happy, making the while the broad series of stock pleasantries which have probably been current in composing rooms since printing was invented. Then he was silent, working more and more quickly, till his right hand could scarcely be followed in its twinklings, and the face of the apprentice duly spread in marvel. When the line was finished he drew out the rule, clapped it down on the top of the last row of letters, and gave the composing stick to the apprentice to essay.

The apprentice began to compose with his feet, his shoulders, his mouth, his eyebrows—with all his body except his hands, which nevertheless travelled spaciously far and wide.

'It's not in seven year, nor in seventy, as you'll learn, young sun of a gun!' said Big James.

And, having unsettled the youth to his foundations with a bland thwack across the head, he resumed the composing stick and began again the exposition of the unique smooth movement which is the root of rapid typesetting.

'Here!' said Big James, when the apprentice had behaved worse than ever. 'Us'll ask Mr Edwin to have a go. 'Us'll see what *he*'ll do.'

And Edwin, sheepish, had to comply. He was in pride bound to surpass the apprentice, and did so.

'There!' said Big James. 'What did I tell ye?' He seemed to imply a prophecy that, because Edwin had saved the printing office from destruction two days previously, he would necessarily prove to be a born compositor.

The next morning, in the printing office, Edwin came upon Big James giving a lesson in composing to the younger apprentice, who in theory had 'learned his cases'. Big James held the

The next morning, in the printing office, Edwin came upon Big James giving a lesson in composing to the younger apprentice, who in theory had 'learned his cases'. Big James held the composing stick in his great left hand, like a match-box, and with his great right thumb and index picked letter after letter from the case, very slowly in order to display the movement, and dropped them into the stick. In his mild, resonant tones he explained that each letter must be picked up unfalteringly in a particular way, so that it would drop face upward into the stick without any intermediate manipulation. And he explained also that the left hand must be held so that the right hand would have to travel to and fro as little as possible. He was revealing the basic mysteries of his craft, and was happy, making the while the broad series of stock pleasantries which have probably been current in composing rooms since printing was invented. Then he was silent, working more and more quickly, till his right hand could scarcely be followed in its twinklings, and the face of the apprentice duly spread in marvel. When the line was finished he drew out the rule, clapped it down on the top of the last row of letters, and gave the composing stick to the apprentice to essay.

The apprentice began to compose with his feet, his shoulders, his mouth, his eyebrows—with all his body except his hands, which nevertheless travelled spaciously far and wide.

'It's not in seven year, nor in seventy, as you'll learn, young sun of a gun!' said Big James.

And, having unsettled the youth to his foundations with a bland thwack across the head, he resumed the composing stick and began again the exposition of the unique smooth movement which is the root of rapid typesetting.

'Here!' said Big James, when the apprentice had behaved worse than ever. 'Us'll ask Mr Edwin to have a go. 'Us'll see what *he*'ll do.'

And Edwin, sheepish, had to comply. He was in pride bound to surpass the apprentice, and did so.

The next morning, in the printing office, Edwin came upon Big James giving a lesson in composing to the younger apprentice, who in theory had 'learned his cases'. Big James held the composing stick in his great left hand, like a match-box, and with his great right thumb and index picked letter after letter from the case, very slowly in order to display the movement, and dropped them into the stick. In his mild, resonant tones he explained that each letter must be picked up unfalteringly in a particular way, so that it would drop face upward into the stick without any intermediate manipulation. And he explained also that the left hand must be held so that the right hand would have to travel to and fro as little as possible. He was revealing the basic mysteries of his craft, and was happy, making the while the broad series of stock pleasantries which have probably been current in composing rooms since printing was invented. Then he was silent, working more and more quickly, till his right hand could scarcely be followed in its twinklings, and the face of the apprentice duly spread in marvel. When the line was finished he drew out the rule, clapped it down on the top of the last row of letters, and gave the composing stick to the apprentice to essay.

The apprentice began to compose with his feet, his shoulders, his mouth, his eyebrows—with all his body except his hands, which nevertheless travelled spaciously far and wide.

'It's not in seven year, nor in seventy, as you'll learn, young sun of a gun!' said Big James.

And, having unsettled the youth to his foundations with a bland thwack across the head, he resumed the composing stick and began again the exposition of the unique smooth movement which is the root of rapid typesetting.

'Here!' said Big James, when the apprentice had behaved worse than ever. 'Us'll ask Mr Edwin to have a go. 'Us'll see

The next morning, in the printing office, Edwin came upon Big James giving a lesson in composing to the younger apprentice, who in theory had 'learned his cases'. Big James held the composing stick in his great left hand, like a match-box, and with his great right thumb and index picked letter after letter from the case, very slowly in order to display the movement, and dropped them into the stick. In his mild, resonant tones he explained that each letter must be picked up unfalteringly in a particular way, so that it would drop face upward into the stick without any intermediate manipulation. And he explained also that the left hand must be held so that the right hand would have to travel to and fro as little as possible. He was revealing the basic mysteries of his craft, and was happy, making the while the broad series of stock pleasantries which have probably been current in composing rooms since printing was invented. Then he was silent, working more and more quickly, till his right hand could scarcely be followed in its twinklings, and the face of the apprentice duly spread in marvel. When the line was finished he drew out the rule, clapped it down on the top of the last row of letters, and gave the composing stick to the apprentice to essay.

The apprentice began to compose with his feet, his shoulders, his mouth, his eyebrows—with all his body except his hands, which nevertheless travelled spaciously far and wide.

'It's not in seven year, nor in seventy, as you'll learn, young sun of a gun!' said Big James.

And, having unsettled the youth to his foundations with a bland thwack across the head, he resumed the composing stick and began again the exposition of the unique smooth move-

The next morning, in the printing office, Edwin came upon Big James giving a lesson in composing to the younger apprentice, who in theory had 'learned his cases'. Big James held the composing stick in his great left hand, like a match-box, and with his great right thumb and index picked letter after letter from the case, very slowly in order to display the movement, and dropped them into the stick. In his mild, resonant tones he explained that each letter must be picked up unfalteringly in a particular way, so that it would drop face upward into the stick without any intermediate manipulation. And he explained also that the left hand must be held so that the right hand would have to travel to and fro as little as possible. He was revealing the basic mysteries of his craft, and was happy, making the while the broad series of stock pleasantries which have probably been current in composing rooms since printing was invented. Then he was silent, working more and more quickly, till his right hand could scarcely be followed in its twinklings, and the face of the apprentice duly spread in marvel. When the line was finished he drew out the rule, clapped it down on the top of the last row of letters, and gave the composing stick to the apprentice to essay.

The apprentice began to compose with his feet, his shoulders, his mouth, his eyebrows —with all his body except his hands, which nevertheless travelled spaciously far and wide.

The next morning, in the printing office, Edwin came upon Big James giving a lesson in composing to the younger apprentice, who in theory had 'learned his cases'. Big James held the composing stick in his great left hand, like a match-box, and with his great right thumb and index picked letter after letter from the case, very slowly in order to display the movement, and dropped them into the stick. In his mild, resonant tones he explained that each letter must be picked up unfalteringly in a particular way, so that it would drop face upward into the stick without any intermediate manipulation. And he explained also that the left hand must be held so that the right hand would have to travel to and fro as little as possible. He was revealing the basic mysteries of his craft, and was happy, making the while the broad series of stock pleasantries which have probably been current in composing rooms since printing was invented. Then he was silent, working more and more quickly, till his right hand could scarcely be followed in its twinklings, and the face of the apprentice duly spread in marvel. When the line was finished he drew out the rule, clapped it down on the top of the last row of letters, and gave the composing stick to the apprentice to essay.

The apprentice began to compose with his feet, his shoulders, his mouth, his eyebrows

The next morning, in the printing office, Edwin came upon Big James giving a lesson in composing to the younger apprentice, who in theory had 'learned his cases'. Big James held the composing stick in his great left hand, like a match-box, and with his great right thumb and index picked letter after letter from the case, very slowly in order to display the movement, and dropped them into the stick. In his mild, resonant tones he explained that each letter must be picked up unfalteringly in a particular way, so that it would drop face upward into the stick without any intermediate manipulation. And he explained also that the left hand must be held so that the right hand would have to travel to and fro as little as possible. He was revealing the basic mysteries of his craft, and was happy, making the while the broad series of stock pleasantries which have probably been current in composing rooms since printing was invented. Then he was silent, working more and more quickly, till his right hand could scarcely be followed in its twinklings, and the face of the apprentice duly spread in marvel. When the line was finished he drew out the rule, clapped it down on the top of the last row of letters, and gave the composing stick to the apprentice

The next morning, in the printing office, Edwin came upon Big James giving a lesson in composing to the younger apprentice, who in theory had 'learned his cases'. Big James held the composing stick in his great left hand, like a match-box, and with his great right thumb and index picked letter after letter from the case, very slowly in order to display the movement, and dropped them into the stick. In his mild, resonant tones he explained that each letter must be picked up unfalteringly in a particular way, so that it would drop face upward into the stick without any intermediate manipulation. And he explained also that the left hand must be held so that the right hand would have to travel to and fro as little as possible. He was revealing the basic mysteries of his craft, and was happy, making the while the broad series of stock pleasantries which have probably been current in composing rooms since printing was invented. Then he was silent, working more and more quickly, till his right hand could scarcely be followed in its twinklings, and the face of the apprentice duly spread in marvel. When the

The next morning, in the printing office, Edwin came upon Big James giving a lesson in composing to the younger apprentice, who in theory had 'learned his cases'. Big James held the composing stick in his great left hand, like a match-box, and with his great right thumb and index picked letter after letter from the case, very slowly in order to display the movement, and dropped them into the stick. In his mild, resonant tones he explained that each letter must be picked up unfalteringly in a particular way, so that it would drop face upward into the stick without any intermediate manipulation. And he explained also that the left hand must be held so that the right hand would have to travel to and fro as little as possible. He was revealing the basic mysteries of his craft, and was happy, making the while the broad series of stock pleasantries which have probably been current in composing rooms since printing was invented. Then he was silent, working more and more quickly, till his right hand could scarcely be followed in its twinklings, and the face of the apprentice duly spread in marvel. When the line was finished he drew out the rule, clapped it down on the top of the last row of letters, and gave the composing stick to the apprentice to essay.

The apprentice began to compose with his feet, his shoulders, his mouth, his eyebrows—with all his body except his hands, which

The next morning, in the printing office, Edwin came upon Big James giving a lesson in composing to the younger apprentice, who in theory had 'learned his cases'. Big James held the composing stick in his great left hand, like a match-box, and with his great right thumb and index picked letter after letter from the case, very slowly in order to display the movement, and dropped them into the stick. In his mild, resonant tones he explained that each letter must be picked up unfalteringly in a particular way, so that it would drop face upward into the stick without any intermediate manipulation. And he explained also that the left hand must be held so that the right hand would have to travel to and fro as little as possible. He was revealing the basic mysteries of his craft, and was happy, making the while the broad series of stock pleasantries which have probably been current in composing rooms since printing was invented. Then he was silent, working more and more quickly, till his right hand could scarcely be followed in its twinklings, and the face of the apprentice duly spread in marvel. When the line was finished he drew out the rule, clapped it down on the top of the last row of

LINE SPACING FOR A FACE WITH A LARGE X-HEIGHT

The line-spacing requirements of faces with large x-heights, like Bookman Light, are different from those with a normal x-height, like Times Roman. In faces with large x-heights, the designed-in white space above the lower-case letters is decreased, so that additional line spacing is required to help horizontal eye movement. Also, since a face with a large x-height has large white spaces within the letters, more space between the lines is needed to even out the overall color on the page.

Adding line space to faces with large x-heights has quite dramatic effects on the overall color of a block of type. Notice the difference between setting Bookman Light in 10/10 (1) and 10/14 (6), or 8/8 (8) and 8/12 (11). In these examples the 10-, 9-, and 8-point settings all fall within acceptable type size/line width proportions, but the 10-point appears large in the measure unless it has adequate line spacing. In 8-, 9-, and 10-point settings, 3 points of line spacing is necessary in order to even out the amount of white space between the lines and within the large counters (5, 10, 14). Even in an 8-point setting, 4 points of space does not seem excessive (11).

As we said before, larger sizes require proportionately more line space; 12/12 (16) and 12/13 (17) not only look extremely large for the measure on which they are set, but they are virtually unreadable because of the lack of a horizontal channel for eye movement. In some contexts, however, settings like 12/16 (19) or 14/20 (20) could look very handsome.

The next morning, in the printing office, Edwin came upon Big James giving a lesson in composing to the younger apprentice, who in theory had 'learned his cases'. Big James held the composing stick in his great left hand, like a match-box, and with his great right thumb and index picked letter after letter from the case, very slowly in order to display the movement, and dropped them into the stick. In his mild, resonant tones he explained that each letter must be picked up unfalteringly in a particular way, so that it would drop face upward into the stick without any intermediate manipulation. And he explained also that the left hand must be held so that the right hand would have to travel to and fro as little as possible. He was revealing the basic mysteries of his craft, and was happy, making the while the broad series of stock pleasantries which have probably been current in composing rooms since printing was invented. Then he was silent, working more and more quickly, till his right hand could scarcely be followed in its twinklings, and the face of the apprentice duly spread in marvel. When the line was finished he drew out the rule, clapped it down on the top of the last row of letters, and gave the composing stick to the apprentice to essay.

The apprentice began to compose with his feet, his shoulders, his mouth, his eyebrows—with all his body except his hands, which nevertheless travelled spaciously far and wide.

'It's not in seven year, nor in seventy, as you'll learn, young sun of a gun!' said Big James.

And, having unsettled the youth to his foundations with a bland thwack across the head, he resumed the composing stick and began again the exposition of the unique smooth movement which is the root of rapid typesetting.

'Here!' said Big James, when the apprentice had

1 10/10 BOOKMAN LIGHT

The next morning, in the printing office, Edwin came upon Big James giving a lesson in composing to the younger apprentice, who in theory had 'learned his cases'. Big James held the composing stick in his great left hand, like a match-box, and with his great right thumb and index picked letter after letter from the case, very slowly in order to display the movement, and dropped them into the stick. In his mild, resonant tones he explained that each letter must be picked up unfalteringly in a particular way, so that it would drop face upward into the stick without any intermediate manipulation. And he explained also that the left hand must be held so that the right hand would have to travel to and fro as little as possible. He was revealing the basic mysteries of his craft, and was happy, making the while the broad series of stock pleasantries which have probably been current in composing rooms since printing was invented. Then he was silent, working more and more quickly, till his right hand could scarcely be followed in its twinklings, and the face of the apprentice duly spread in marvel. When the line was finished he drew out the rule, clapped it down on the top of the last row of letters, and gave the composing stick to the apprentice to essay.

The apprentice began to compose with his feet, his shoulders, his mouth, his eyebrows—with all his body except his hands, which nevertheless travelled spaciously far and wide.

'It's not in seven year, nor in seventy, as you'll learn, young sun of a gun!' said Big James.

And, having unsettled the youth to his foundations with a bland thwack across the head, he resumed the composing stick and began again the exposition of the unique smooth movement which

The next morning, in the printing office, Edwin came upon Big James giving a lesson in composing to the younger apprentice, who in theory had 'learned his cases'. Big James held the composing stick in his great left hand, like a match-box, and with his great right thumb and index picked letter after letter from the case, very slowly in order to display the movement, and dropped them into the stick. In his mild, resonant tones he explained that each letter must be picked up unfalteringly in a particular way, so that it would drop face upward into the stick without any intermediate manipulation. And he explained also that the left hand must be held so that the right hand would have to travel to and fro as little as possible. He was revealing the basic mysteries of his craft, and was happy, making the while the broad series of stock pleasantries which have probably been current in composing rooms since printing was invented. Then he was silent, working more and more quickly, till his right hand could scarcely be followed in its twinklings, and the face of the apprentice duly spread in marvel. When the line was finished he drew out the rule, clapped it down on the top of the last row of letters, and gave the composing stick to the apprentice to essay.

The apprentice began to compose with his feet, his shoulders, his mouth, his eyebrows—with all his body except his hands, which nevertheless travelled spaciously far and wide.

'It's not in seven year, nor in seventy, as you'll learn, young sun of a gun!' said Big James.

And, having unsettled the youth to his foundations with a bland thwack across the head, he resumed the composing stick and began again the

The next morning, in the printing office, Edwin came upon Big James giving a lesson in composing to the younger apprentice, who in theory had 'learned his cases'. Big James held the composing stick in his great left hand, like a match-box, and with his great right thumb and index picked letter after letter from the case, very slowly in order to display the movement, and dropped them into the stick. In his mild, resonant tones he explained that each letter must be picked up unfalteringly in a particular way, so that it would drop face upward into the stick without any intermediate manipulation. And he explained also that the left hand must be held so that the right hand would have to travel to and fro as little as possible. He was revealing the basic mysteries of his craft, and was happy, making the while the broad series of stock pleasantries which have probably been current in composing rooms since printing was invented. Then he was silent, working more and more quickly, till his right hand could scarcely be followed in its twinklings, and the face of the apprentice duly spread in marvel. When the line was finished he drew out the rule, clapped it down on the top of the last row of letters, and gave the composing stick to the apprentice to essay.

The apprentice began to compose with his feet, his shoulders, his mouth, his eyebrows—with all his body except his hands, which nevertheless travelled spaciously far and wide.

'It's not in seven year, nor in seventy, as you'll learn, young sun of a gun!' said Big James.

The next morning, in the printing office, Edwin came upon Big James giving a lesson in composing to the younger apprentice, who in theory had 'learned his cases'. Big James held the composing stick in his great left hand, like a match-box, and with his great right thumb and index picked letter after letter from the case, very slowly in order to display the movement, and dropped them into the stick. In his mild, resonant tones he explained that each letter must be picked up unfalteringly in a particular way, so that it would drop face upward into the stick without any intermediate manipulation. And he explained also that the left hand must be held so that the right hand would have to travel to and fro as little as possible. He was revealing the basic mysteries of his craft, and was happy, making the while the broad series of stock pleasantries which have probably been current in composing rooms since printing was invented. Then he was silent, working more and more quickly, till his right hand could scarcely be followed in its twinklings, and the face of the apprentice duly spread in marvel. When the line was finished he drew out the rule, clapped it down on the top of the last row of letters, and gave the composing stick to the apprentice to essay.

The apprentice began to compose with his feet, his shoulders, his mouth, his eyebrows—with all his body except his hands, which nevertheless trav-

The next morning, in the printing office, Edwin came upon Big James giving a lesson in composing to the younger apprentice, who in theory had 'learned his cases'. Big James held the composing stick in his great left hand, like a match-box, and with his great right thumb and index picked letter after letter from the case, very slowly in order to display the movement, and dropped them into the stick. In his mild, resonant tones he explained that each letter must be picked up unfalteringly in a particular way, so that it would drop face upward into the stick without any intermediate manipulation. And he explained also that the left hand must be held so that the right hand would have to travel to and fro as little as possible. He was revealing the basic mysteries of his craft, and was happy, making the while the broad series of stock pleasantries which have probably been current in composing rooms since printing was invented. Then he was silent, working more and more quickly, till his right hand could scarcely be followed in its twinklings, and the face of the apprentice duly spread in marvel. When the line was finished he drew out the rule, clapped it down on the top of the last row of letters, and gave the composing stick to the apprentice to essay.

The apprentice began to compose with his feet,

The next morning, in the printing office, Edwin came upon Big James giving a lesson in composing to the younger apprentice, who in theory had 'learned his cases'. Big James held the composing stick in his great left hand, like a match-box, and with his great right thumb and index picked letter after letter from the case, very slowly in order to display the movement, and dropped them into the stick. In his mild, resonant tones he explained that each letter must be picked up unfalteringly in a particular way, so that it would drop face upward into the stick without any intermediate manipulation. And he explained also that the left hand must be held so that the right hand would have to travel to and fro as little as possible. He was revealing the basic mysteries of his craft, and was happy, making the while the broad series of stock pleasantries which have probably been current in composing rooms since printing was invented. Then he was silent, working more and more quickly, till his right hand could scarcely be followed in its twinklings, and the face of the apprentice duly spread in marvel. When the line was finished he drew out the rule, clapped it down on the top of the last row of letters,

The next morning, in the printing office, Edwin came upon Big James giving a lesson in composing to the younger apprentice, who in theory had 'learned his cases'. Big James held the composing stick in his great left hand, like a match-box, and with his great right thumb and index picked letter after letter from the case, very slowly in order to display the movement, and dropped them into the stick. In his mild, resonant tones he explained that each letter must be picked up unfalteringly in a particular way, so that it would drop face upward into the stick without any intermediate manipulation. And he explained also that the left hand must be held so that the right hand would have to travel to and fro as little as possible. He was revealing the basic mysteries of his craft, and was happy, making the while the broad series of stock pleasantries which have probably been current in composing rooms since printing was invented. Then he was silent, working more and more quickly, till his right hand could scarcely be followed in its twinklings, and the face of the apprentice duly spread in marvel. When the line was finished he drew out the rule, clapped it down on the top of the last row of letters, and gave the composing stick to the apprentice to essay.

The apprentice began to compose with his feet, his shoulders, his mouth, his eyebrows—with all his body except his hands, which nevertheless travelled spaciously far and wide.

'It's not in seven year, nor in seventy, as you'll learn, young sun of a gun!' said Big James.

And, having unsettled the youth to his foundations with a bland thwack across the head, he resumed the composing stick and began again the exposition of the unique smooth movement which is the root of rapid typesetting.

'Here!' said Big James, when the apprentice had behaved worse than ever. 'Us'll ask Mr Edwin to have a go. 'Us'll see what *he*'ll do.'

And Edwin, sheepish, had to comply. He was in pride bound to surpass the apprentice, and did so.

'There!' said Big James. 'What did I tell ye?' He seemed to imply a prophecy that, because Edwin had saved the printing office from destruction two days previously, he would necessarily prove to be a born compositor.

The next morning, in the printing office, Edwin came upon Big James giving a lesson in composing to the younger apprentice, who in theory had 'learned his cases'. Big James held the composing stick in his great left hand, like a match-box, and with his great right thumb and index picked letter after letter from the case, very slowly in order to display the movement, and dropped them into the stick. In his mild, resonant tones he explained that each letter must be picked up unfalteringly in a particular way, so that it would drop face upward into the stick

The next morning, in the printing office, Edwin came upon Big James giving a lesson in composing to the younger apprentice, who in theory had 'learned his cases'. Big James held the composing stick in his great left hand, like a match-box, and with his great right thumb and index picked letter after letter from the case, very slowly in order to display the movement, and dropped them into the stick. In his mild, resonant tones he explained that each letter must be picked up unfalteringly in a particular way, so that it would drop face upward into the stick without any intermediate manipulation. And he explained also that the left hand must be held so that the right hand would have to travel to and fro as little as possible. He was revealing the basic mysteries of his craft, and was happy, making the while the broad series of stock pleasantries which have probably been current in composing rooms since printing was invented. Then he was silent, working more and more quickly, till his right hand could scarcely be followed in its twinklings, and the face of the apprentice duly spread in marvel. When the line was finished he drew out the rule, clapped it down on the top of the last row of letters, and gave the composing stick to the apprentice to essay.

The apprentice began to compose with his feet, his shoulders, his mouth, his eyebrows—with all his body except his hands, which nevertheless travelled spaciously far and wide.

'It's not in seven year, nor in seventy, as you'll learn, young sun of a gun!' said Big James.

And, having unsettled the youth to his foundations with a bland thwack across the head, he resumed the composing stick and began again the exposition of the unique smooth movement which is the root of rapid typesetting.

'Here!' said Big James, when the apprentice had behaved worse than ever. 'Us'll ask Mr Edwin to have a go. 'Us'll see what *he*'ll do.'

And Edwin, sheepish, had to comply. He was in pride bound to surpass the apprentice, and did so.

'There!' said Big James. 'What did I tell ye?' He seemed to imply a prophecy that, because Edwin had saved the printing office from destruction two days previously, he would necessarily prove to be a born compositor.

The next morning, in the printing office, Edwin came upon Big James giving a lesson in composing to the younger apprentice, who in theory had 'learned his cases'. Big James held the

The next morning, in the printing office, Edwin came upon Big James giving a lesson in composing to the younger apprentice, who in theory had 'learned his cases'. Big James held the composing stick in his great left hand, like a match-box, and with his great right thumb and index picked letter after letter from the case, very slowly in order to display the movement, and dropped them into the stick. In his mild, resonant tones he explained that each letter must be picked up unfalteringly in a particular way, so that it would drop face upward into the stick without any intermediate manipulation. And he explained also that the left hand must be held so that the right hand would have to travel to and fro as little as possible. He was revealing the basic mysteries of his craft, and was happy, making the while the broad series of stock pleasantries which have probably been current in composing rooms since printing was invented. Then he was silent, working more and more quickly, till his right hand could scarcely be followed in its twinklings, and the face of the apprentice duly spread in marvel. When the line was finished he drew out the rule, clapped it down on the top of the last row of letters, and gave the stick to the apprentice to essay.

The apprentice began to compose with his feet, his shoulders, his mouth, his eyebrows—with all his body except his hands, which nevertheless travelled spaciously far and wide.

'It's not in seven year, nor in seventy, as you'll learn, young sun of a gun!' said Big James.

And, having unsettled the youth to his foundations with a bland thwack across the head, he resumed the composing stick and began again the exposition of the unique smooth movement which is the root of rapid typesetting.

'Here!' said Big ames, when the apprentice had behaved worse than ever. 'Us'll ask Mr Edwin to have a go. 'Us'll see what *he*'ll do.'

And Edwin, sheepish, had to comply. He was in pride bound to surpass the apprentice, and did so.

'There!' said Big James. 'What did I tell ye?' He seemed to

The next morning, in the printing office, Edwin came upon Big James giving a lesson in composing to the younger apprentice, who in theory had 'learned his cases'. Big James held the composing stick in his great left hand, like a match-box, and with his great right thumb and index picked letter after letter from the case, very slowly in order to display the movement, and dropped them into the stick. In his mild, resonant tones he explained that each letter must be picked up unfalteringly in a particular way, so that it would drop face upward into the stick without any intermediate manipulation. And he explained also that the left hand must be held so that the right hand would have to travel to and fro as little as possible. He was revealing the basic mysteries of his craft, and was happy, making the while the broad series of stock pleasantries which have probably been current in composing rooms since printing was invented. Then he was silent, working more and more quickly, till his right hand could scarcely be followed in its twinklings, and the face of the apprentice duly spread in marvel. When the line was finished he drew out the rule, clapped it down on the top of the last row of letters, and gave the composing stick to the apprentice to essay.

The apprentice began to compose with his feet, his shoulders, his mouth, his eyebrows—with all his body except his hands, which nevertheless travelled spaciously far and wide.

'It's not in seven year, nor in seventy, as you'll learn, young sun of a gun!' said Big James.

And, having unsettled the youth to his foundations with a bland thwack across the head, he resumed the composing stick and began again the exposition of the unique smooth movement which is the root of rapid typesetting.

'Here!' said Big James, when the apprentice had behaved worse than ever. 'Us'll ask Mr Edwin to have a go. 'Us'll see what

The next morning, in the printing office, Edwin came upon Big James giving a lesson in composing to the apprentice, who in theory had 'learned his cases'. Big James held the composing stick in his great left hand, like a match-box, and with his great right thumb and index picked letter after letter from the case, very slowly in order to display the movement, and dropped them into the stick. In his mild, resonant tones he explained that each letter must be picked up unfalteringly in a particular way, so that it would drop face upward into the stick without any intermediate manipulation. And he explained also that the left hand must be held so that the right hand would have to travel to and fro as little as possible. He was revealing the basic mysteries of his craft, and was happy, making the while the broad series of stock pleasantries which have probably been current in composing rooms since printing was invented. Then he was silent, working more and more quickly, till his right hand could scarcely be followed in its twinklings, and the face of the apprentice duly spread in marvel. When the line was finished he drew out the rule, clapped it down on the top of the last row of letters, and gave the composing stick to the apprentice to essay.

The apprentice began to compose with his feet, his shoulders, his mouth, his eyebrows—with all his body except his hands, which nevertheless travelled spaciously far and wide.

'It's not in seven year, nor in seventy, as you'll learn, young sun of a gun!' said Big James.

And, having unsettled the youth to his foundations with a bland thwack across the head, he resumed the composing stick and began again the exposition of the smooth movement which is the root of rapid typesetting.

'Here!' said Big James, when the apprentice had behaved worse than ever. 'Us'll ask Mr Edwin to have a go. 'Us'll see what *he*'ll do.'

And Edwin, sheepish, had to comply. He was in pride bound to surpass the apprentice, and did so.

'There!' said James. 'What did I tell ye?' He seemed to imply a prophecy that, because Edwin had saved the printing office from destruction two days previously, he would necessarily prove to be a born compositor.

The next morning, in the printing office, Edwin came upon Big James giving a lesson in composing to the apprentice, who in theory had 'learned his cases'. Big James held the composing stick in his great left hand, like a match-box, and with his great right thumb and index picked letter after letter from the case, very slowly in order to display the movement, and dropped them into the stick. In his mild, resonant tones he explained that each letter must be picked up unfalteringly in a particular way, so that it would drop face upward into the stick without any intermediate manipulation. And he explained also that the left hand must be held so that the right hand would have to travel to and fro as little as possible. He was revealing the basic mysteries of his craft, and was happy, making the while the broad series of stock pleasantries which have probably been current in composing rooms since printing was invented. Then he was silent, working more and more quickly, till his right hand could scarcely be followed in its twinklings, and the face of the apprentice duly spread in marvel. When the line was finished he drew out the rule, clapped it down on the top of the last row of letters, and gave the composing stick to the apprentice to essay.

The apprentice began to compose with his feet, his shoulders, his mouth, his eyebrows—with all his body except his hands, which nevertheless travelled spaciously far and wide.

'It's not in seven year, nor in seventy, as you'll learn, young sun of a gun!' said Big James.

And, having unsettled the youth to his foundations with a bland thwack across the head, he resumed the composing stick and began again the exposition of the smooth movement which is the root of rapid typesetting.

'Here!' said Big James, when the apprentice had behaved worse than ever. 'Us'll ask Mr Edwin to have a go.

The next morning, in the printing office, Edwin came upon Big James giving a lesson in composing to the apprentice, who in theory had 'learned his cases'. Big James held the composing stick in his great left hand, like a match-box, and with his great right thumb and index picked letter after letter from the case, very slowly in order to display the movement, and dropped them into the stick. In his mild, resonant tones he explained that each letter must be picked up unfalteringly in a particular way, so that it would drop face upward into the stick without any intermediate manipulation. And he explained also that the left hand must be held so that the right hand would have to travel to and fro as little as possible. He was revealing the basic mysteries of his craft, and was happy, making the while the broad series of stock pleasantries which have probably been current in composing rooms since printing was invented. Then he was silent, working more and more quickly, till his right hand could scarcely be followed in its twinklings, and the face of the apprentice duly spread in marvel. When the line was finished he drew out the rule, clapped it down on the top of the last row of letters, and gave the composing stick to the apprentice to essay.

The apprentice began to compose with his feet, his shoulders, his mouth, his eyebrows—with all his body except his hands, which nevertheless travelled spaciously far and wide.

'It's not in seven year, nor in seventy, as you'll learn, young sun of a gun!' said Big James.

And, having unsettled the youth to his foundations with a bland thwack across the head, he resumed the composing stick and began again the exposition of the

The next morning, in the printing office, Edwin came upon Big James giving a lesson in composing to the apprentice, who in theory had 'learned his cases'. Big James held the composing stick in his great left hand, like a match-box, and with his great right thumb and index picked letter after letter from the case, very slowly in order to display the movement, and dropped them into the stick. In his mild, resonant tones he explained that each letter must be picked up unfalteringly in a particular way, so that it would drop face upward into the stick without any intermediate manipulation. And he explained also that the left hand must be held so that the right hand would have to travel to and fro as little as possible. He was revealing the basic mysteries of his craft, and was happy, making the while the broad series of stock pleasantries which have probably been current in composing rooms since printing was invented. Then he was silent, working more and more quickly, till his right hand could scarcely be followed in its twinklings, and the face of the apprentice duly spread in marvel. When the line was finished he drew out the rule, clapped it down on the top of the last row of letters, and gave the composing stick to the apprentice to essay.

The apprentice began to compose with his feet, his shoulders, his mouth, his eyebrows—with all his body except his hands, which nevertheless travelled spaciously far and wide.

'It's not in seven year, nor in seventy, as you'll learn, young sun of a gun!' said Big James.

The next morning, in the printing office, Edwin came upon Big James giving a lesson in composing to the younger apprentice, who in theory had 'learned his cases'. Big James held the composing stick in his great left hand, like a match-box, and with his great right thumb and index picked letter after letter from the case, very slowly in order to display the movement, and dropped them into the stick. In his mild, resonant tones he explained that each letter must be picked up unfalteringly in a particular way, so that it would drop face upward into the stick without any intermediate manipulation. And he explained also that the left hand must be held so that the right hand would have to travel to and fro as little as possible. He was revealing the basic mysteries of his craft, and was happy, making the while the broad series of stock pleasantries which have probably been current in composing rooms since printing was invented. Then he was silent, working more and more quickly, till his right hand could scarcely be followed in its twinklings, and the face of the apprentice duly spread in marvel. When the line was finished he drew out the rule, clapped it down on the top of the last row of letters, and gave the composing stick to the apprentice to essay.

The apprentice began to compose with his feet, his shoulders, his mouth, his eye-

The next morning, in the printing office, Edwin came upon Big James giving a lesson in composing to the younger apprentice, who in theory had 'learned his cases'. Big James held the composing stick in his great left hand, like a match-box, and with his great right thumb and index picked letter after letter from the case, very slowly in order to display the movement, and dropped them into the stick. In his mild, resonant tones he explained that each letter must be picked up unfalteringly in a particular way, so that it would drop face upward into the stick without any intermediate manipulation. And he explained also that the left hand must be held so that the right hand would have to travel to and fro as little as possible. He was revealing the basic mysteries of his craft, and was happy, making the while the broad series of stock pleasantries which have probably been current in composing rooms since printing was invented. Then he was silent, working more and more quickly, till his right hand could scarcely be followed in its twinklings, and the face of the apprentice duly spread in marvel. When the line was finished he drew out the rule, clapped it down on the top of the last row of letters, and gave the composing stick to the

The next morning, in the printing office, Edwin came upon Big James giving a lesson in composing to the younger apprentice, who in theory had 'learned his cases'. Big James held the composing stick in his great left hand, like a match-box, and with his great right thumb and index picked letter after letter from the case, very slowly in order to display the movement, and dropped them into the stick. In his mild, resonant tones he explained that each letter must be picked up unfalteringly in a particular way, so that it would drop face upward into the stick without any intermediate manipulation. And he explained also that the left hand must be held so that the right hand would have to travel to and fro as little as possible. He was revealing the basic mysteries of his craft, and was happy, making the while the broad series of stock pleasantries which have probably been current in composing rooms since printing was invented. Then he was silent, working more and more quickly, till his right hand could scarcely be followed in its twinklings, and the face of the apprentice duly spread in marvel. When the line was finished he drew out the rule,

The next morning, in the printing office, Edwin came upon Big James giving a lesson in composing to the younger apprentice, who in theory had 'learned his cases'. Big James held the composing stick in his great left hand, like a match-box, and with his great right thumb and index picked letter after letter from the case, very slowly in order to display the movement, and dropped them into the stick. In his mild, resonant tones he explained that each letter must be picked up unfalteringly in a particular way, so that it would drop face upward into the stick without any intermediate manipulation. And he explained also that the left hand must be held so that the right hand would have to travel to and fro as little as possible. He was revealing the basic mysteries of his craft, and was happy, making the while the broad series of stock pleasantries which have probably been current in composing rooms since printing was invented. Then he was silent, working more and more quickly, till his right hand could scarcely be

The next morning, in the printing office, Edwin came upon Big James giving a lesson in composing to the younger apprentice, who in theory had 'learned his cases'. Big James held the composing stick in his great left hand, like a matchbox, and with his great right thumb and index picked letter after letter from the case, very slowly in order to display the movement, and dropped them into the stick. In his mild, resonant tones he explained that each letter must be picked up unfalteringly in a particular way, so that it would drop face upward into the stick without any intermediate manipulation. And he explained also that the left hand must be held so that the right hand would have to travel to and fro as little as possible. He was revealing the basic mysteries of his craft, and was happy, making the while the broad series of stock pleasantries which have probably been current in composing rooms since printing was invented. Then he was silent, working more and more quickly, till his right hand could scarcely be followed in its twinklings, and the face of the apprentice duly spread in marvel. When the line was finished he drew out the rule, clapped it down on the top of the last row of letters, and gave the composing stick to the apprentice to essay.

The next morning, in the printing office, Edwin came upon Big James giving a lesson in composing to the younger apprentice, who in theory had 'learned his cases'. Big James held the composing stick in his great left hand, like a matchbox, and with his great right thumb and index picked letter after letter from the case, very slowly in order to display the movement, and dropped them into the stick. In his mild, resonant tones he explained that each letter must be picked up unfalteringly in a particular way, so that it would drop face upward into the stick without any intermediate manipulation. And he explained also that the left hand must be held so that the right hand would have to travel to and fro as little as possible. He was revealing the basic mysteries of his craft, and was happy, making the while the broad series of stock pleasantries which have probably been current in composing rooms since printing was invented. Then he was silent, working more and more quickly, till his right hand could scarcely be followed in its twinklings, and the face of the apprentice duly spread in marvel. When the line was

LINE SPACING FOR A FACE WITH A SMALL X-HEIGHT

In faces with small x-heights, like Caslon #2, there is designed-in space above the lowercase letters that creates a horizontal channel even when the type is set solid, as in 1 (10/10) and 12 (9/9). Although example 8 (8/8) has a character count too great for the width of line, if you isolate a 10-pica segment, you will see that in an appropriate measure, the line spacing is adequate for readability. However, as line space increases in these sizes, the overall color becomes quite light. In 7 (10/16), 11 (8/12), and 15 (9/13) the space between lines dominates the lines of type. Although this might be an attractive effect for some uses, it is inappropriate for sustained reading.

Because of its small x-height, Caslon #2 has an acceptable type size/line width proportion even in 12 point on a 20-pica line. However, note that in this size, solid spacing (16) looks tight, whereas 12/13 (17) and 12/14 (18) work well. Even in 14 point on a very wide measure, 3 points of line spacing is adequate for readability (20), and the 6 points of line spacing that were needed for Bookman in this size seem excessive for Caslon (21).

The next morning, in the printing office, Edwin came upon Big James giving a lesson in composing to the younger apprentice, who in theory had 'learned his cases'. Big James held the composing stick in his great left hand, like a match-box, and with his great right thumb and index picked letter after letter from the case, very slowly in order to display the movement, and dropped them into the stick. In his mild, resonant tones he explained that each letter must be picked up unfalteringly in a particular way, so that it would drop face upward into the stick without any intermediate manipulation. And he explained also that the left hand must be held so that the right hand would have to travel to and fro as little as possible. He was revealing the basic mysteries of his craft, and was happy, making the while the broad series of stock pleasantries which have probably been current in composing rooms since printing was invented. Then he was silent, working more and more quickly, till his right hand could scarcely be followed in its twinklings, and the face of the apprentice duly spread in marvel. When the line was finished he drew out the rule, clapped it down on the top of the last row of letters, and gave the composing stick to the apprentice to essay.

The apprentice began to compose with his feet, his shoulders, his mouth, his eyebrows—with all his body except his hands, which nevertheless travelled spaciously far and wide.

'It's not in seven year, nor in seventy, as you'll learn, young sun of a gun!' said Big James.

And, having unsettled the youth to his foundations with a bland thwack across the head, he resumed the composing stick and began again the exposition of the unique smooth movement which is the root of rapid typesetting.

'Here!' said Big James, when the apprentice had behaved worse than ever. 'Us'll ask Mr Edwin to have a go. 'Us'll see what *he*'ll do.'

And Edwin, sheepish, had to comply. He was in pride bound to surpass the apprentice, and did so.

'There!' said Big James. 'What did I tell ye?' He seemed to imply a prophecy that, because Edwin had saved the printing office from destruction two days previously, he would necessar-

1 10/10 CASLON #2

The next morning, in the printing office, Edwin came upon Big James giving a lesson in composing to the younger apprentice, who in theory had 'learned his cases'. Big James held the composing stick in his great left hand, like a match-box, and with his great right thumb and index picked letter after letter from the case, very slowly in order to display the movement, and dropped them into the stick. In his mild, resonant tones he explained that each letter must be picked up unfalteringly in a particular way, so that it would drop face upward into the stick without any intermediate manipulation. And he explained also that the left hand must be held so that the right hand would have to travel to and fro as little as possible. He was revealing the basic mysteries of his craft, and was happy, making the while the broad series of stock pleasantries which have probably been current in composing rooms since printing was invented. Then he was silent, working more and more quickly, till his right hand could scarcely be followed in its twinklings, and the face of the apprentice duly spread in marvel. When the line was finished he drew out the rule, clapped it down on the top of the last row of letters, and gave the composing stick to the apprentice to essay.

The apprentice began to compose with his feet, his shoulders, his mouth, his eyebrows—with all his body except his hands, which nevertheless travelled spaciously far and wide.

'It's not in seven year, nor in seventy, as you'll learn, young sun of a gun!' said Big James.

And, having unsettled the youth to his foundations with a bland thwack across the head, he resumed the composing stick and began again the exposition of the unique smooth movement which is the root of rapid typesetting.

'Here!' said Big James, when the apprentice had behaved worse than ever. 'Us'll ask Mr Edwin to have a go. 'Us'll see what *he*'ll do.'

And Edwin, sheepish, had to comply. He was in pride bound to surpass the apprentice, and did so.

'There!' said Big James. 'What did I tell ye?' He seemed to

The next morning, in the printing office, Edwin came upon Big James giving a lesson in composing to the younger apprentice, who in theory had 'learned his cases'. Big James held the composing stick in his great left hand, like a match-box, and with his great right thumb and index picked letter after letter from the case, very slowly in order to display the movement, and dropped them into the stick. In his mild, resonant tones he explained that each letter must be picked up unfalteringly in a particular way, so that it would drop face upward into the stick without any intermediate manipulation. And he explained also that the left hand must be held so that the right hand would have to travel to and fro as little as possible. He was revealing the basic mysteries of his craft, and was happy, making the while the broad series of stock pleasantries which have probably been current in composing rooms since printing was invented. Then he was silent, working more and more quickly, till his right hand could scarcely be followed in its twinklings, and the face of the apprentice duly spread in marvel. When the line was finished he drew out the rule, clapped it down on the top of the last row of letters, and gave the composing stick to the apprentice to essay.

The apprentice began to compose with his feet, his shoulders, his mouth, his eyebrows—with all his body except his hands, which nevertheless travelled spaciously far and wide.

'It's not in seven year, nor in seventy, as you'll learn, young sun of a gun!' said Big James.

And, having unsettled the youth to his foundations with a bland thwack across the head, he resumed the composing stick and began again the exposition of the unique smooth movement which is the root of rapid typesetting.

'Here!' said Big James, when the apprentice had behaved worse than ever. 'Us'll ask Mr Edwin to have a go. 'Us'll see what *he*'ll do.'

And Edwin, sheepish, had to comply. He was in pride bound to surpass the apprentice, and did so.

The next morning, in the printing office, Edwin came upon Big James giving a lesson in composing to the younger apprentice, who in theory had 'learned his cases'. Big James held the composing stick in his great left hand, like a match-box, and with his great right thumb and index picked letter after letter from the case, very slowly in order to display the movement, and dropped them into the stick. In his mild, resonant tones he explained that each letter must be picked up unfalteringly in a particular way, so that it would drop face upward into the stick without any intermediate manipulation. And he explained also that the left hand must be held so that the right hand would have to travel to and fro as little as possible. He was revealing the basic mysteries of his craft, and was happy, making the while the broad series of stock pleasantries which have probably been current in composing rooms since printing was invented. Then he was silent, working more and more quickly, till his right hand could scarcely be followed in its twinklings, and the face of the apprentice duly spread in marvel. When the line was finished he drew out the rule, clapped it down on the top of the last row of letters, and gave the composing stick to the apprentice to essay.

The apprentice began to compose with his feet, his shoulders, his mouth, his eyebrows—with all his body except his hands, which nevertheless travelled spaciously far and wide.

'It's not in seven year, nor in seventy, as you'll learn, young sun of a gun!' said Big James.

And, having unsettled the youth to his foundations with a bland thwack across the head, he resumed the composing stick and began again the exposition of the unique smooth movement which is the root of rapid typesetting.

'Here!' said Big James, when the apprentice had behaved worse than ever. 'Us'll ask Mr Edwin to have a go. 'Us'll see

The next morning, in the printing office, Edwin came upon Big James giving a lesson in composing to the younger apprentice, who in theory had 'learned his cases'. Big James held the composing stick in his great left hand, like a match-box, and with his great right thumb and index picked letter after letter from the case, very slowly in order to display the movement, and dropped them into the stick. In his mild, resonant tones he explained that each letter must be picked up unfalteringly in a particular way, so that it would drop face upward into the stick without any intermediate manipulation. And he explained also that the left hand must be held so that the right hand would have to travel to and fro as little as possible. He was revealing the basic mysteries of his craft, and was happy, making the while the broad series of stock pleasantries which have probably been current in composing rooms since printing was invented. Then he was silent, working more and more quickly, till his right hand could scarcely be followed in its twinklings, and the face of the apprentice duly spread in marvel. When the line was finished he drew out the rule, clapped it down on the top of the last row of letters, and gave the composing stick to the apprentice to essay.

The apprentice began to compose with his feet, his shoulders, his mouth, his eyebrows—with all his body except his hands, which nevertheless travelled spaciously far and wide.

'It's not in seven year, nor in seventy, as you'll learn, young sun of a gun!' said Big James.

And, having unsettled the youth to his foundations with a bland thwack across the head, he resumed the composing stick and began again the exposition of the unique smooth move-

The next morning, in the printing office, Edwin came upon Big James giving a lesson in composing to the younger apprentice, who in theory had 'learned his cases'. Big James held the composing stick in his great left hand, like a match-box, and with his great right thumb and index picked letter after letter from the case, very slowly in order to display the movement, and dropped them into the stick. In his mild, resonant tones he explained that each letter must be picked up unfalteringly in a particular way, so that it would drop face upward into the stick without any intermediate manipulation. And he explained also that the left hand must be held so that the right hand would have to travel to and fro as little as possible. He was revealing the basic mysteries of his craft, and was happy, making the while the broad series of stock pleasantries which have probably been current in composing rooms since printing was invented. Then he was silent, working more and more quickly, till his right hand could scarcely be followed in its twinklings, and the face of the apprentice duly spread in marvel. When the line was finished he drew out the rule, clapped it down on the top of the last row of letters, and gave the composing stick to the apprentice to essay.

The apprentice began to compose with his feet, his shoulders, his mouth, his eyebrows—with all his body except his hands, which nevertheless travelled spaciously far and wide.

'It's not in seven year, nor in seventy, as you'll learn, young sun of a gun!' said Big James.

And, having unsettled the youth to his foundations with a

The next morning, in the printing office, Edwin came upon Big James giving a lesson in composing to the younger apprentice, who in theory had 'learned his cases'. Big James held the composing stick in his great left hand, like a match-box, and with his great right thumb and index picked letter after letter from the case, very slowly in order to display the movement, and dropped them into the stick. In his mild, resonant tones he explained that each letter must be picked up unfalteringly in a particular way, so that it would drop face upward into the stick without any intermediate manipulation. And he explained also that the left hand must be held so that the right hand would have to travel to and fro as little as possible. He was revealing the basic mysteries of his craft, and was happy, making the while the broad series of stock pleasantries which have probably been current in composing rooms since printing was invented. Then he was silent, working more and more quickly, till his right hand could scarcely be followed in its twinklings, and the face of the apprentice duly spread in marvel. When the line was finished he drew out the rule, clapped it down on the top of the last row of letters, and gave the composing stick to the apprentice to essay.

The apprentice began to compose with his feet, his shoulders, his mouth, his eyebrows—with all his body except his hands, which nevertheless travelled spaciously far and wide.

The next morning, in the printing office, Edwin came upon Big James giving a lesson in composing to the younger apprentice, who in theory had 'learned his cases'. Big James held the composing stick in his great left hand, like a match-box, and with his great right thumb and index picked letter after letter from the case, very slowly in order to display the movement, and dropped them into the stick. In his mild, resonant tones he explained that each letter must be picked up unfalteringly in a particular way, so that it would drop face upward into the stick without any intermediate manipulation. And he explained also that the left hand must be held so that the right hand would have to travel to and fro as little as possible. He was revealing the basic mysteries of his craft, and was happy, making the while the broad series of stock pleasantries which have probably been current in composing rooms since printing was invented. Then he was silent, working more and more quickly, till his right hand could scarcely be followed in its twinklings, and the face of the apprentice duly spread in marvel. When the line was finished he drew out the rule, clapped it down on the top of the last row of letters, and gave the composing stick to the apprentice to essay.

The apprentice began to compose with his feet, his shoulders, his mouth, his eyebrows—with all his body except his hands, which nevertheless travelled spaciously far and wide.

'It's not in seven year, nor in seventy, as you'll learn, young sun of a gun!' said Big James.

And, having unsettled the youth to his foundations with a bland thwack across the head, he resumed the composing stick and began again the exposition of the unique smooth movement which is the root of rapid typesetting.

'Here!' said Big James, when the apprentice had behaved worse than ever. 'Us'll ask Mr Edwin to have a go. 'Us'll see what *he*'ll do.'

And Edwin, sheepish, had to comply. He was in pride bound to surpass the apprentice, and did so.

'There!' said Big James. 'What did I tell ye?' He seemed to imply a prophecy that, because Edwin had saved the printing office from destruction two days previously, he would necessarily prove to be a born compositor.

The next morning, in the printing office, Edwin came upon Big James giving a lesson in composing to the younger apprentice, who in theory had 'learned his cases'. Big James held the composing stick in his great left hand, like a match-box, and with his great right thumb and index picked letter after letter from the case, very slowly in order to display the movement, and dropped them into the stick. In his mild, resonant tones he explained that each letter must be picked up unfalteringly in a particular way, so that it would drop face upward into the stick without any intermediate manipulation. And he explained also that the left hand must be held so that the right hand would have to travel to and fro as little as possible. He was revealing the basic mysteries of his craft, and was happy, making the while the broad series of stock pleasantries which have probably been current in composing rooms since printing was invented. Then he was silent, working more and more quickly, till his right hand could scarcely be followed in its twinklings, and the face of the apprentice duly spread in marvel. When the line was finished he drew out the rule, clapped it down on the top of the last row of letters, and gave the composing stick to the ap-

The next morning, in the printing office, Edwin came upon Big James giving a lesson in composing to the younger apprentice, who in theory had 'learned his cases'. Big James held the composing stick in his great left hand, like a match-box, and with his great right thumb and index picked letter after letter from the case, very slowly in order to display the movement, and dropped them into the stick. In his mild, resonant tones he explained that each letter must be picked up unfalteringly in a particular way, so that it would drop face upward into the stick without any intermediate manipulation. And he explained also that the left hand must be held so that the right hand would have to travel to and fro as little as possible. He was revealing the basic mysteries of his craft, and was happy, making the while the broad series of stock pleasantries which have probably been current in composing rooms since printing was invented. Then he was silent, working more and more quickly, till his right hand could scarcely be followed in its twinklings, and the face of the apprentice duly spread in marvel. When the line was finished he drew out the rule, clapped it down on the top of the last row of letters, and gave the composing stick to the apprentice to essay.

The apprentice began to compose with his feet, his shoulders, his mouth, his eyebrows—with all his body except his hands, which nevertheless travelled spaciously far and wide.

'It's not in seven year, nor in seventy, as you'll learn, young sun of a gun!' said Big James.

And, having unsettled the youth to his foundations with a bland thwack across the head, he resumed the composing stick and began again the exposition of the unique smooth movement which is the root of rapid typesetting.

'Here!' said Big James, when the apprentice had behaved worse than ever. 'Us'll ask Mr Edwin to have a go. 'Us'll see what *he*'ll do.'

And Edwin, sheepish, had to comply. He was in pride bound to surpass the apprentice, and did so.

'There!' said Big James. 'What did I tell ye?' He seemed to imply a prophecy that, because Edwin had saved the printing office from destruction two days previously, he would necessarily prove to be a born compositor.

The next morning, in the printing office, Edwin came upon Big James giving a lesson in composing to the younger apprentice, who in theory had 'learned his cases'. Big James held the composing stick in his great left hand, like a match-box, and with his great right thumb and index picked letter after letter from the case, very slowly in order to display the movement, and dropped them into the stick. In his mild, resonant tones he explained that each letter must be picked up unfalteringly in a particular way, so that it would drop face upward into the stick without any intermediate manipulation. And he explained also that the left hand must be held so that the right hand would have to travel to and fro as little as possible. He was revealing the basic mysteries of his craft,

The next morning, in the printing office, Edwin came upon Big James giving a lesson in composing to the younger apprentice, who in theory had 'learned his cases'. Big James held the composing stick in his great left hand, like a match-box, and with his great right thumb and index picked letter after letter from the case, very slowly in order to display the movement, and dropped them into the stick. In his mild, resonant tones he explained that each letter must be picked up unfalteringly in a particular way, so that it would drop face upward into the stick without any intermediate manipulation. And he explained also that the left hand must be held so that the right hand would have to travel to and fro as little as possible. He was revealing the basic mysteries of his craft, and was happy, making the while the broad series of stock pleasantries which have probably been current in composing rooms since printing was invented. Then he was silent, working more and more quickly, till his right hand could scarcely be followed in its twinklings, and the face of the apprentice duly spread in marvel. When the line was finished he drew out the rule, clapped it down on the top of the last row of letters, and gave the composing stick to the apprentice to essay.

The apprentice began to compose with his feet, his shoulders, his mouth, his eyebrows—with all his body except his hands, which nevertheless travelled spaciously far and wide.

'It's not in seven year, nor in seventy, as you'll learn, young sun of a gun!' said Big James.

And, having unsettled the youth to his foundations with a bland thwack across the head, he resumed the composing stick and began again the exposition of the unique smooth movement which is the root of rapid typesetting.

'Here!' said Big James, when the apprentice had behaved worse than ever. 'Us'll ask Mr Edwin to have a go. 'Us'll see what *he*'ll do.'

And Edwin, sheepish, had to comply. He was in pride bound to surpass the apprentice, and did so.

'There!' said Big James. 'What did I tell ye?' He seemed to imply a prophecy that, because Edwin had saved the printing office from destruction two days previously, he would necessarily prove to be a born compositor.

The next morning, in the printing office, Edwin came upon Big James giving a lesson in composing to the younger apprentice, who in theory had 'learned his cases'. Big James held the composing stick in his great left hand, like a

The next morning, in the printing office, Edwin came upon Big James giving a lesson in composing to the younger apprentice, who in theory had 'learned his cases'. Big James held the composing stick in his great left hand, like a match-box, and with his great right thumb and index picked letter after letter from the case, very slowly in order to display the movement, and dropped them into the stick. In his mild, resonant tones he explained that each letter must be picked up unfalteringly in a particular way, so that it would drop face upward into the stick without any intermediate manipulation. And he explained also that the left hand must be held so that the right hand would have to travel to and fro as little as possible. He was revealing the basic mysteries of his craft, and was happy, making the while the broad series of stock pleasantries which have probably been current in composing rooms since printing was invented. Then he was silent, working more and more quickly, till his right hand could scarcely be followed in its twinklings, and the face of the apprentice duly spread in marvel. When the line was finished he drew out the rule, clapped it down on the top of the last row of letters, and gave the composing stick to the apprentice to essay.

The apprentice began to compose with his feet, his shoulders, his mouth, his eyebrows—with all his body except his hands, which nevertheless travelled spaciously far and wide.

'It's not in seven year, nor in seventy, as you'll learn, young sun of a gun!' said Big James.

And, having unsettled the youth to his foundations with a bland thwack across the head, he resumed the composing stick and began again the exposition of the unique smooth movement which is the root of rapid typesetting.

'Here!' said Big James, when the apprentice had behaved worse than ever. 'Us'll ask Mr Edwin to have a go. 'Us'll see what *he*'ll do.'

And Edwin, sheepish, had to comply. He was in pride bound to surpass the apprentice, and did so.

'There!' said Big James. 'What did I tell ye?' He seemed to imply a prophecy that, because Edwin had saved the printing office from destruction two days previously, he would necessarily prove to be a born compositor.

The next morning, in the printing office, Edwin came upon Big James giving a lesson in composing to the younger apprentice, who in theory had 'learned his cases'. Big James held the composing stick in his great left hand, like a match-box, and with his great right thumb and index picked letter after letter from the case, very slowly in order to display the movement, and dropped them into the stick. In his mild, resonant tones he explained that each letter must be picked up unfalteringly in a particular way, so that it would drop face upward into the stick without any intermediate manipulation. And he explained also that the left hand must be held so that the right hand would have to travel to and fro as little as possible. He was revealing the basic mysteries of his craft, and was happy, making the while the broad series of stock pleasantries which have probably been current in composing rooms since printing was invented. Then he was silent, working more and more quickly, till his right hand could scarcely be followed in its twinklings, and the face of the apprentice duly spread in marvel. When the line was finished he drew out the rule, clapped it down on the top of the last row of letters, and gave the composing stick to the apprentice to essay.

The apprentice began to compose with his feet, his shoulders, his mouth, his eyebrows—with all his body except his hands, which nevertheless travelled spaciously far and wide.

'It's not in seven year, nor in seventy, as you'll learn, young sun of a gun!' said Big James.

And, having unsettled the youth to his foundations with a bland thwack across the head, he resumed the composing stick and began again the exposition of the unique smooth movement which is the root of rapid typesetting.

'Here!' said Big James, when the apprentice had behaved worse than ever. 'Us'll ask Mr Edwin to have a go. 'Us'll see what *he*'ll do.'

And Edwin, sheepish, had to comply. He was in pride bound to surpass the apprentice, and did so.

'There!' said Big James. 'What did I tell ye?' He seemed to imply a prophecy that, because Edwin had saved the printing office from destruction two days previously, he would necessarily prove to be a born compositor.

The next morning, in the printing office, Edwin came upon Big James giving a lesson in composing to the younger apprentice, who in theory had 'learned his cases'. Big James held the composing stick in his great left hand, like a match-box, and with his great right thumb and index picked letter after letter from the case, very slowly in order to display the movement, and dropped them into the stick. In his mild,

The next morning, in the printing office, Edwin came upon Big James giving a lesson in composing to the younger apprentice, who in theory had 'learned his cases'. Big James held the composing stick in his great left hand, like a match-box, and with his great right thumb and index picked letter after letter from the case, very slowly in order to display the movement, and dropped them into the stick. In his mild, resonant tones he explained that each letter must be picked up unfalteringly in a particular way, so that it would drop face upward into the stick without any intermediate manipulation. And he explained also that the left hand must be held so that the right hand would have to travel to and fro as little as possible. He was revealing the basic mysteries of his craft, and was happy, making the while the broad series of stock pleasantries which have probably been current in composing rooms since printing was invented. Then he was silent, working more and more quickly, till his right hand could scarcely be followed in its twinklings, and the face of the apprentice duly spread in marvel. When the line was finished he drew out the rule, clapped it down on the top of the last row of letters, and gave the composing stick to the apprentice to essay.

The apprentice began to compose with his feet, his shoulders, his mouth, his eyebrows—with all his body except his hands, which nevertheless travelled spaciously far and wide.

'It's not in seven year, nor in seventy, as you'll learn, young sun of a gun!' said Big James.

And, having unsettled the youth to his foundations with a bland thwack across the head, he resumed the composing stick and began again the exposition of the unique smooth movement which is the root of rapid typesetting.

'Here!' said Big James, when the apprentice had behaved worse than ever. 'Us'll ask Mr Edwin to have a go. 'Us'll see what *he*'ll do.'

And Edwin, sheepish, had to comply. He was in pride bound to surpass the apprentice, and did so.

'There!' said Big James. 'What did I tell ye?' He seemed to imply a prophecy that, because Edwin had saved the printing office from destruction two days previously, he would necessarily prove to be a born

The next morning, in the printing office, Edwin came upon Big James giving a lesson in composing to the younger apprentice, who in theory had 'learned his cases'. Big James held the composing stick in his great left hand, like a match-box, and with his great right thumb and index picked letter after letter from the case, very slowly in order to display the movement, and dropped them into the stick. In his mild, resonant tones he explained that each letter must be picked up unfalteringly in a particular way, so that it would drop face upward into the stick without any intermediate manipulation. And he explained also that the left hand must be held so that the right hand would have to travel to and fro as little as possible. He was revealing the basic mysteries of his craft, and was happy, making the while the broad series of stock pleasantries which have probably been current in composing rooms since printing was invented. Then he was silent, working more and more quickly, till his right hand could scarcely be followed in its twinklings, and the face of the apprentice duly spread in marvel. When the line was finished he drew out the rule, clapped it down on the top of the last row of letters, and gave the composing stick to the apprentice to essay.

The apprentice began to compose with his feet, his shoulders, his mouth, his eyebrows—with all his body except his hands, which nevertheless travelled spaciously far and wide.

'It's not in seven year, nor in seventy, as you'll learn, young sun of a gun!' said Big James.

And, having unsettled the youth to his foundations with a bland thwack across the head, he resumed the composing stick and began again the exposition of the unique smooth movement which is the root of rapid typesetting.

'Here!' said Big James, when the apprentice had behaved worse than ever. 'Us'll ask Mr Edwin to have a go. 'Us'll see what *he*'ll do.'

And Edwin, sheepish, had to comply. He was in pride bound to surpass the apprentice, and did so.

The next morning, in the printing office, Edwin came upon Big James giving a lesson in composing to the younger apprentice, who in theory had 'learned his cases'. Big James held the composing stick in his great left hand, like a match-box, and with his great right thumb and index picked letter after letter from the case, very slowly in order to display the movement, and dropped them into the stick. In his mild, resonant tones he explained that each letter must be picked up unfalteringly in a particular way, so that it would drop face upward into the stick without any intermediate manipulation. And he explained also that the left hand must be held so that the right hand would have to travel to and fro as little as possible. He was revealing the basic mysteries of his craft, and was happy, making the while the broad series of stock pleasantries which have probably been current in composing rooms since printing was invented. Then he was silent, working more and more quickly, till his right hand could scarcely be followed in its twinklings, and the face of the apprentice duly spread in marvel. When the line was finished he drew out the rule, clapped it down on the top of the last row of letters, and gave the composing stick to the apprentice to essay.

The apprentice began to compose with his feet, his shoulders, his mouth, his eyebrows—with all his body except his hands, which nevertheless travelled spaciously far and wide.

'It's not in seven year, nor in seventy, as you'll learn, young sun of a gun!' said Big James.

And, having unsettled the youth to his foundations with a bland thwack across the head, he resumed the composing stick and began again the exposition of the unique smooth movement which is the root of rapid typesetting.

'Here!' said Big James, when the apprentice had behaved worse

The next morning, in the printing office, Edwin came upon Big James giving a lesson in composing to the younger apprentice, who in theory had 'learned his cases'. Big James held the composing stick in his great left hand, like a match-box, and with his great right thumb and index picked letter after letter from the case, very slowly in order to display the movement, and dropped them into the stick. In his mild, resonant tones he explained that each letter must be picked up unfalteringly in a particular way, so that it would drop face upward into the stick without any intermediate manipulation. And he explained also that the left hand must be held so that the right hand would have to travel to and fro as little as possible. He was revealing the basic mysteries of his craft, and was happy, making the while the broad series of stock pleasantries which have probably been current in composing rooms since printing was invented. Then he was silent, working more and more quickly, till his right hand could scarcely be followed in its twinklings, and the face of the apprentice duly spread in marvel. When the line was finished he drew out the rule, clapped it down on the top of the last row of letters, and gave the composing stick to the apprentice to essay.

The apprentice began to compose with his feet, his shoulders, his mouth, his eyebrows—with all his body except his hands, which nevertheless travelled spaciously far and wide.

'It's not in seven year, nor in seventy, as you'll learn, young sun of a gun!' said Big James.

And, having unsettled the youth to his foundations with a bland thwack across the head, he resumed

The next morning, in the printing office, Edwin came upon Big James giving a lesson in composing to the younger apprentice, who in theory had 'learned his cases'. Big James held the composing stick in his great left hand, like a match-box, and with his great right thumb and index picked letter after letter from the case, very slowly in order to display the movement, and dropped them into the stick. In his mild, resonant tones he explained that each letter must be picked up unfalteringly in a particular way, so that it would drop face upward into the stick without any intermediate manipulation. And he explained also that the left hand must be held so that the right hand would have to travel to and fro as little as possible. He was revealing the basic mysteries of his craft, and was happy, making the while the broad series of stock pleasantries which have probably been current in composing rooms since printing was invented. Then he was silent, working more and more quickly, till his right hand could scarcely be followed in its twinklings, and the face of the apprentice duly spread in marvel. When the line was finished he drew out the rule, clapped it down on the top of the last row of letters, and gave the composing stick to the apprentice to essay.

The apprentice began to compose with his feet, his shoulders, his mouth, his eyebrows—with all his body except his hands, which nevertheless travelled spaciously far and wide.

'It's not in seven year, nor in seventy, as you'll learn,

The next morning, in the printing office, Edwin came upon Big James giving a lesson in composing to the younger apprentice, who in theory had 'learned his cases'. Big James held the composing stick in his great left hand, like a match-box, and with his great right thumb and index picked letter after letter from the case, very slowly in order to display the movement, and dropped them into the stick. In his mild, resonant tones he explained that each letter must be picked up unfalteringly in a particular way, so that it would drop face upward into the stick without any intermediate manipulation. And he explained also that the left hand must be held so that the right hand would have to travel to and fro as little as possible. He was revealing the basic mysteries of his craft, and was happy, making the while the broad series of stock pleasantries which have probably been current in composing rooms since printing was invented. Then he was silent, working more and more quickly, till his right hand could scarcely be followed in its twinklings, and the face of the apprentice duly spread in marvel. When the line was finished he drew out the rule, clapped it down on the top of the last row of letters, and gave the composing stick to the apprentice to essay.

The apprentice began to compose with his feet, his shoulders, his mouth, his eyebrows—with all his body except his hands, which nevertheless travelled spa-

The next morning, in the printing office, Edwin came upon Big James giving a lesson in composing to the younger apprentice, who in theory had 'learned his cases'. Big James held the composing stick in his great left hand, like a match-box, and with his great right thumb and index picked letter after letter from the case, very slowly in order to display the movement, and dropped them into the stick. In his mild, resonant tones he explained that each letter must be picked up unfalteringly in a particular way, so that it would drop face upward into the stick without any intermediate manipulation. And he explained also that the left hand must be held so that the right hand would have to travel to and fro as little as possible. He was revealing the basic mysteries of his craft, and was happy, making the while the broad series of stock pleasantries which have probably been current in composing rooms since printing was invented. Then he was silent, working more and more quickly, till his right hand could scarcely be followed in its twinklings, and the face of the apprentice duly spread in marvel. When the line was finished he drew out the rule, clapped it down on the top of the last row of letters, and gave the composing stick to the apprentice to essay.

The next morning, in the printing office, Edwin came upon Big James giving a lesson in composing to the younger apprentice, who in theory had 'learned his cases'. Big James held the composing stick in his great left hand, like a match-box, and with his great right thumb and index picked letter after letter from the case, very slowly in order to display the movement, and dropped them into the stick. In his mild, resonant tones he explained that each letter must be picked up unfalteringly in a particular way, so that it would drop face upward into the stick without any intermediate manipulation. And he explained also that the left hand must be held so that the right hand would have to travel to and fro as little as possible. He was revealing the basic mysteries of his craft, and was happy, making the while the broad series of stock pleasantries which have probably been current in composing rooms since printing was invented. Then he was silent, working more and more quickly, till his right hand could scarcely be followed in its twinklings, and the face of the apprentice duly spread in marvel. When the line was finished he drew out the rule, clapped it down on the top of the last row of letters, and gave the composing stick to the apprentice to essay.

The apprentice began to compose with his feet, his shoulders, his mouth, his eyebrows—with all his body except his hands, which nevertheless travelled spaciously far and wide.

'It's not in seven year, nor in seventy, as you'll learn, young sun of a

The next morning, in the printing office, Edwin came upon Big James giving a lesson in composing to the younger apprentice, who in theory had 'learned his cases'. Big James held the composing stick in his great left hand, like a match-box, and with his great right thumb and index picked letter after letter from the case, very slowly in order to display the movement, and dropped them into the stick. In his mild, resonant tones he explained that each letter must be picked up unfalteringly in a particular way, so that it would drop face upward into the stick without any intermediate manipulation. And he explained also that the left hand must be held so that the right hand would have to travel to and fro as little as possible. He was revealing the basic mysteries of his craft, and was happy, making the while the broad series of stock pleasantries which have probably been current in composing rooms since printing was invented. Then he was silent, working more and more quickly, till his right hand could scarcely be followed in its twinklings, and the face of the apprentice duly spread in marvel. When the line was finished he drew out the rule, clapped it down on the top of the last row of letters, and gave the composing stick to the apprentice to essay.

The apprentice began to compose with his feet, his shoulders, his

LINE SPACING AND STROKE WEIGHT / 1

The following six spreads demonstrate how changing the line spacing affects the overall color of the page in faces with differing stroke weights and amounts of thick/thin contrast. The effects of line spacing depend not only on the x-height of the type and the proportion of line length to type size, as shown on the preceding spreads, but on other design factors as well, such as weight and contrast of line and distribution of internal spaces. Study these pages in three ways: first, by viewing them from slightly farther than reading distance to get an overall impression; then by reading the page and evaluating the ease of reading; and finally by isolating shorter line widths using white paper and observing how line spacing is affected by line length.

Aster Medium is a moderately heavy face with a fair degree of contrast in stroke weight. Notice that the example shown in 1 (9/12) has a more active overall texture than that shown in 2, although it has enough space between the lines for easy readability. Because of the activity of the face, a setting like 3 (9/15), which would be excessive for most faces with this x-height, creates a pleasant and readable overall look.

The next morning, in the printing office, Edwin came upon Big James giving a lesson in composing to the younger apprentice, who in theory had 'learned his cases'. Big James held the composing stick in his great left hand, like a match-box, and with his great right thumb and index picked letter after letter from the case, very slowly in order to display the movement, and dropped them into the stick. In his mild, resonant tones he explained that each letter must be picked up unfalteringly in a particular way, so that it would drop face upward into the stick without any intermediate manipulation. And he explained also that the left hand must be held so that the right hand would have to travel to and fro as little as possible. He was revealing the basic mysteries of his craft, and was happy, making the while the broad series of stock pleasantries which have probably been current in composing rooms since printing was invented. Then he was silent, working more and more quickly, till his right hand could scarcely be followed in its twinklings, and the face of the apprentice duly spread in marvel. When the line was finished he drew out the rule, clapped it down on the top of the last row of letters, and gave the composing stick to the apprentice to essay.

The apprentice began to compose with his feet, his shoulders, his mouth, his eyebrows—with all his body except his hands, which nevertheless travelled spaciously far and wide.

'It's not in seven year, nor in seventy, as you'll learn, young sun of a gun!' said Big James.

And, having unsettled the youth to his foundations with a bland thwack across the head, he resumed the composing stick and began again the exposition of the unique smooth movement which is the root of rapid typesetting.

1 9/12 ASTER MEDIUM

The next morning, in the printing office, Edwin came upon Big James giving a lesson in composing to the younger apprentice, who in theory had 'learned his cases'. Big James held the composing stick in his great left hand, like a match-box, and with his great right thumb and index picked letter after letter from the case, very slowly in order to display the movement, and dropped them into the stick. In his mild, resonant tones he explained that each letter must be picked up unfalteringly in a particular way, so that it would drop face upward into the stick without any intermediate manipulation. And he explained also that the left hand must be held so that the right hand would have to travel to and fro as little as possible. He was revealing the basic mysteries of his craft, and was happy, making the while the broad series of stock pleasantries which have probably been current in composing rooms since printing was invented. Then he was silent, working more and more quickly, till his right hand could scarcely be followed in its twinklings, and the face of the apprentice duly spread in marvel. When the line was finished he drew out the rule, clapped it down on the top of the last row of letters, and gave the composing stick to the apprentice to essay.

The apprentice began to compose with his feet, his shoulders, his mouth, his eyebrows—with all his body except his hands, which nevertheless travelled spaciously far and wide.

'It's not in seven year, nor in seventy, as you'll learn, young sun of a gun!' said Big James.

And, having unsettled the youth to his foundations with

The next morning, in the printing office, Edwin came upon Big James giving a lesson in composing to the younger apprentice, who in theory had 'learned his cases'. Big James held the composing stick in his great left hand, like a match-box, and with his great right thumb and index picked letter after letter from the case, very slowly in order to display the movement, and dropped them into the stick. In his mild, resonant tones he explained that each letter must be picked up unfalteringly in a particular way, so that it would drop face upward into the stick without any intermediate manipulation. And he explained also that the left hand must be held so that the right hand would have to travel to and fro as little as possible. He was revealing the basic mysteries of his craft, and was happy, making the while the broad series of stock pleasantries which have probably been current in composing rooms since printing was invented. Then he was silent, working more and more quickly, till his right hand could scarcely be followed in its twinklings, and the face of the apprentice duly spread in marvel. When the line was finished he drew out the rule, clapped it down on the top of the last row of letters, and gave the composing stick to the apprentice to essay.

The apprentice began to compose with his feet, his shoulders, his mouth, his eyebrows—with all his body ex-

LINE SPACING AND STROKE WEIGHT/2

Palatino Bold has a much heavier stroke weight than the Aster shown on the preceding spread, as well as less contrast between thicks and thins. Although you would not ordinarily consider using such a heavy face for prolonged reading, you can if you add line space to change the overall color, especially for narrow measures with proportionally large margins.

The next morning, in the printing office, Edwin came upon Big James giving a lesson in composing to the younger apprentice, who in theory had 'learned his cases'. Big James held the composing stick in his great left hand, like a match-box, and with his great right thumb and index picked letter after letter from the case, very slowly in order to display the movement, and dropped them into the stick. In his mild, resonant tones he explained that each letter must be picked up unfalteringly in a particular way, so that it would drop face upward into the stick without any intermediate manipulation. And he explained also that the left hand must be held so that the right hand would have to travel to and fro as little as possible. He was revealing the basic mysteries of his craft, and was happy, making the while the broad series of stock pleasantries which have probably been current in composing rooms since printing was invented. Then he was silent, working more and more quickly, till his right hand could scarcely be followed in its twinklings, and the face of the apprentice duly spread in marvel. When the line was finished he drew out the rule, clapped it down on the top of the last row of letters, and gave the composing stick to the apprentice to essay.

The apprentice began to compose with his feet, his shoulders, his mouth, his eyebrows—with all his body except his hands, which nevertheless travelled spaciously far and wide.

'It's not in seven year, nor in seventy, as you'll learn, young sun of a gun!' said Big James.

And, having unsettled the youth to his foundations with a bland thwack across the head, he resumed the composing stick and began again the exposition of the unique smooth movement which is the root of rapid typesetting.

The next morning, in the printing office, Edwin came upon Big James giving a lesson in composing to the younger apprentice, who in theory had 'learned his cases'. Big James held the composing stick in his great left hand, like a match-box, and with his great right thumb and index picked letter after letter from the case, very slowly in order to display the movement, and dropped them into the stick. In his mild, resonant tones he explained that each letter must be picked up unfalteringly in a particular way, so that it would drop face upward into the stick without any intermediate manipulation. And he explained also that the left hand must be held so that the right hand would have to travel to and fro as little as possible. He was revealing the basic mysteries of his craft, and was happy, making the while the broad series of stock pleasantries which have probably been current in composing rooms since printing was invented. Then he was silent, working more and more quickly, till his right hand could scarcely be followed in its twinklings, and the face of the apprentice duly spread in marvel. When the line was finished he drew out the rule, clapped it down on the top of the last row of letters, and gave the composing stick to the apprentice to essay.

The apprentice began to compose with his feet, his shoulders, his mouth, his eyebrows—with all his body except his hands, which travelled spaciously far and wide.

'It's not in seven year, nor in seventy, as you'll learn, young sun of a gun!' said Big James.

And, having unsettled the youth to his foundations with a bland thwack across the head, he resumed the compos-

The next morning, in the printing office, Edwin came upon Big James giving a lesson in composing to the younger apprentice, who in theory had 'learned his cases'. Big James held the composing stick in his great left hand, like a match-box, and with his great right thumb and index picked letter after letter from the case, very slowly in order to display the movement, and dropped them into the stick. In his mild, resonant tones he explained that each letter must be picked up unfalteringly in a particular way, so that it would drop face upward into the stick without any intermediate manipulation. And he explained also that the left hand must be held so that the right hand would have to travel to and fro as little as possible. He was revealing the basic mysteries of his craft, and was happy, making the while the broad series of stock pleasantries which have probably been current in composing rooms since printing was invented. Then he was silent, working more and more quickly, till his right hand could scarcely be followed in its twinklings, and the face of the apprentice duly spread in marvel. When the line was finished he drew out the rule, clapped it down on the top of the last row of letters, and gave the composing stick to the apprentice to essay.

The apprentice began to compose with his feet, his shoulders, his mouth, his eyebrows—with all his body except his hands, which nevertheless travelled spaciously far and

Helvetica Heavy has a very heavy stroke weight and no thick/thin contrast. The internal spaces of the letters, however, are quite evenly distributed. Adding line space to text set in faces like this does not lighten the overall texture of the page; instead, it creates an almost striped effect of black and white. Heavy, even-stroked faces can create dramatic textural effects but should be used with caution for prolonged reading.

The next morning, in the printing office, Edwin came upon Big James giving a lesson in composing to the younger apprentice, who in theory had 'learned his cases'. Big James held the composing stick in his great left hand, like a match-box, and with his great right thumb and index picked letter after letter from the case, very slowly in order to display the movement, and dropped them into the stick. In his mild, resonant tones he explained that each letter must be picked up unfalteringly in a particular way, so that it would drop face upward into the stick without any intermediate manipulation. And he explained also that the left hand must be held so that the right hand would have to travel to and fro as little as possible. He was revealing the basic mysteries of his craft, and was happy, making the while the broad series of stock pleasantries which have probably been current in composing rooms since printing was invented. Then he was silent, working more and more quickly, till his right hand could scarcely be followed in its twinklings, and the face of the apprentice duly spread in marvel. When the line was finished he drew out the rule, clapped it down on the top of the last row of letters, and gave the composing stick to the apprentice to essay.

The apprentice began to compose with his feet, his shoulders, his mouth, his eyebrows—with all his body except his hands, which nevertheless travelled spaciously far and wide.

'It's not in seven year, nor in seventy, as you'll learn, young sun of a gun!' said Big James.

And, having unsettled the youth to his foundations

The next morning, in the printing office, Edwin came upon Big James giving a lesson in composing to the younger apprentice, who in theory had 'learned his cases'. Big James held the composing stick in his great left hand, like a match-box, and with his great right thumb and index picked letter after letter from the case, very slowly in order to display the movement, and dropped them into the stick. In his mild, resonant tones he explained that each letter must be picked up unfalteringly in a particular way, so that it would drop face upward into the stick without any intermediate manipulation. And he explained also that the left hand must be held so that the right hand would have to travel to and fro as little as possible. He was revealing the basic mysteries of his craft, and was happy, making the while the broad series of stock pleasantries which have probably been current in composing rooms since printing was invented. Then he was silent, working more and more quickly, till his right hand could scarcely be followed in its twinklings, and the face of the apprentice duly spread in marvel. When the line was finished he drew out the rule, clapped it down on the top of the last row of letters, and gave the composing stick to the apprentice to essay.

 The apprentice began to compose with his feet, his shoulders, his mouth, his eyebrows—with all his body

The next morning, in the printing office, Edwin came upon Big James giving a lesson in composing to the younger apprentice, who in theory had 'learned his cases'. Big James held the composing stick in his great left hand, like a match-box, and with his great right thumb and index picked letter after letter from the case, very slowly in order to display the movement, and dropped them into the stick. In his mild, resonant tones he explained that each letter must be picked up unfalteringly in a particular way, so that it would drop face upward into the stick without any intermediate manipulation. And he explained also that the left hand must be held so that the right hand would have to travel to and fro as little as possible. He was revealing the basic mysteries of his craft, and was happy, making the while the broad series of stock pleasantries which have probably been current in composing rooms since printing was invented. Then he was silent, working more and more quickly, till his right hand could scarcely be followed in its twinklings, and the face of the apprentice duly spread in marvel. When the line was finished he drew out the rule, clapped it down on the top of the last row of letters, and gave the composing stick to the appren-

Gill Sans Light is a face with a very light and even stroke weight. However, because of the irregular distribution of internal space, it does not create as even a texture as many other sans serif faces. In these examples we see not only how the overall color of the page gets lighter with increasing line space, but how the overall texture becomes less active when the space between the lines predominates over the internal spaces of the letters.

The next morning, in the printing office, Edwin came upon Big James giving a lesson in composing to the younger apprentice, who in theory had 'learned his cases'. Big James held the composing stick in his great left hand, like a match-box, and with his great right thumb and index picked letter after letter from the case, very slowly in order to display the movement, and dropped them into the stick. In his mild, resonant tones he explained that each letter must be picked up unfalteringly in a particular way, so that it would drop face upward into the stick without any intermediate manipulation. And he explained also that the left hand must be held so that the right hand would have to travel to and fro as little as possible. He was revealing the basic mysteries of his craft, and was happy, making the while the broad series of stock pleasantries which have probably been current in composing rooms since printing was invented. Then he was silent, working more and more quickly, till his right hand could scarcely be followed in its twinklings, and the face of the apprentice duly spread in marvel. When the line was finished he drew out the rule, clapped it down on the top of the last row of letters, and gave the composing stick to the apprentice to essay.

The apprentice began to compose with his feet, his shoulders, his mouth, his eyebrows—with all his body except his hands, which nevertheless travelled spaciously far and wide.

'It's not in seven year, nor in seventy, as you'll learn, young sun of a gun!' said Big James.

And, having unsettled the youth to his foundations with a bland thwack across the head, he resumed the composing stick and began again the exposition of the unique smooth movement which is the root of rapid typesetting.

'Here!' said Big James, when the apprentice had behaved worse than ever. 'Us'll ask Mr Edwin to have a go. 'Us'll see what *he*'ll do.'

And Edwin, sheepish, had to comply. He was in pride bound to surpass the apprentice, and did so.

1 10/11 GILL SANS LIGHT

The next morning, in the printing office, Edwin came upon Big James giving a lesson in composing to the younger apprentice, who in theory had 'learned his cases'. Big James held the composing stick in his great left hand, like a match-box, and with his great right thumb and index picked letter after letter from the case, very slowly in order to display the movement, and dropped them into the stick. In his mild, resonant tones he explained that each letter must be picked up unfalteringly in a particular way, so that it would drop face upward into the stick without any intermediate manipulation. And he explained also that the left hand must be held so that the right hand would have to travel to and fro as little as possible. He was revealing the basic mysteries of his craft, and was happy, making the while the broad series of stock pleasantries which have probably been current in composing rooms since printing was invented. Then he was silent, working more and more quickly, till his right hand could scarcely be followed in its twinklings, and the face of the apprentice duly spread in marvel. When the line was finished he drew out the rule, clapped it down on the top of the last row of letters, and gave the composing stick to the apprentice to essay.

The apprentice began to compose with his feet, his shoulders, his mouth, his eyebrows—with all his body except his hands, which nevertheless travelled spaciously far and wide.

'It's not in seven year, nor in seventy, as you'll learn, young sun of a gun!' said Big James.

And, having unsettled the youth to his foundations with a bland thwack across the head, he resumed the composing stick and began again the exposition of the unique smooth movement which is the root of rapid typesetting.

'Here!' said Big James, when the apprentice had behaved worse than ever. 'Us'll ask Mr Edwin to have a go. 'Us'll see

The next morning, in the printing office, Edwin came upon Big James giving a lesson in composing to the younger apprentice, who in theory had 'learned his cases'. Big James held the composing stick in his great left hand, like a match-box, and with his great right thumb and index picked letter after letter from the case, very slowly in order to display the movement, and dropped them into the stick. In his mild, resonant tones he explained that each letter must be picked up unfalteringly in a particular way, so that it would drop face upward into the stick without any intermediate manipulation. And he explained also that the left hand must be held so that the right hand would have to travel to and fro as little as possible. He was revealing the basic mysteries of his craft, and was happy, making the while the broad series of stock pleasantries which have probably been current in composing rooms since printing was invented. Then he was silent, working more and more quickly, till his right hand could scarcely be followed in its twinklings, and the face of the apprentice duly spread in marvel. When the line was finished he drew out the rule, clapped it down on the top of the last row of letters, and gave the composing stick to the apprentice to essay.

The apprentice began to compose with his feet, his shoulders, his mouth, his eyebrows—with all his body except his hands, which nevertheless travelled spaciously far and wide.

'It's not in seven year, nor in seventy, as you'll learn, young sun of a gun!' said Big James.

And, having unsettled the youth to his foundations with a

LINE SPACING AND STROKE WEIGHT / 5

Berkeley Old Style Medium is a moderately heavy face with moderately low thick/thin contrast. However, the very small counters of the *a* and *e* give it an active texture that, like the Gill Sans Light on the preceding page, can be modified by increasing the line space.

The next morning, in the printing office, Edwin came upon Big James giving a lesson in composing to the younger apprentice, who in theory had 'learned his cases'. Big James held the composing stick in his great left hand, like a match-box, and with his great right thumb and index picked letter after letter from the case, very slowly in order to display the movement, and dropped them into the stick. In his mild, resonant tones he explained that each letter must be picked up unfalteringly in a particular way, so that it would drop face upward into the stick without any intermediate manipulation. And he explained also that the left hand must be held so that the right hand would have to travel to and fro as little as possible. He was revealing the basic mysteries of his craft, and was happy, making the while the broad series of stock pleasantries which have probably been current in composing rooms since printing was invented. Then he was silent, working more and more quickly, till his right hand could scarcely be followed in its twinklings, and the face of the apprentice duly spread in marvel. When the line was finished he drew out the rule, clapped it down on the top of the last row of letters, and gave the composing stick to the apprentice to essay.

The apprentice began to compose with his feet, his shoulders, his mouth, his eyebrows—with all his body except his hands, which travelled spaciously far and wide.

'It's not in seven year, nor in seventy, as you'll learn, young sun of a gun!' said Big James.

And, having unsettled the youth to his foundations with a bland thwack across the head, he resumed the composing stick and began again the exposition of the unique smooth movement which is the root of rapid typesetting.

'Here!' said Big James, when the apprentice had behaved worse than ever. 'Us'll ask Mr Edwin to have a go. 'Us'll see what *he*'ll do.'

And Edwin, sheepish, had to comply. He was in pride bound to surpass the apprentice, and did so.

'There!' said Big James. 'What did I tell ye?' He seemed to imply a prophecy that, because Edwin had saved the

The next morning, in the printing office, Edwin came upon Big James giving a lesson in composing to the younger apprentice, who in theory had 'learned his cases'. Big James held the composing stick in his great left hand, like a match-box, and with his great right thumb and index picked letter after letter from the case, very slowly in order to display the movement, and dropped them into the stick. In his mild, resonant tones he explained that each letter must be picked up unfalteringly in a particular way, so that it would drop face upward into the stick without any intermediate manipulation. And he explained also that the left hand must be held so that the right hand would have to travel to and fro as little as possible. He was revealing the basic mysteries of his craft, and was happy, making the while the broad series of stock pleasantries which have probably been current in composing rooms since printing was invented. Then he was silent, working more and more quickly, till his right hand could scarcely be followed in its twinklings, and the face of the apprentice duly spread in marvel. When the line was finished he drew out the rule, clapped it down on the top of the last row of letters, and gave the composing stick to the apprentice to essay.

The apprentice began to compose with his feet, his shoulders, his mouth, his eyebrows—with all his body except his hands, which travelled spaciously far and wide.

'It's not in seven year, nor in seventy, as you'll learn, young sun of a gun!' said Big James.

And, having unsettled the youth to his foundations with a bland thwack across the head, he resumed the composing stick and began again the exposition of the unique smooth movement which is the root of rapid typesetting.

'Here!' said Big James, when the apprentice had behaved

The next morning, in the printing office, Edwin came upon Big James giving a lesson in composing to the younger apprentice, who in theory had 'learned his cases'. Big James held the composing stick in his great left hand, like a match-box, and with his great right thumb and index picked letter after letter from the case, very slowly in order to display the movement, and dropped them into the stick. In his mild, resonant tones he explained that each letter must be picked up unfalteringly in a particular way, so that it would drop face upward into the stick without any intermediate manipulation. And he explained also that the left hand must be held so that the right hand would have to travel to and fro as little as possible. He was revealing the basic mysteries of his craft, and was happy, making the while the broad series of stock pleasantries which have probably been current in composing rooms since printing was invented. Then he was silent, working more and more quickly, till his right hand could scarcely be followed in its twinklings, and the face of the apprentice duly spread in marvel. When the line was finished he drew out the rule, clapped it down on the top of the last row of letters, and gave the composing stick to the apprentice to essay.

The apprentice began to compose with his feet, his shoulders, his mouth, his eyebrows—all his body except his hands, which nevertheless travelled spaciously far and wide.

'It's not in seven year, nor in seventy, as you'll learn, young sun of a gun!' said Big James.

And, having unsettled the youth to his foundations with a bland thwack across the head, he resumed the compos-

LINE SPACING AND STROKE WEIGHT / 6

Bodoni Book, with hairline thins and a very small x-height, creates an extremely nervous overall texture. Despite its small x-height, 1 point of line space (1) is not enough to keep the eye moving horizontally, because of the vertical pull of the ascenders. Adding 2 more points of line space (2) retains the active texture of the page but makes horizontal eye movement easier. Adding still another 2 points (3) gives quite a different effect.

The next morning, in the printing office, Edwin came upon Big James giving a lesson in composing to the younger apprentice, who in theory had 'learned his cases'. Big James held the composing stick in his great left hand, like a match-box, and with his great right thumb and index picked letter after letter from the case, very slowly in order to display the movement, and dropped them into the stick. In his mild, resonant tones he explained that each letter must be picked up unfalteringly in a particular way, so that it would drop face upward into the stick without any intermediate manipulation. And he explained also that the left hand must be held so that the right hand would have to travel to and fro as little as possible. He was revealing the basic mysteries of his craft, and was happy, making the while the broad series of stock pleasantries which have probably been current in composing rooms since printing was invented. Then he was silent, working more and more quickly, till his right hand could scarcely be followed in its twinklings, and the face of the apprentice duly spread in marvel. When the line was finished he drew out the rule, clapped it down on the top of the last row of letters, and gave the composing stick to the apprentice to essay.

The apprentice began to compose with his feet, his shoulders, his mouth, his eyebrows—with all his body except his hands, which nevertheless travelled spaciously far and wide.

'It's not in seven year, nor in seventy, as you'll learn, young sun of a gun!' said Big James.

And, having unsettled the youth to his foundations with a bland thwack across the head, he resumed the composing stick and began again the exposition of the unique smooth movement which is the root of rapid typesetting.

'Here!' said Big James, when the apprentice had behaved worse than ever. 'Us'll ask Mr Edwin to have a go. 'Us'll see what *he*'ll do.'

And Edwin, sheepish, had to comply. He was in pride bound to surpass the apprentice, and did so.

1 10/11 BODONI BOOK

The next morning, in the printing office, Edwin came upon Big James giving a lesson in composing to the younger apprentice, who in theory had 'learned his cases'. Big James held the composing stick in his great left hand, like a match-box, and with his great right thumb and index picked letter after letter from the case, very slowly in order to display the movement, and dropped them into the stick. In his mild, resonant tones he explained that each letter must be picked up unfalteringly in a particular way, so that it would drop face upward into the stick without any intermediate manipulation. And he explained also that the left hand must be held so that the right hand would have to travel to and fro as little as possible. He was revealing the basic mysteries of his craft, and was happy, making the while the broad series of stock pleasantries which have probably been current in composing rooms since printing was invented. Then he was silent, working more and more quickly, till his right hand could scarcely be followed in its twinklings, and the face of the apprentice duly spread in marvel. When the line was finished he drew out the rule, clapped it down on the top of the last row of letters, and gave the composing stick to the apprentice to essay.

The apprentice began to compose with his feet, his shoulders, his mouth, his eyebrows—with all his body except his hands, which nevertheless travelled spaciously far and wide.

'It's not in seven year, nor in seventy, as you'll learn, young sun of a gun!' said Big James.

And, having unsettled the youth to his foundations with a bland thwack across the head, he resumed the composing stick and began again the exposition of the unique smooth move-

The next morning, in the printing office, Edwin came upon Big James giving a lesson in composing to the younger apprentice, who in theory had 'learned his cases'. Big James held the composing stick in his great left hand, like a match-box, and with his great right thumb and index picked letter after letter from the case, very slowly in order to display the movement, and dropped them into the stick. In his mild, resonant tones he explained that each letter must be picked up unfalteringly in a particular way, so that it would drop face upward into the stick without any intermediate manipulation. And he explained also that the left hand must be held so that the right hand would have to travel to and fro as little as possible. He was revealing the basic mysteries of his craft, and was happy, making the while the broad series of stock pleasantries which have probably been current in composing rooms since printing was invented. Then he was silent, working more and more quickly, till his right hand could scarcely be followed in its twinklings, and the face of the apprentice duly spread in marvel. When the line was finished he drew out the rule, clapped it down on the top of the last row of letters, and gave the composing stick to the apprentice to essay.

The apprentice began to compose with his feet, his shoulders, his mouth, his eyebrows—with all his body except his hands, which nevertheless travelled spaciously far and wide.

'It's not in seven year, nor in seventy, as you'll learn, young

COMPARISON OF DIFFERING X-HEIGHTS WITH 2-POINT LINE SPACING

The following spreads show the same line spacing used with faces that have different design characteristics. These faces are the same as those used in the previous spreads and so permit you to see how the same line space with the same line length affects differing x-heights, stroke weights, and thick/thin contrasts.

The examples on this spread offer a comparison of faces with normal (Times Roman), small (Caslon), and large (Bookman) x-heights, each with 2 points of line spacing. Although each is a possible choice for readability, you can see how much more open a small x-height face (2) looks with this line space than one with a large x-height (3).

The next morning, in the printing office, Edwin came upon Big James giving a lesson in composing to the younger apprentice, who in theory had 'learned his cases'. Big James held the composing stick in his great left hand, like a match-box, and with his great right thumb and index picked letter after letter from the case, very slowly in order to display the movement, and dropped them into the stick. In his mild, resonant tones he explained that each letter must be picked up unfalteringly in a particular way, so that it would drop face upward into the stick without any intermediate manipulation. And he explained also that the left hand must be held so that the right hand would have to travel to and fro as little as possible. He was revealing the basic mysteries of his craft, and was happy, making the while the broad series of stock pleasantries which have probably been current in composing rooms since printing was invented. Then he was silent, working more and more quickly, till his right hand could scarcely be followed in its twinklings, and the face of the apprentice duly spread in marvel. When the line was finished he drew out the rule, clapped it down on the top of the last row of letters, and gave the composing stick to the apprentice to essay.

The apprentice began to compose with his feet, his shoulders, his mouth, his eyebrows—with all his body except his hands, which nevertheless travelled spaciously far and wide.

'It's not in seven year, nor in seventy, as you'll learn, young sun of a gun!' said Big James.

And, having unsettled the youth to his foundations with a bland thwack across the head, he resumed the composing stick and began again the exposition of the

1 10/12 TIMES ROMAN

The next morning, in the printing office, Edwin came upon Big James giving a lesson in composing to the younger apprentice, who in theory had 'learned his cases'. Big James held the composing stick in his great left hand, like a match-box, and with his great right thumb and index picked letter after letter from the case, very slowly in order to display the movement, and dropped them into the stick. In his mild, resonant tones he explained that each letter must be picked up unfalteringly in a particular way, so that it would drop face upward into the stick without any intermediate manipulation. And he explained also that the left hand must be held so that the right hand would have to travel to and fro as little as possible. He was revealing the basic mysteries of his craft, and was happy, making the while the broad series of stock pleasantries which have probably been current in composing rooms since printing was invented. Then he was silent, working more and more quickly, till his right hand could scarcely be followed in its twinklings, and the face of the apprentice duly spread in marvel. When the line was finished he drew out the rule, clapped it down on the top of the last row of letters, and gave the composing stick to the apprentice to essay.

The apprentice began to compose with his feet, his shoulders, his mouth, his eyebrows—with all his body except his hands, which nevertheless travelled spaciously far and wide.

'It's not in seven year, nor in seventy, as you'll learn, young sun of a gun!' said Big James.

And, having unsettled the youth to his foundations with a bland thwack across the head, he resumed the composing stick and began again the exposition of the unique smooth movement which is the root of rapid typesetting.

'Here!' said Big James, when the apprentice had behaved worse than ever. 'Us'll ask Mr Edwin to have a go. 'Us'll see

The next morning, in the printing office, Edwin came upon Big James giving a lesson in composing to the younger apprentice, who in theory had 'learned his cases'. Big James held the composing stick in his great left hand, like a match-box, and with his great right thumb and index picked letter after letter from the case, very slowly in order to display the movement, and dropped them into the stick. In his mild, resonant tones he explained that each letter must be picked up unfalteringly in a particular way, so that it would drop face upward into the stick without any intermediate manipulation. And he explained also that the left hand must be held so that the right hand would have to travel to and fro as little as possible. He was revealing the basic mysteries of his craft, and was happy, making the while the broad series of stock pleasantries which have probably been current in composing rooms since printing was invented. Then he was silent, working more and more quickly, till his right hand could scarcely be followed in its twinklings, and the face of the apprentice duly spread in marvel. When the line was finished he drew out the rule, clapped it down on the top of the last row of letters, and gave the composing stick to the apprentice to essay.

The apprentice began to compose with his feet, his shoulders, his mouth, his eyebrows—with all his body except his hands, which nevertheless travelled spaciously far and wide.

'It's not in seven year, nor in seventy, as you'll learn, young sun of a gun!' said Big James.

**COMPARISON OF DIFFERING X-HEIGHTS WITH
4-POINT LINE SPACING**

These examples show the same group of faces used on
the preceding spread, set here with 4-point line spacing.
Bookman, the large x-height face (3) that appeared un-
comfortably large with 2-point line spacing, is now in
better proportion to the space between the lines. Caslon,
the small x-height face (2), looks weak in relation to the
4-point line spacing.

The next morning, in the printing office, Edwin came
upon Big James giving a lesson in composing to the youn-
ger apprentice, who in theory had 'learned his cases'.
Big James held the composing stick in his great left hand,
like a match-box, and with his great right thumb and
index picked letter after letter from the case, very slowly
in order to display the movement, and dropped them into
the stick. In his mild, resonant tones he explained that
each letter must be picked up unfalteringly in a particular
way, so that it would drop face upward into the stick
without any intermediate manipulation. And he ex-
plained also that the left hand must be held so that the
right hand would have to travel to and fro as little as pos-
sible. He was revealing the basic mysteries of his craft,
and was happy, making the while the broad series of
stock pleasantries which have probably been current in
composing rooms since printing was invented. Then he
was silent, working more and more quickly, till his right
hand could scarcely be followed in its twinklings, and
the face of the apprentice duly spread in marvel. When
the line was finished he drew out the rule, clapped it
down on the top of the last row of letters, and gave the
composing stick to the apprentice to essay.

The apprentice began to compose with his feet, his
shoulders, his mouth, his eyebrows—with all his body
except his hands, which nevertheless travelled spaciously
far and wide.

1 **10/14 TIMES ROMAN**

The next morning, in the printing office, Edwin came upon Big James giving a lesson in composing to the younger apprentice, who in theory had 'learned his cases'. Big James held the composing stick in his great left hand, like a match-box, and with his great right thumb and index picked letter after letter from the case, very slowly in order to display the movement, and dropped them into the stick. In his mild, resonant tones he explained that each letter must be picked up unfalteringly in a particular way, so that it would drop face upward into the stick without any intermediate manipulation. And he explained also that the left hand must be held so that the right hand would have to travel to and fro as little as possible. He was revealing the basic mysteries of his craft, and was happy, making the while the broad series of stock pleasantries which have probably been current in composing rooms since printing was invented. Then he was silent, working more and more quickly, till his right hand could scarcely be followed in its twinklings, and the face of the apprentice duly spread in marvel. When the line was finished he drew out the rule, clapped it down on the top of the last row of letters, and gave the composing stick to the apprentice to essay.

The apprentice began to compose with his feet, his shoulders, his mouth, his eyebrows—with all his body except his hands, which nevertheless travelled spaciously far and wide.

'It's not in seven year, nor in seventy, as you'll learn, young sun of a gun!' said Big James.

And, having unsettled the youth to his foundations with a

The next morning, in the printing office, Edwin came upon Big James giving a lesson in composing to the younger apprentice, who in theory had 'learned his cases'. Big James held the composing stick in his great left hand, like a match-box, and with his great right thumb and index picked letter after letter from the case, very slowly in order to display the movement, and dropped them into the stick. In his mild, resonant tones he explained that each letter must be picked up unfalteringly in a particular way, so that it would drop face upward into the stick without any intermediate manipulation. And he explained also that the left hand must be held so that the right hand would have to travel to and fro as little as possible. He was revealing the basic mysteries of his craft, and was happy, making the while the broad series of stock pleasantries which have probably been current in composing rooms since printing was invented. Then he was silent, working more and more quickly, till his right hand could scarcely be followed in its twinklings, and the face of the apprentice duly spread in marvel. When the line was finished he drew out the rule, clapped it down on the top of the last row of letters, and gave the composing stick to the apprentice to essay.

The apprentice began to compose with his feet,

COMPARISON OF DIFFERING STROKE WEIGHTS
WITH 2-POINT LINE SPACING

These examples compare the appearance of faces with normal (Baskerville), light (Helvetica Thin), and heavy (Palatino Bold) stroke weights set with 2-point line spacing. Even with the same amount of space between the lines, the overall color is very different. A heavy face like Palatino Bold set with 2-point line spacing would be too dark for prolonged reading unless there were very few lines on the page and very large margins. Baskerville and the much lighter Helvetica Thin have very different overall textures. Because of the large x-height of 2, the texture is fairly dense, even though the stroke weight is very light.

The next morning, in the printing office, Edwin came upon Big James giving a lesson in composing to the younger apprentice, who in theory had 'learned his cases'. Big James held the composing stick in his great left hand, like a match-box, and with his great right thumb and index picked letter after letter from the case, very slowly in order to display the movement, and dropped them into the stick. In his mild, resonant tones he explained that each letter must be picked up unfalteringly in a particular way, so that it would drop face upward into the stick without any intermediate manipulation. And he explained also that the left hand must be held so that the right hand would have to travel to and fro as little as possible. He was revealing the basic mysteries of his craft, and was happy, making the while the broad series of stock pleasantries which have probably been current in composing rooms since printing was invented. Then he was silent, working more and more quickly, till his right hand could scarcely be followed in its twinklings, and the face of the apprentice duly spread in marvel. When the line was finished he drew out the rule, clapped it down on the top of the last row of letters, and gave the composing stick to the apprentice to essay.

The apprentice began to compose with his feet, his shoulders, his mouth, his eyebrows—with all his body except his hands, which nevertheless travelled spaciously far and wide.

'It's not in seven year, nor in seventy, as you'll learn, young son of a gun!' said Big James.

And, having unsettled the youth to his foundations with a bland thwack across the head, he resumed the

The next morning, in the printing office, Edwin came upon Big James giving a lesson in composing to the younger apprentice, who in theory had 'learned his cases'. Big James held the composing stick in his great left hand, like a match-box, and with his great right thumb and index picked letter after letter from the case, very slowly in order to display the movement, and dropped them into the stick. In his mild, resonant tones he explained that each letter must be picked up unfalteringly in a particular way, so that it would drop face upward into the stick without any intermediate manipulation. And he explained also that the left hand must be held so that the right hand would have to travel to and fro as little as possible. He was revealing the basic mysteries of his craft, and was happy, making the while the broad series of stock pleasantries which have probably been current in composing rooms since printing was invented. Then he was silent, working more and more quickly, till his right hand could scarcely be followed in its twinklings, and the face of the apprentice duly spread in marvel. When the line was finished he drew out the rule, clapped it down on the top of the last row of letters, and gave the composing stick to the apprentice to essay.

The apprentice began to compose with his feet, his shoulders, his mouth, his eyebrows—with all his body except his hands, which nevertheless travelled spaciously far and wide.

'It's not in seven year, nor in seventy, as you'll learn, young sun of a gun!' said Big James.

And, having unsettled the youth to his foundations with a bland thwack across the head, he resumed the composing stick and began again the exposition of the unique smooth movement which is the root of rapid typesetting.

The next morning, in the printing office, Edwin came upon Big James giving a lesson in composing to the younger apprentice, who in theory had 'learned his cases'. Big James held the composing stick in his great left hand, like a match-box, and with his great right thumb and index picked letter after letter from the case, very slowly in order to display the movement, and dropped them into the stick. In his mild, resonant tones he explained that each letter must be picked up unfalteringly in a particular way, so that it would drop face upward into the stick without any intermediate manipulation. And he explained also that the left hand must be held so that the right hand would have to travel to and fro as little as possible. He was revealing the basic mysteries of his craft, and was happy, making the while the broad series of stock pleasantries which have probably been current in composing rooms since printing was invented. Then he was silent, working more and more quickly, till his right hand could scarcely be followed in its twinklings, and the face of the apprentice duly spread in marvel. When the line was finished he drew out the rule, clapped it down on the top of the last row of letters, and gave the composing stick to the apprentice to essay.

The apprentice began to compose with his feet, his shoulders, his mouth, his eyebrows—with all his body except his hands, which nevertheless travelled spaciously far and wide.

'It's not in seven year, nor in seventy, as you'll learn, young sun of a gun!' said Big James.

And, having unsettled the youth to his foundations

**COMPARISON OF DIFFERING STROKE WEIGHTS WITH
4-POINT LINE SPACING**

The same faces used on the preceding spread are set here with 4-point line spacing. Note how a heavy face like Palatino Bold (3) can be lightened in overall appearance by additional line spacing. Note also how much lighter a face with a light and even stroke weight like Helvetica Thin (2) becomes. As usual, Baskerville, a face of medium stroke weight and x-height (1), works well in a greater variety of settings.

The next morning, in the printing office, Edwin came upon Big James giving a lesson in composing to the younger apprentice, who in theory had 'learned his cases'. Big James held the composing stick in his great left hand, like a match-box, and with his great right thumb and index picked letter after letter from the case, very slowly in order to display the movement, and dropped them into the stick. In his mild, resonant tones he explained that each letter must be picked up unfalteringly in a particular way, so that it would drop face upward into the stick without any intermediate manipulation. And he explained also that the left hand must be held so that the right hand would have to travel to and fro as little as possible. He was revealing the basic mysteries of his craft, and was happy, making the while the broad series of stock pleasantries which have probably been current in composing rooms since printing was invented. Then he was silent, working more and more quickly, till his right hand could scarcely be followed in its twinklings, and the face of the apprentice duly spread in marvel. When the line was finished he drew out the rule, clapped it down on the top of the last row of letters, and gave the composing stick to the apprentice to essay.

The apprentice began to compose with his feet, his shoulders, his mouth, his eyebrows—with all his body except his hands, which nevertheless travelled spa-

1 10/14 BASKERVILLE

The next morning, in the printing office, Edwin came upon Big James giving a lesson in composing to the younger apprentice, who in theory had 'learned his cases'. Big James held the composing stick in his great left hand, like a match-box, and with his great right thumb and index picked letter after letter from the case, slowly in order to display the movement, and dropped them into the stick. In his mild, resonant tones he explained that each letter must be picked up unfalteringly in a particular way, so that it would drop face upward into the stick without any intermediate manipulation. And he explained also that the left hand must be held so that the right hand would have to travel to and fro as little as possible. He was revealing the basic mysteries of his craft, and was happy, making the while the broad series of stock pleasantries which have probably been current in composing rooms since printing was invented. Then he was silent, working more and more quickly, till his right hand could scarcely be followed in its twinklings, and the face of the apprentice duly spread in marvel. When the line was finished he drew out the rule, clapped it down on the top of the last row of letters, and gave the composing stick to the apprentice to essay.

The apprentice began to compose with his feet, his shoulders, his mouth, his eyebrows—with all his body except his hands, which nevertheless travelled spaciously far and wide.

'It's not in seven year, nor in seventy, as you'll learn, young

The next morning, in the printing office, Edwin came upon Big James giving a lesson in composing to the younger apprentice, who in theory had 'learned his cases'. Big James held the composing stick in his great left hand, like a match-box, and with his great right thumb and index picked letter after letter from the case, very slowly in order to display the movement, and dropped them into the stick. In his mild, resonant tones he explained that each letter must be picked up unfalteringly in a particular way, so that it would drop face upward into the stick without any intermediate manipulation. And he explained also that the left hand must be held so that the right hand would have to travel to and fro as little as possible. He was revealing the basic mysteries of his craft, and was happy, making the while the broad series of stock pleasantries which have probably been current in composing rooms since printing was invented. Then he was silent, working more and more quickly, till his right hand could scarcely be followed in its twinklings, and the face of the apprentice duly spread in marvel. When the line was finished he drew out the rule, clapped it down on the top of the last row of letters, and gave the composing stick to the apprentice to essay.

The apprentice began to compose with his feet, his shoulders, his mouth, his eyebrows—with all his

COMPARISON OF FACES WITH DIFFERING THICK/THIN
CONTRASTS WITH 2-POINT LINE SPACING

These examples show very slight (Souvenir), normal (Century Old Style), and extreme (Walbaum) thick/thin contrasts set with 2-point line spacing. Both the activity of the texture of 3 and the evenness of the texture of 1 are very pronounced using 2 points of line spacing.

The next morning, in the printing office, Edwin came upon Big James giving a lesson in composing to the younger apprentice, who in theory had 'learned his cases'. Big James held the composing stick in his great left hand, like a match-box, and with his great right thumb and index picked letter after letter from the case, very slowly in order to display the movement, and dropped them into the stick. In his mild, resonant tones he explained that each letter must be picked up unfalteringly in a particular way, so that it would drop face upward into the stick without any intermediate manipulation. And he explained also that the left hand must be held so that the right hand would have to travel to and fro as little as possible. He was revealing the basic mysteries of his craft, and was happy, making the while the broad series of stock pleasantries which have probably been current in composing rooms since printing was invented. Then he was silent, working more and more quickly, till his right hand could scarcely be followed in its twinklings, and the face of the apprentice duly spread in marvel. When the line was finished he drew out the rule, clapped it down on the top of the last row of letters, and gave the composing stick to the apprentice to essay.

The apprentice began to compose with his feet, his shoulders, his mouth, his eyebrows—with all his body except his hands, which nevertheless travelled spaciously far and wide.

'It's not in seven year, nor in seventy, as you'll learn, young sun of a gun!' said Big James.

And, having unsettled the youth to his foundations with a bland thwack across the head, he resumed the composing stick and began again the exposition of the unique smooth movement which is the root of rapid typesetting.

1 10/12 SOUVENIR

The next morning, in the printing office, Edwin came upon Big James giving a lesson in composing to the younger apprentice, who in theory had 'learned his cases'. Big James held the composing stick in his great left hand, like a match-box, and with his great right thumb and index picked letter after letter from the case, very slowly in order to display the movement, and dropped them into the stick. In his mild, resonant tones he explained that each letter must be picked up unfalteringly in a particular way, so that it would drop face upward into the stick without any intermediate manipulation. And he explained also that the left hand must be held so that the right hand would have to travel to and fro as little as possible. He was revealing the basic mysteries of his craft, and was happy, making the while the broad series of stock pleasantries which have probably been current in composing rooms since printing was invented. Then he was silent, working more and more quickly, till his right hand could scarcely be followed in its twinklings, and the face of the apprentice duly spread in marvel. When the line was finished he drew out the rule, clapped it down on the top of the last row of letters, and gave the composing stick to the apprentice to essay.

The apprentice began to compose with his feet, his shoulders, his mouth, his eyebrows—with all his body except his hands, which nevertheless travelled spaciously far and wide.

'It's not in seven year, nor in seventy, as you'll learn, young sun of a gun!' said Big James.

And, having unsettled the youth to his foundations with a bland thwack across the head, he resumed the composing stick and began again the exposition of the unique smooth movement which is the root of rapid typesetting.

'Here!' said Big James, when the apprentice had behaved

The next morning, in the printing office, Edwin came upon Big James giving a lesson in composing to the younger apprentice, who in theory had 'learned his cases'. Big James held the composing stick in his great left hand, like a match-box, and with his great right thumb and index picked letter after letter from the case, very slowly in order to display the movement, and dropped them into the stick. In his mild, resonant tones he explained that each letter must be picked up unfalteringly in a particular way, so that it would drop face upward into the stick without any intermediate manipulation. And he explained also that the left hand must be held so that the right hand would have to travel to and fro as little as possible. He was revealing the basic mysteries of his craft, and was happy, making the while the broad series of stock pleasantries which have probably been current in composing rooms since printing was invented. Then he was silent, working more and more quickly, till his right hand could scarcely be followed in its twinklings, and the face of the apprentice duly spread in marvel. When the line was finished he drew out the rule, clapped it down on the top of the last row of letters, and gave the composing stick to the apprentice to essay.

The apprentice began to compose with his feet, his shoulders, his mouth, his eyebrows—with all his body except his hands, which nevertheless travelled spaciously far and wide.

'It's not in seven year, nor in seventy, as you'll learn, young sun of a gun!' said Big James.

And, having unsettled the youth to his foundations with a bland thwack across the head, he resumed the

COMPARISON OF FACES WITH DIFFERING THICK/THIN CONTRASTS WITH 4-POINT LINE SPACING

Additional line space de-emphasizes the activity of a highly contrasted face like 3 and, at the same time, gives a bit more activity to a low-contrast face like 1. Again, the face with medium contrast (2) looks good in both settings.

The next morning, in the printing office, Edwin came upon Big James giving a lesson in composing to the younger apprentice, who in theory had 'learned his cases'. Big James held the composing stick in his great left hand, like a match-box, and with his great right thumb and index picked letter after letter from the case, very slowly in order to display the movement, and dropped them into the stick. In his mild, resonant tones he explained that each letter must be picked up unfalteringly in a particular way, so that it would drop face upward into the stick without any intermediate manipulation. And he explained also that the left hand must be held so that the right hand would have to travel to and fro as little as possible. He was revealing the basic mysteries of his craft, and was happy, making the while the broad series of stock pleasantries which have probably been current in composing rooms since printing was invented. Then he was silent, working more and more quickly, till his right hand could scarcely be followed in its twinklings, and the face of the apprentice duly spread in marvel. When the line was finished he drew out the rule, clapped it down on the top of the last row of letters, and gave the composing stick to the apprentice to essay.

The apprentice began to compose with his feet, his shoulders, his mouth, his eyebrows—with all his body except his hands, which nevertheless travelled spaciously far and wide.

'It's not in seven year, nor in seventy, as you'll learn,

The next morning, in the printing office, Edwin came upon Big James giving a lesson in composing to the younger apprentice, who in theory had 'learned his cases'. Big James held the composing stick in his great left hand, like a match-box, and with his great right thumb and index picked letter after letter from the case, very slowly in order to display the movement, and dropped them into the stick. In his mild, resonant tones he explained that each letter must be picked up unfalteringly in a particular way, so that it would drop face upward into the stick without any intermediate manipulation. And he explained also that the left hand must be held so that the right hand would have to travel to and fro as little as possible. He was revealing the basic mysteries of his craft, and was happy, making the while the broad series of stock pleasantries which have probably been current in composing rooms since printing was invented. Then he was silent, working more and more quickly, till his right hand could scarcely be followed in its twinklings, and the face of the apprentice duly spread in marvel. When the line was finished he drew out the rule, clapped it down on the top of the last row of letters, and gave the composing stick to the apprentice to essay.

The apprentice began to compose with his feet, his shoulders, his mouth, his eyebrows—with all his body except his hands, which nevertheless travelled spaciously far and wide.

'It's not in seven year, nor in seventy, as you'll learn, young sun of a gun!' said Big James.

The next morning, in the printing office, Edwin came upon Big James giving a lesson in composing to the younger apprentice, who in theory had 'learned his cases'. Big James held the composing stick in his great left hand, like a match-box, and with his great right thumb and index picked letter after letter from the case, very slowly in order to display the movement, and dropped them into the stick. In his mild, resonant tones he explained that each letter must be picked up unfalteringly in a particular way, so that it would drop face upward into the stick without any intermediate manipulation. And he explained also that the left hand must be held so that the right hand would have to travel to and fro as little as possible. He was revealing the basic mysteries of his craft, and was happy, making the while the broad series of stock pleasantries which have probably been current in composing rooms since printing was invented. Then he was silent, working more and more quickly, till his right hand could scarcely be followed in its twinklings, and the face of the apprentice duly spread in marvel. When the line was finished he drew out the rule, clapped it down on the top of the last row of letters, and gave the composing stick to the apprentice to essay.

The apprentice began to compose with his feet, his shoulders, his mouth, his eyebrows—with all his

The two criteria by which we judge good word spacing are the "rightness" of the average space between words and the apparent consistency of this space overall. The first of these, the optimum amount of space between words, is to some degree a matter of judgment and typographic style. However, in every instance there must be enough space between words so that they can be distinguished as words but not so much space that they fail to combine smoothly into sentences and paragraphs.

Achieving a consistent overall texture means that the spaces between words should appear equal, with no big holes caused by very large spaces placed between the words and no dark blotches caused by words being too crowded together. In justified type equal space is necessarily an illusion. Since characters have different widths and lines have different numbers of words, the amount of extra space distributed between words is necessarily varied to make the lines end equally. The typesetting system must provide for sufficient variation in the spaces between words so that lines can be justified without excessive hyphenation but not so much variation that the spaces between words differ obviously from line to

WORD SPACING AND TYPE COLOR

line. In unjustified type the word spacing can be equal. However, unjustified type presents its own set of problems, which will be explored in Chapter 7.

In all computer typesetting systems, the decision about how much space to leave for distribution between words is made in a process called hyphenation-and-justification or h-and-j. The process works something like this. Upper and lower limits for the amount of space allowable between words are assigned. Then, as each character is input by the type-setter, the computer keeps track of the line's accumulating unit width (see Chapter 1). When the number of units approaches the total number of units allowed (called the justification range), the program attempts to distribute the remaining units within the predetermined limits. If the amount of available space is too great, the computer will try to stay within these limits by adding a word or part of a word on the line by hyphenation. If there is too little space, the computer will carry over a word or part of a word. Depending on the sophistication of the system, the computer will try more or fewer alternatives.

The allowable amounts of space are called the spacing defines, spacing parameters, or sometimes even spacebands, although, like leading, this term refers to an obsolete technology. The typographer, not the designer, normally decides what word-spacing defines to use, since the typographer is most familiar with his or her own equipment and programs. However, the designer should be sensitive to setting that is too tight, too loose, or too uneven and should communicate this criticism to the typesetter if the type is not up to standard. Sometimes the designer's own specifications will make good word spacing impossible, as when a too-large face is set on a too-narrow measure. Usually changes in the defines can improve the result.

In the following pages we will look at type set with different spacing parameters. Since even word spacing is more difficult to achieve on a narrow measure, most of these samples are set on a 15-pica width to exaggerate the results. Occasionally, a bit of space between letters is added or removed in order to keep within the required word-spacing parameters. This is a normal typesetting procedure. Equally important, we will see how the design of the typeface itself determines how much space looks right between words.

WORD SPACING WITH A FACE OF NORMAL PROPORTIONS

These examples have been set in Times Roman with the following minimum and maximum allowable space between words (spacing defines): 3-5 units (1); 4-6 units (2), 4-8 units (3), and 4-10 units (4). Hold the page just beyond reading distance and notice the change in overall density of the type mass. Hold the page still a little farther away and squint your eyes slightly. You will be able to see any unevenness of texture, especially any large white areas or streaks. Then read each sample and see which you feel seems most comfortable.

Example 1 is set with very small allowable space and very small space variation permitted and so has an extremely tight and even texture. Some designers like this tightly interwoven look, but in lines in which the minimum is used, individual words become difficult to distinguish. The best typographer I know says firmly, "Three units is not a word space."

In examples 2, 3, and 4, the minimum space is the same (4 points) but the maximum space is increased. You can see how much more irregular the word spacing is in 4 than in 2 and how the example changes in its overall color. Several lines are so widely spaced that the feeling of consecutive reading is lost. One consequence of greater permissible variation is that there are fewer hyphens. The copy in 4 has five hyphens only; 2 and 3 have eight and seven hyphens respectively. Another consequence is the difference greater word space can make in length. The long paragraph in 3 and 4 sets one line longer than the same paragraph in 1 and 2.

For a normally proportioned face like Times Roman, 4-6 units (2) or 4-8 units (3) result in even, readable settings, even in a narrow measure. The example in 3 might be slightly more readable, although 2 is a little more even overall.

The next morning, in the printing office, Edwin came upon Big James giving a lesson in composing to the younger apprentice, who in theory had 'learned his cases'. Big James held the composing stick in his great left hand, like a match-box, and with his great right thumb and index picked letter after letter from the case, very slowly in order to display the movement, and dropped them into the stick. In his mild, resonant tones he explained that each letter must be picked up unfalteringly in a particular way, so that it would drop face upward into the stick without any intermediate manipulation. And he explained also that the left hand must be held so that the right hand would have to travel to and fro as little as possible. He was revealing the basic mysteries of his craft, and was happy, making the while the broad series of stock pleasantries which have probably been current in composing rooms since printing was invented. Then he was silent, working more and more quickly, till his right hand could scarcely be followed in its twinklings, and the face of the apprentice duly spread in marvel. When the line was finished he drew out the rule, clapped it down on the top of the last row of letters, and gave the composing stick to the apprentice to essay.

The apprentice began to compose with his feet, his shoulders, his mouth, his eye-

1 10/12 TIMES ROMAN: 3-5 UNITS

The next morning, in the printing office, Edwin came upon Big James giving a lesson in composing to the younger apprentice, who in theory had 'learned his cases'. Big James held the composing stick in his great left hand, like a match-box, and with his great right thumb and index picked letter after letter from the case, in order to display movement, and dropped them into the stick. In his mild, resonant tones he explained that each letter must be picked up unfalteringly in a particular way, so that it would drop face upward into the stick without any intermediate manipulation. And he explained also that the left hand must be held so that the right hand would have to travel to and fro as little as possible. He was revealing the basic mysteries of his craft, and was happy, making the while the broad series of stock pleasantries which have probably been current in composing rooms since printing was invented. Then he was silent, working quickly, till his right hand could scarcely be followed in its twinklings, and the face of the apprentice duly spread in marvel. When the line was finished he drew out the rule, clapped it down on the top of the last row of letters, and gave the composing stick to the apprentice to essay.

The apprentice began to compose with his feet, his shoulders, his mouth, his eye-

The next morning, in the printing office, Edwin came upon Big James giving a lesson in composing to the younger apprentice, who in theory had 'learned his cases'. Big James held the composing stick in his great left hand, like a match-box, and with his great right thumb and index picked letter after letter from the case, very slowly in order to display the movement, and dropped them into the stick. In his mild, resonant tones he explained that each letter must be picked up unfalteringly in a particular way, so that it would drop face upward into the stick without any intermediate manipulation. And he explained also that the left hand must be held so that the right hand would have to travel to and fro as little as possible. He was revealing the basic mysteries of his craft, and was happy, making the while the broad series of stock pleasantries which have probably been current in composing rooms since printing was invented. Then he was silent, working more and more quickly, till his right hand could scarcely be followed in its twinklings, and the face of the apprentice duly spread in marvel. When the line was finished he drew out the rule, clapped it down on the top of the last row of letters, and gave the composing stick to the apprentice to essay.

The apprentice began to compose with

The next morning, in the printing office, Edwin came upon Big James giving a lesson in composing to the younger apprentice, who in theory had 'learned his cases'. Big James held the composing stick in his great left hand, like a match-box, and with his great right thumb and index picked letter after letter from the case, very slowly in order to display the movement, and dropped them into the stick. In his mild, resonant tones he explained that each letter must be picked up unfalteringly in a particular way, so that it would drop face upward into the stick without any intermediate manipulation. And he explained also that the left hand must be held so that the right hand would have to travel to and fro as little as possible. He was revealing the basic mysteries of his craft, and was happy, making the while the broad series of stock pleasantries which have probably been current in composing rooms since printing was invented. Then he was silent, working more and more quickly, till his right hand could scarcely be followed in its twinklings, and the face of the apprentice duly spread in marvel. When the line was finished he drew out the rule, clapped it down on the top of the last row of letters, and gave the composing stick to the apprentice to essay.

The apprentice began to compose with

WORD SPACING WITH A CONDENSED FACE

Here a condensed face is set using the same spacing defines as those used on the preceding spread. Because both the internal spaces of the letters and the spaces between the letters are so small, the example using 4-8 units (3), which looked fine with a normal face, looks too widely spaced here. Example 1 (3-5 units), which looked very tight in Times Roman, looks normal here. However, note that even though the overall texture may look good, there are some unacceptably tight individual lines (for example, lines 9, 10, and 12).

The next morning, in the printing office, Edwin came upon Big James giving a lesson in composing to the younger apprentice, who in theory had 'learned his cases'. Big James held the composing stick in his great left hand, like a match-box, and with his great right thumb and index picked letter after letter from the case, very slowly in order to display the movement, and dropped them into the stick. In his mild, resonant tones he explained that each letter must be picked up unfalteringly in a particular way, so that it would drop face upward into the stick without any intermediate manipulation. And he explained also that the left hand must be held so that the right hand would have to travel to and fro as little as possible. He was revealing the basic mysteries of his craft, and was happy, making the while the broad series of stock pleasantries which have probably been current in composing rooms since printing was invented. Then he was silent, working more and more quickly, till his right hand could scarcely be followed in its twinklings, and the face of the apprentice duly spread in marvel. When the line was finished he drew out the rule, clapped it down on the top of the last row of letters, and gave the composing stick to the apprentice to essay.

The apprentice began to compose with his feet, his shoulders, his mouth, his eyebrows—with all his body except his hands, which nevertheless travelled spaciously far and wide.

'It's not in seven year, nor in seventy, as you'll learn, young sun of a gun!' said Big James.

And, having unsettled the youth to his foundations with a bland thwack across the head, he resumed the

1 10/12 CENTURY CONDENSED BOOK: 3-5 UNITS

The next morning, in the printing office, Edwin came upon Big James giving a lesson in composing to the younger apprentice, who in theory had 'learned his cases'. Big James held the composing stick in his great left hand, like a match-box, and with his great right thumb and index picked letter after letter from the case, very slowly in order to display the movement, and dropped them into the stick. In his mild, resonant tones he explained that each letter must be picked up unfalteringly in a particular way, so that it would drop face upward into the stick without any intermediate manipulation. And he explained also that the left hand must be held so that the right hand would have to travel to and fro as little as possible. He was revealing the basic mysteries of his craft, and was happy, making the while the broad series of stock pleasantries which have probably been current in composing rooms since printing was invented. Then he was silent, working more and more quickly, till his right hand could scarcely be followed in its twinklings, and the face of the apprentice duly spread in marvel. When the line was finished he drew out the rule, clapped it down on the top of the last row of letters, and gave the composing stick to the apprentice to essay.

The apprentice began to compose with his feet, his shoulders, his mouth, his eyebrows—with all his body except his hands, which nevertheless travelled spaciously far and wide.

'It's not in seven year, nor in seventy, as you'll learn, young sun of a gun!' said Big James.

And, having unsettled the youth to his foundations

The next morning, in the printing office, Edwin came upon Big James giving a lesson in composing to the younger apprentice, who in theory had 'learned his cases'. Big James held the composing stick in his great left hand, like a match-box, and with his great right thumb and index picked letter after letter from the case, very slowly in order to display the movement, and dropped them into the stick. In his mild, resonant tones he explained that each letter must be picked up unfalteringly in a particular way, so that it would drop face upward into the stick without any intermediate manipulation. And he explained also that the left hand must be held so that the right hand would have to travel to and fro as little as possible. He was revealing the basic mysteries of his craft, and was happy, making the while the broad series of stock pleasantries which have probably been current in composing rooms since printing was invented. Then he was silent, working more and more quickly, till his right hand could scarcely be followed in its twinklings, and the face of the apprentice duly spread in marvel. When the line was finished he drew out the rule, clapped it down on the top of the last row of letters, and gave the composing stick to the apprentice to essay.

The apprentice began to compose with his feet, his shoulders, his mouth, his eyebrows—with all his body except his hands, which nevertheless travelled spaciously far and wide.

'It's not in seven year, nor in seventy, as you'll learn, young sun of a gun!' said Big James.

And, having unsettled the youth to his founda-

The next morning, in the printing office, Edwin came upon Big James giving a lesson in composing to the younger apprentice, who in theory had 'learned his cases'. Big James held the composing stick in his great left hand, like a match-box, and with his great right thumb and index picked letter after letter from the case, very slowly in order to display the movement, and dropped them into the stick. In his mild, resonant tones he explained that each letter must be picked up unfalteringly in a particular way, so that it would drop face upward into the stick without any intermediate manipulation. And he explained also that the left hand must be held so that the right hand would have to travel to and fro as little as possible. He was revealing the basic mysteries of his craft, and was happy, making the while the broad series of stock pleasantries which have probably been current in composing rooms since printing was invented. Then he was silent, working more and more quickly, till his right hand could scarcely be followed in its twinklings, and the face of the apprentice duly spread in marvel. When the line was finished he drew out the rule, clapped it down on the top of the last row of letters, and gave the composing stick to the apprentice to essay.

The apprentice began to compose with his feet, his shoulders, his mouth, his eyebrows—with all his body except his hands, which nevertheless travelled spaciously far and wide.

'It's not in seven year, nor in seventy, as you'll learn, young sun of a gun!' said Big James.

And, having unsettled the youth to his founda-

WORD SPACING WITH AN EXPANDED FACE

Here the same spacing defines are used again, but with Clarendon, a very expanded face. Because so few characters fit on a line of this measure, many lines were impossible to justify without either adding or removing space between the letters. Even in 4, with 4-10 unit defines, one line requires letterspacing. Changing letterspacing from line to line creates an uneven overall color.

Because of the very large internal spaces in this face, a good amount of space between words is necessary so that they do not appear to run together. Both 1 and 2 appear to have only as much space between the words as inside them, making them hard to read. Using 4-8 units defines the words in 3 quite well. Looking carefully at 4 and evaluating the most widely spaced lines, we might decide that 6-10 units (less variation but a larger amount of space) might work best.

The next morning, in the printing office. Edwin came upon Big James giving a lesson in composing to the younger apprentice, who in theory had 'learned his cases'. Big James held the composing stick in his great left hand, like a match-box, and with his great right thumb and index picked letter after letter from the case, very slowly in order to display the movement, and dropped them into the stick. In his mild, resonant tones he explained that each letter must be picked up unfalteringly in a particular way, so that it would drop face upward into the stick without any intermediate manipulation. And he explained also that the left hand must be held so that the right hand would have to travel to and fro as little as possible. He was revealing the basic mysteries of his craft, and was happy, making the while the broad series of stock pleasantries which have probably been current in composing rooms since printing was invented. Then he was silent, working more and more quickly, till his right hand could scarcely be followed in its twinklings, and the face of the apprentice duly spread in marvel. When the line was finished he drew out the rule, clapped it down on the top of the last row of let-

The next morning, in the printing office, Edwin came upon Big James giving a lesson in composing to the younger apprentice, who in theory had 'learned his cases'. Big James held the composing stick in his great left hand, like a match-box, and with his great right thumb and index picked letter after letter from the case, very slowly in order to display the movement, and dropped them into the stick. In his mild, resonant tones he explained that each letter must be picked up unfalteringly in a particular way, so that it would drop face upward into the stick without any intermediate manipulation. And he explained also that the left hand must be held so that the right hand would have to travel to and fro as little as possible. He was revealing the basic mysteries of his craft, and was happy, making the while the broad series of stock pleasantries which have probably been current in composing rooms since printing was invented. Then he was silent, working more and more quickly, till his right hand could scarcely be followed in its twinklings, and the face of the apprentice duly spread in marvel. When the line was finished he drew out the rule, clapped

The next morning, in the printing office, Edwin came upon Big James giving a lesson in composing to the younger apprentice, who in theory had 'learned his cases'. Big James held the composing stick in his great left hand, like a match-box, and with his great right thumb and index picked letter after letter from the case, very slowly in order to display the movement, and dropped them into the stick. In his mild, resonant tones he explained that each letter must be picked up unfalteringly in a particular way, so that it would drop face upward into the stick without any intermediate manipulation. And he explained also that the left hand must be held so that the right hand would have to travel to and fro as little as possible. He was revealing the basic mysteries of his craft, and was happy, making the while the broad series of stock pleasantries which have probably been current in composing rooms since printing was invented. Then he was silent, working more and more quickly, till his right hand could scarcely be followed in its twinklings, and the face of the apprentice duly spread in marvel. When the line was finished he drew out the rule, clapped

The next morning, in the printing office, Edwin came upon Big James giving a lesson in composing to the younger apprentice, who in theory had 'learned his cases'. Big James held the composing stick in his great left hand, like a match-box, and with his great right thumb and index picked letter after letter from the case, very slowly in order to display the movement, and dropped them into the stick. In his mild, resonant tones he explained that each letter must be picked up unfalteringly in a particular way, so that it would drop face upward into the stick without any intermediate manipulation. And he explained also that the left hand must be held so that the right hand would have to travel to and fro as little as possible. He was revealing the basic mysteries of his craft, and was happy, making the while the broad series of stock pleasantries which have probably been current in composing rooms since printing was invented. Then he was silent, working more and more quickly, till his right hand could scarcely be followed in its twinklings, and the face of the apprentice duly spread in marvel. When the line was finished

EXCESSIVELY WIDE SPACING DEFINES

These examples show the unevenness of overall color that results from too great a variation in permissible word spacing, even on a wider measure. The example in 1 shows defines of 6-10; 2 shows 6-14; and 3 shows 6 with no upper limit. Looking at these from beyond reading distance, you will see that the overall density of the page is irregular. This much variation in word spacing is unacceptable in professional typesetting.

The next morning, in the printing office, Edwin came upon Big James giving a lesson in composing to the younger apprentice, who in theory had 'learned his cases'. Big James held the composing stick in his great left hand, like a match-box, and with his great right thumb and index picked letter after letter from the case, very slowly in order to display the movement, and dropped them into the stick. In his mild, resonant tones he explained that each letter must be picked up unfalteringly in a particular way, so that it would drop face upward into the stick without any intermediate manipulation. And he explained also that the left hand must be held so that the right hand would have to travel to and fro as little as possible. He was revealing the basic mysteries of his craft, and was happy, making the while the broad series of stock pleasantries which have probably been current in composing rooms since printing was invented. Then he was silent, working more and more quickly, till his right hand could scarcely be followed in its twinklings, and the face of the apprentice duly spread in marvel. When the line was finished he drew out the rule, clapped it down on the top of the last row of letters, and gave the composing stick to the apprentice to essay.

The apprentice began to compose with his feet, his shoulders, his mouth, his eyebrows—with all his body except his hands, which nevertheless travelled spaciously far and wide.

'It's not in seven year, nor in seventy, as you'll learn, young sun of a gun!' said Big James.

And, having unsettled the youth to his foundations with a bland thwack across the head, he resumed the

1 10/12 TIMES ROMAN: 6-10 UNITS

The next morning, in the printing office, Edwin came upon Big James giving a lesson in composing to the younger apprentice, who in theory had 'learned his cases'. Big James held the composing stick in his great left hand, like a match-box, and with his great right thumb and index picked letter after letter from the case, very slowly in order to display the movement, and dropped them into the stick. In his mild, resonant tones he explained that each letter must be picked up unfalteringly in a particular way, so that it would drop face upward into the stick without any intermediate manipulation. And he explained also that the left hand must be held so that the right hand would have to travel to and fro as little as possible. He was revealing the basic mysteries of his craft, and was happy, making the while the broad series of stock pleasantries which have probably been current in composing rooms since printing was invented. Then he was silent, working more and more quickly, till his right hand could scarcely be followed in its twinklings, and the face of the apprentice duly spread in marvel. When the line was finished he drew out the rule, clapped it down on the top of the last row of letters, and gave the composing stick to the apprentice to essay.

The apprentice began to compose with his feet, his shoulders, his mouth, his eyebrows—with all his body except his hands, which nevertheless travelled spaciously far and wide.

'It's not in seven year, nor in seventy, as you'll learn, young sun of a gun!' said Big James.

And, having unsettled the youth to his foundations

The next morning, in the printing office, Edwin came upon Big James giving a lesson in composing to the younger apprentice, who in theory had 'learned his cases'. Big James held the composing stick in his great left hand, like a match-box, and with his great right thumb and index picked letter after letter from the case, very slowly in order to display the movement, and dropped them into the stick. In his mild, resonant tones he explained that each letter must be picked up unfalteringly in a particular way, so that it would drop face upward into the stick without any intermediate manipulation. And he explained also that the left hand must be held so that the right hand would have to travel to and fro as little as possible. He was revealing the basic mysteries of his craft, and was happy, making the while the broad series of stock pleasantries which have probably been current in composing rooms since printing was invented. Then he was silent, working more and more quickly, till his right hand could scarcely be followed in its twinklings, and the face of the apprentice duly spread in marvel. When the line was finished he drew out the rule, clapped it down on the top of the last row of letters, and gave the composing stick to the apprentice to essay.

The apprentice began to compose with his feet, his shoulders, his mouth, his eyebrows—with all his body except his hands, which nevertheless travelled spaciously far and wide.

'It's not in seven year, nor in seventy, as you'll learn, young sun of a gun!' said Big James.

And, having unsettled the youth to his foundations

WORD-SPACING STANDARDS

These Times Roman samples show a progression from very even to quite uneven word spacing, all within the range that you might get from a good typesetter. Look at them from a distance for overall color, then line by line. Notice any line you consider too open or too tight. Also notice lines in which it was necessary to alter the spaces between the letters to keep within the word-spacing limits.

The next morning, in the printing office, Edwin came upon Big James giving a lesson in composing to the younger apprentice, who in theory had 'learned his cases'. Big James held the composing stick in his great left hand, like a match-box, and with his great right thumb and index picked letter after letter from the case, very slowly in order to display the movement, and dropped them into the stick. In his mild, resonant tones he explained that each letter must be picked up unfalteringly in a particular way, so that it would drop face upward into the stick without any intermediate manipulation. And he explained also that the left hand must be held so that the right hand would have to travel to and fro as little as possible. He was revealing the basic mysteries of his craft, and was happy, making the while the broad series of stock pleasantries which have probably been current in composing rooms since printing was invented. Then he was silent, working more and more quickly, till his right hand could scarcely be followed in its twinklings, and the face of the apprentice duly spread in marvel. When the line was finished he drew out the rule, clapped it down on the top of the last row of letters, and gave the composing stick to the apprentice to essay.

The apprentice began to compose with his feet, his shoulders, his mouth, his eye-

1 10/12 TIMES ROMAN: VERY EVEN

The next morning, in the printing office, Edwin came upon Big James giving a lesson in composing to the younger apprentice, who in theory had 'learned his cases'. Big James held the composing stick in his great left hand, like a match-box, and with his great right thumb and index picked letter after letter from the case, very slowly in order to display the movement, and dropped them into the stick. In his mild, resonant tones he explained that each letter must be picked up unfalteringly in a particular way, so that it would drop face upward into the stick without any intermediate manipulation. And he explained also that the left hand must be held so that the right hand would have to travel to and fro as little as possible. He was revealing the basic mysteries of his craft, and was happy, making the while the broad series of stock pleasantries which have probably been current in composing rooms since printing was invented. Then he was silent, working more and more quickly, till his right hand could scarcely be followed in its twinklings, and the face of the apprentice duly spread in marvel. When the line was finished he drew out the rule, clapped it down on the top of the last row of letters, and gave the composing stick to the apprentice to essay.

The apprentice began to compose with

The next morning, in the printing office, Edwin came upon Big James giving a lesson in composing to the younger apprentice, who in theory had 'learned his cases'. Big James held the composing stick in his great left hand, like a match-box, and with his great right thumb and index picked letter after letter from the case, very slowly in order to display the movement, and dropped them into the stick. In his mild, resonant tones he explained that each letter must be picked up unfalteringly in a particular way, so that it would drop face upward into the stick without any intermediate manipulation. And he explained also that the left hand must be held so that the right hand would have to travel to and fro as little as possible. He was revealing the basic mysteries of his craft, and was happy, making the while the broad series of stock pleasantries which have probably been current in composing rooms since printing was invented. Then he was silent, working more and more quickly, till his right hand could scarcely be followed in its twinklings, and the face of the apprentice duly spread in marvel. When the line was finished he drew out the rule, clapped it down on the top of the last row of letters, and gave the composing stick to the apprentice to essay.

The apprentice began to compose with

The next morning, in the printing office, Edwin came upon Big James giving a lesson in composing to the younger apprentice, who in theory had 'learned his cases'. Big James held the composing stick in his great left hand, like a match-box, and with his great right thumb and index picked letter after letter from the case, very slowly in order to display the movement, and dropped them into the stick. In his mild, resonant tones he explained that each letter must be picked up unfalteringly in a particular way, so that it would drop face upward into the stick without any intermediate manipulation. And he explained also that the left hand must be held so that the right hand would have to travel to and fro as little as possible. He was revealing the basic mysteries of his craft, and was happy, making the while the broad series of stock pleasantries which have probably been current in composing rooms since printing was invented. Then he was silent, working more and more quickly, till his right hand could scarcely be followed in its twinklings, and the face of the apprentice duly spread in marvel. When the line was finished he drew out the rule, clapped it down on the top of the last row of letters, and gave the composing stick to the apprentice to essay.

The apprentice began to compose with

2 10/12 TIMES ROMAN: EVEN

3 10/12 TIMES ROMAN: UNEVEN

4 10/11 TIMES ROMAN: VERY UNEVEN

WORD SPACING, TYPE SIZE, AND MEASURE

The most extreme word-spacing problems arise when the type size is too large for the measure and when the measure itself is narrow. Compare 1 and 2, which show 11-point and 9-point Helvetica set on the same measure and with the same spacing defines. In order to hold to the defines, character spacing in 1 had to be altered on many of the lines, resulting in a very uneven texture that produces a crowded and unreadable overall effect. Where the type size and measure are in good relation, as in 2, an even color is achieved.

Example 3 shows an expanded face (Clarendon) on a narrow measure; a wide variation between the minimum and maximum space has been used to achieve justification. The resulting unevenness is very apparent and represents clearly unacceptable typesetting. In example 4, the narrowness of the Century Condensed and the tightness of the line spacing combine to make the widely word-spaced line stand out strongly, which becomes evident when you squint at the page.

The next morning, in the printing office, Edwin came upon Big James giving a lesson in composing to the younger apprentice, who in theory had 'learned his cases'. Big James held the composing stick in his great left hand, like a matchbox, and with his great right thumb and index picked letter after letter from the case, very slowly in order to display the movement, and dropped them into the stick. In his mild, resonant tones he explained that each letter must be picked up unfalteringly in a particular way, so that it would drop face upward into the stick without any intermediate manipulation. And he explained also that the left hand must be held so that the right hand would have to travel to and fro as little as possible. He was revealing the basic mysteries of his craft, and was happy, making the while the broad series of stock pleasantries which have probably been current in composing rooms since printing was invented. Then he was silent,

The next morning, in the printing office, Edwin came upon Big James giving a lesson in composing to the younger apprentice, who in theory had 'learned his cases'. Big James held the composing stick in his great left hand, like a match-box, and with his great right thumb and index picked letter after letter from the case, very slowly in order to display the movement, and dropped them into the stick. In his mild, resonant tones he explained that each letter must be picked up unfalteringly in a particular way, so that it would drop face upward into the stick without any intermediate manipulation. And he explained also that the left hand must be held so that the right hand would have to travel to and fro as little as possible. He was revealing the basic mysteries of his craft, and was happy, making the while the broad series of stock pleasantries which have probably been current in composing rooms since printing was invented. Then he was silent, working more and more quickly, till his right hand could scarcely be followed in its twinklings, and the face of the apprentice duly spread in marvel. When the line was finished he drew out the rule, clapped it down on

The next morning, in the printing office, Edwin came upon Big James giving a lesson in composing to the younger apprentice, who in theory had 'learned his cases'. Big James held the composing stick in his great left hand, like a match-box, and with his great right thumb and index picked letter after letter from the case, very slowly in order to display the movement, and dropped them into the stick. In his mild, resonant tones he explained that each letter must be picked up unfalteringly in a particular way, so that it would drop face upward into the stick without any intermediate manipulation. And he explained also that the left hand must be held so that the right hand would have to travel to and fro as little as possible. He was revealing the basic mysteries of his craft, and was happy, making the while the broad

The next morning, in the printing office, Edwin came upon Big James giving a lesson in composing to the younger apprentice, who in theory had 'learned his cases'. Big James held the composing stick in his great left hand, like a match-box, and with his great right thumb and index picked letter after letter from the case, very slowly in order to display the movement, and dropped them into the stick. In his mild, resonant tones he explained that each letter must be picked up unfalteringly in a particular way, so that it would drop face upward into the stick without any intermediate manipulation. And he explained also that the left hand must be held so that the right hand would have to travel to and fro as little as possible. He was revealing the basic mysteries of his craft, and was happy, making the while the broad series of stock pleasantries which have probably been current in composing rooms since printing was invented. Then he was silent, working more and more quickly, till his right hand could scarcely be followed in its twinklings, and the face of the apprentice duly spread in marvel. When the line was finished he drew out the rule, clapped it down on the top of the last row of letters, and gave the composing stick to the apprentice to essay.

The apprentice began to compose with his feet, his shoulders, his mouth, his eyebrows—with all his body except his hands, which nevertheless travelled spaciously far and wide.

'It's not in seven year, nor in seventy, as you'll learn, young sun of a gun!' said Big James.

And, having unsettled the youth to his foundations with a bland thwack across the head, he resumed the composing stick

UNACCEPTABLE WORD SPACING

Even when the type size and measure are in fairly good relationship to each other, bad word spacing sometimes occurs because of various factors, including many very long words, poor computer programming, or copyfitting restraints. Typesetting with such loosely set or over-tight lines should be rerun. The three examples here all fall within the unacceptable range.

The next morning, in the printing office, Edwin came upon Big James giving a lesson in composing to the younger apprentice, who in theory had 'learned his cases'. Big James held the composing stick in his great left hand, like a match-box, and with his great right thumb and index picked letter after letter from the case, very slowly in order to display the movement, and dropped them into the stick. In his mild, resonant tones he explained that each letter must be picked up unfalteringly in a particular way, so that it would drop face upward into the stick without any intermediate manipulation. And he explained also that the left hand must be held so that the right hand would have to travel to and fro as little as possible. He was revealing the basic mysteries of his craft, and was happy, making the while the broad series of stock pleasantries which have probably been current in composing rooms since printing was invented. Then he was silent, working more and more quickly, till his right hand could scarcely be followed in its twinklings, and the face of the apprentice duly spread in marvel. When the line was finished he drew out the rule, clapped it down on the top of the last row of letters, and gave the composing stick to the apprentice to essay.

The apprentice began to compose with his feet, his shoulders, his mouth, his eyebrows—with all his body except his hands, which nevertheless travelled spaciously far and wide.

'It's not in seven year, nor in seventy, as you'll learn, young sun of a gun!' said Big James.

And, having unsettled the youth to his foundations with a bland thwack across the head, he resumed the composing stick and began again the exposition of the

1 10/12 TIMES ROMAN, RANDOM LOOSE LINES IN EVEN TEXTURE

The next morning, in the printing office, Edwin came upon Big James giving a lesson in composing to the younger apprentice, who in theory had 'learned his cases'. Big James held the composing stick in his great left hand, like a match-box, and with his great right thumb and index picked letter after letter from the case, very slowly in order to display the movement, and dropped them into the stick. In his mild, resonant tones he explained that each letter must be picked up unfalteringly in a particular way, so that it would drop face upward into the stick without any intermediate manipulation. And he explained also that the left hand must be held so that the right hand would have to travel to and fro as little as possible. He was revealing the basic mysteries of his craft, and was happy, making the while the broad series of stock pleasantries which have probably been current in composing rooms since printing was invented. Then he was silent, working more and more quickly, till his right hand could scarcely be followed in its twinklings, and the face of the apprentice duly spread in marvel. When the line was finished he drew out the rule, clapped it down on the top of the last row of letters, and gave the composing stick to the apprentice to essay.

The apprentice began to compose with his feet, his shoulders, his mouth, his eyebrows—with all his body except his hands, which nevertheless travelled spaciously far and wide.

'It's not in seven year, nor in seventy, as you'll learn, young sun of a gun!' said Big James.

And, having unsettled the youth to his foundations with a bland thwack across the head, he resumed the composing stick and began again the exposition of the unique smooth movement which is the root of rapid typesetting.

'Here!' said Big James, when the apprentice had be-

The next morning, in the printing office, Edwin came upon Big James giving a lesson in composing to the younger apprentice, who in theory had 'learned his cases'. Big James held the composing stick in his great left hand, like a match-box, and with his great right thumb and index picked letter after letter from the case, very slowly in order to display the movement, and dropped them into the stick. In his mild, resonant tones he explained that each letter must be picked up unfalteringly in a particular way, so that it would drop face upward into the stick without any intermediate manipulation. And he explained also that the left hand must be held so that the right hand would have to travel to and fro as little as possible. He was revealing the basic mysteries of his craft, and was happy, making the while the broad series of stock pleasantries which have probably been current in composing rooms since printing ing was invented. Then he was silent, working more and more quickly, till his right hand could scarcely be followed in its twinklings, and the face of the apprentice duly spread in marvel. When the line was finished he drew out the rule, clapped it down on the top of the last row of letters, and gave the composing stick to the apprentice to essay.

The apprentice began to compose with his feet, his shoulders, his mouth, his eyebrows—with all his body except his hands, which nevertheless travelled spaciously far and wide.

'It's not in seven year, nor in seventy, as you'll learn, young sun of a gun!' said Big James.

And, having unsettled the youth to his foundations with a bland thwack across the head, he resumed the

We have already seen that the goal in spacing words is to achieve an even overall texture in which the apparent space between words is equal. The goal in spacing characters is also to achieve the illusion of equal spacing. As with word spacing, there are built-in factors that make equal spacing difficult. Some of these factors are related to the basic forms of the roman alphabet, and some to the limits of the technology producing our type.

Our alphabet consists of straight-edged letters such as *i, I, L, M*; curved letters such as *o, O, c, G*; sloped letters such as *v, V, A, w*; and letters with trapped open spaces, such as *T, L,* and *Y.* Any of these contours may appear in combination with any other: straight-edges with curved, sloped with open, and so on. What the eye perceives is the overall space between characters. This overall space differs greatly according to the shapes of the letters, even if the measurable space at the narrowest or widest point is equal. For example, if two straight-edged letters, say *ll,* have the same space between them that a curved pair like *oo* has at its closest point, the straight-edged pair will appear to be much closer together. The degree of the curve, the angle of the slope, the width of serifs, and other design elements of each face all tend to affect the apparent space between characters. And some faces present more severe spacing problems than others.

Since the invention of movable type, type designers have had to con-

CHARACTER SPACING AND TYPE COLOR

sider these variations of edge shape in deciding on the amount of space to allow around each character so that it can pair with every other character with the spaces appearing more or less equal. Inevitably, compromises must be made. When any type design is adapted by the manufacturer for a typesetting system, space is assigned around each character. The specific spaces, which vary from system to system, are part of the typesetting program for that face.

Most contemporary typesetting systems, however, are capable of modifying the spacing programs provided by the manufacturers in two ways: by overall kerning and by pair kerning. The simplest method is by overall kerning; that is, taking out or adding very small increments of space throughout the alphabet. The space between characters of large sizes should be proportionately less than the space between smaller sizes. Some systems reduce this space in larger sizes as part of their normal program. Other systems require an overall kerning to reduce this space.

Pair kerning is more complex. In pair kerning, the space between individual pairs of characters is altered. For example, the system can be programmed so that every time a *T* appears with an *a*, space is removed in such a way that the *a* can tuck under the cross-bar of the *T*. In this way, a careful and sensitive typographer can alter difficult letter pairs throughout a font. This is a time-consuming and difficult task; each altered pair may affect the appearance of all the other pairs in the alpha-

bet. In text setting, pair kerning is usually restricted to the exceptionally difficult pairs and to the exceptionally difficult alphabets, such as Avant Garde and Lubalin Graph. In practice a combination of overall kerning and selective pair kerning is often used.

Typographers do not always agree on how close together characters should be for good typesetting. Computer typesetting permits much tighter composition than older methods, and for a time this ability to set very tight type encouraged typographers to do so, frequently to the detriment of readability. Very tight typesetting is still used in advertising typography and where the overall texture is more critical than readability. As a general rule, spacing should not be so tight that the letters lose their distinct outlines, nor so open that the words are not perceived as wholes. Spacing between words, of course, is also related to the space between letters. If type is set open, word spacing should be proportionately greater in order to maintain the integrity of the word. If type is set very tight, normal spacing will appear very large.

On the following pages we will look at the way in which different manufacturers space some standard fonts, as well as modifications of this standard spacing with overall kerning.

We will also look at how some aspects of type design affect character spacing and how some faces whose design elements make for difficult spacing can be helped by judicious pair kerning.

KERNING A NORMAL FACE

These examples show the effects of overall kerning on Baskerville, a face that has normal thick/thin contrast and normal letter proportions. The example in 1 shows the face with no alteration of the space between characters; 2 with 3/8 unit (see Chapter 1) removed between each character; and 3 with 5/8 unit removed. It is easy to see the change in overall color, particularly between 1 and 3. The first sample is very loose, and the words barely cohere as single visual units. Both 2 and 3 are acceptable settings, but in 2 words with a series of rounded letters, like *compose*, look too open, and in 3, words with a series of vertical letters, like *little*, look a bit tight.

Example 4 shows a setting using an overall kern of 1/2 unit and additional special kerning of certain letter pairs. Some of these are the pairs that need attention in almost all serif faces, such as *nd*, *ng*, *ou*, *ox*, and *xp*. Other pairs that might not be altered in another face have been altered here: *ef*, *mp*, *ot*, and *Bi*. Notice that the alteration runs in both directions, with space being added as well as removed. Example 4 represents a high standard of text setting, one that takes time and care and is not inexpensive.

The next morning, in the printing office, Edwin came upon Big James giving a lesson in composing to the younger apprentice, who in theory had 'learned his cases'. Big James held the composing stick in his great left hand, like a match-box, and with his great right thumb and index picked letter after letter from the case, very slowly in order to display the movement, and dropped them into the stick. In his mild, resonant tones he explained that each letter must be picked up unfalteringly in a particular way, so that it would drop face upward into the stick without any intermediate manipulation. And he explained also that the left hand must be held so that the right hand would have to travel to and fro as little as possible. He was revealing the basic mysteries of his craft, and was happy, making the while the broad series of stock pleasantries which have probably been current in composing rooms since printing was invented. Then he was silent, working more and more quickly, till his right hand could scarcely be followed in its twinklings, and the face of the apprentice duly spread in marvel. When the line was finished he drew out the rule, clapped it down on the top of the last row of letters, and gave the composing stick to the apprentice to essay.

The apprentice began to compose with his feet, his shoulders, his mouth, his eyebrows—with all his body except his hands, which nevertheless travelled spaciously far and wide.

'It's not in seven year, nor in seventy, as you'll learn, young sun of a gun!' said Big James impatiently.

And, having unsettled the youth to his foundations with a bland thwack across the head, he resumed the

1 10/12 BASKERVILLE : NO KERN

The next morning, in the printing office, Edwin came upon Big James giving a lesson in composing to the younger apprentice, who in theory had 'learned his cases'. Big James held the composing stick in his great left hand, like a match-box, and with his great right thumb and index picked letter after letter from the case, very slowly in order to display the movement, and dropped them into the stick. In his mild, resonant tones he explained that each letter must be picked up unfalteringly in a particular way, so that it would drop face upward into the stick without any intermediate manipulation. And he explained also that the left hand must be held so that the right hand would have to travel to and fro as little as possible. He was revealing the basic mysteries of his craft, and was happy, making the while the broad series of stock pleasantries which have probably been current in composing rooms since printing was invented. Then he was silent, working more and more quickly, till his right hand could scarcely be followed in its twinklings, and the face of the apprentice duly spread in marvel. When the line was finished he drew out the rule, clapped it down on the top of the last row of letters, and gave the composing stick to the apprentice to essay.

The apprentice began to compose with his feet, his shoulders, his mouth, his eyebrows—with all his body except his hands, which nevertheless travelled spaciously far and wide.

'It's not in seven year, nor in seventy, as you'll learn, young sun of a gun!' said Big James impatiently.

And, having unsettled the youth to his foundations with a bland thwack across the head, he resumed the composing stick and began again the exposition of the

The next morning, in the printing office, Edwin came upon Big James giving a lesson in composing to the younger apprentice, who in theory had 'learned his cases'. Big James held the composing stick in his great left hand, like a match-box, and with his great right thumb and index picked letter after letter from the case, very slowly in order to display the movement, and dropped them into the stick. In his mild, resonant tones he explained that each letter must be picked up unfalteringly in a particular way, so that it would drop face upward into the stick without any intermediate manipulation. And he explained also that the left hand must be held so that the right hand would have to travel to and fro as little as possible. He was revealing the basic mysteries of his craft, and was happy, making the while the broad series of stock pleasantries which have probably been current in composing rooms since printing was invented. Then he was silent, working more and more quickly, till his right hand could scarcely be followed in its twinklings, and the face of the apprentice duly spread in marvel. When the line was finished he drew out the rule, clapped it down on the top of the last row of letters, and gave the composing stick to the apprentice to essay.

The apprentice began to compose with his feet, his shoulders, his mouth, his eyebrows—with all his body except his hands, which nevertheless travelled spaciously far and wide.

'It's not in seven year, nor in seventy, as you'll learn, young sun of a gun!' said Big James impatiently.

And, having unsettled the youth to his foundations with a bland thwack across the head, he resumed the composing stick and began again the exposition of the unique smooth movement which is the root of rapid typesetting.

The next morning, in the printing office, Edwin came upon Big James giving a lesson in composing to the younger apprentice, who in theory had 'learned his cases'. Big James held the composing stick in his great left hand, like a match-box, and with his great right thumb and index picked letter after letter from the case, very slowly in order to display the movement, and dropped them into the stick. In his mild, resonant tones he explained that each letter must be picked up unfalteringly in a particular way, so that it would drop face upward into the stick without any intermediate manipulation. And he explained also that the left hand must be held so that the right hand would have to travel to and fro as little as possible. He was revealing the basic mysteries of his craft, and was happy, making the while the broad series of stock pleasantries which have probably been current in composing rooms since printing was invented. Then he was silent, working more and more quickly, till his right hand could scarcely be followed in its twinklings, and the face of the apprentice duly spread in marvel. When the line was finished he drew out the rule, clapped it down on the top of the last row of letters, and gave the composing stick to the apprentice to essay.

The apprentice began to compose with his feet, his shoulders, his mouth, his eyebrows—with all his body except his hands, which nevertheless travelled spaciously far and wide.

'It's not in seven year, nor in seventy, as you'll learn, young sun of a gun!' said Big James impatiently.

And, having unsettled the youth to his foundations with a bland thwack across the head, he resumed the composing stick and began again the exposition of the unique

The next morning, in the printing office, Edwin came upon Big James giving a lesson in composing to the younger apprentice, who in theory had 'learned his cases'. Big James held the composing stick in his great left hand, like a match-box, and with his great right thumb and index picked letter after letter from the case, very slowly in order to display the movement, and dropped them into the stick. In his mild, resonant tones he explained that each letter must be picked up unfalteringly in a particular way, so that it would drop face upward into the stick without any intermediate manipulation. And he explained also that the left hand must be held so that the right hand would have to travel to and fro as little as possible. He was revealing the basic mysteries of his craft, and was happy, making the while the broad series of stock pleasantries which have probably been current in composing rooms since printing was invented. Then he was silent, working more and more quickly, till his right hand could scarcely be followed in its twinklings, and the face of the apprentice duly spread in marvel. When the line was finished he drew out the rule, clapped it down on the top of the last row of letters, and gave the composing stick to the apprentice to essay.

The apprentice began to compose with his feet, his shoulders, his mouth, his eyebrows—with all his body except his hands, which nevertheless travelled spaciously far and wide.

'It's not in seven year, nor in seventy, as you'll learn, young sun of a gun!' said Big James impatiently.

And, having unsettled the youth to his foundations with a bland thwack across the head, he resumed the composing stick and began again the exposition of the unique smooth movement which is the root of rapid typesetting.

'Here!' said Big James, when the apprentice had behaved

The next morning, in the printing office, Edwin came upon Big James giving a lesson in composing to the younger apprentice, who in theory had 'learned his cases'. Big James held the composing stick in his great left hand, like a matchbox, and with his great right thumb and index picked letter after letter from the case, very slowly in order to display the movement, and dropped them into the stick. In his mild, resonant tones he explained that each letter must be picked up unfalteringly in a particular way, so that it would drop face upward into the stick without any intermediate manipulation. And he explained also that the left hand must be held so that the right hand would have to travel to and fro as little as possible. He was revealing the basic mysteries of his craft, and was happy, making the while the broad series of stock pleasantries which have probably been current in composing rooms since printing was invented. Then he was silent, working more and more quickly, till his right hand could scarcely be followed in its twinklings, and the face of the apprentice duly spread in marvel. When the line was finished he drew out the rule, clapped it down on the top of the last row of letters, and gave the composing stick to the apprentice to essay.

The apprentice began to compose with his feet, his shoulders, his mouth, his eyebrows—with all his body except his hands, which nevertheless travelled spaciously far and wide.

'It's not in seven year, nor in seventy, as you'll learn, young sun of a gun!' said Big James impatiently.

And, having unsettled the youth to his foundations with a bland thwack across the head, he resumed the composing stick and began again the exposition of the unique smooth movement which is the root of rapid typesetting.

'Here!' said Big James, when the apprentice had behaved

The next morning, in the printing office, Edwin came upon Big James giving a lesson in composing to the younger apprentice, who in theory had 'learned his cases'. Big James held the composing stick in his great left hand, like a match-box, and with his great right thumb and index picked letter after letter from the case, very slowly in order to display the movement, and dropped them into the stick. In his mild, resonant tones he explained that each letter must be picked up unfalteringly in a particular way, so that it would drop face upward into the stick without any intermediate manipulation. And he explained also that the left hand must be held so that the right hand would have to travel to and fro as little as possible. He was revealing the basic mysteries of his craft, and was happy, making the while the broad series of stock pleasantries which have probably been current in composing rooms since printing was invented. Then he was silent, working more and more quickly, till his right hand could scarcely be followed in its twinklings, and the face of the apprentice duly spread in marvel. When the line was finished he drew out the rule, clapped it down on the top of the last row of letters, and gave the composing stick to the apprentice to essay.

The apprentice began to compose with his feet, his shoulders, his mouth, his eyebrows—with all his body except his hands, which nevertheless travelled spaciously far and wide.

'It's not in seven year, nor in seventy, as you'll learn, young sun of a gun!' said Big James impatiently.

And, having unsettled the youth to his foundations with a bland thwack across the head, he resumed the composing stick and began again the exposition of the unique

KERNING AN EXPANDED FACE OF EVEN STROKE WEIGHT

The same sequence of changing overall kerns shown on the preceding spreads is used here for American Typewriter. However, the effects are somewhat different because the face has so much space within the letters and such extended serifs. Example 2, with only 3/8 unit removed, looks quite even overall. Example 3 is attractive, although the face begins to look slightly more condensed than it is. There are also some unfortunate letter pairs, like *as* and *gl*, that would need attention if you decided on a 5/8 kern for this face.

Example 4 is again a combination of 1/2 unit overall kerning and pair kerning. This setting retains the open and expanded feeling of the face while giving the words a cohesive look. In a face like this, with wide serifs, the 7/8 kern (5) creates many touching letter pairs; these begin to compromise the letterforms themselves and make an expanded face resemble a condensed face. The *as* is particularly bad. However, the width of the serifs keeps even vertical pairs, like *ll* from becoming illegibly tight.

Examples 6 and 7 again show a 3/4 unit overall kern, the same word spacing as in examples 6 and 7 on page 131. Because of the greater internal space of the letters, 7 would be a possible word-space setting, although I prefer 6.

The next morning, in the printing office, Edwin came upon Big James giving a lesson in composing to the younger apprentice, who in theory had 'learned his cases'. Big James held the composing stick in his great left hand, like a match-box, and with his great right thumb and index picked letter after letter from the case, very slowly in order to display the movement, and dropped them into the stick. In his mild, resonant tones he explained that each letter must be picked up unfalteringly in a particular way, so that it would drop face upward into the stick without any intermediate manipulation. And he explained also that the left hand must be held so that the right hand would have to travel to and fro as little as possible. He was revealing the basic mysteries of his craft, and was happy, making the while the broad series of stock pleasantries which have probably been current in composing rooms since printing was invented. Then he was silent, working more and more quickly, till his right hand could scarcely be followed in its twinklings, and the face of the apprentice duly spread in marvel. When the line was finished he drew out the rule, clapped it down on the top of the last row of letters, and gave the composing stick to the apprentice to essay.

The apprentice began to compose with his feet, his shoulders, his mouth, his eyebrows—with all his body except his hands, which nevertheless travelled spaciously far and wide.

'It's not in seven year, nor in seventy, as you'll learn, young sun of a gun!' said Big James.

1 10/12 AMERICAN TYPEWRITER MEDIUM : NO KERN

The next morning, in the printing office, Edwin came upon Big James giving a lesson in composing to the younger apprentice, who in theory had 'learned his cases'. Big James held the composing stick in his great left hand, like a match-box, and with his great right thumb and index picked letter after letter from the case, very slowly in order to display the movement, and dropped them into the stick. In his mild, resonant tones he explained that each letter must be picked up unfalteringly in a particular way, so that it would drop face upward into the stick without any intermediate manipulation. And he explained also that the left hand must be held so that the right hand would have to travel to and fro as little as possible. He was revealing the basic mysteries of his craft, and was happy, making the while the broad series of stock pleasantries which have probably been current in composing rooms since printing was invented. Then he was silent, working more and more quickly, till his right hand could scarcely be followed in its twinklings, and the face of the apprentice duly spread in marvel. When the line was finished he drew out the rule, clapped it down on the top of the last row of letters, and gave the composing stick to the apprentice to essay.

The apprentice began to compose with his feet, his shoulders, his mouth, his eyebrows—with all his body except his hands, which nevertheless travelled spaciously far and wide.

'It's not in seven year, nor in seventy, as you'll learn, young sun of a gun!' said Big James.

And, having unsettled the youth to his foundations

The next morning, in the printing office, Edwin came upon Big James giving a lesson in composing to the younger apprentice, who in theory had 'learned his cases'. Big James held the composing stick in his great left hand, like a match-box, and with his great right thumb and index picked letter after letter from the case, very slowly in order to display the movement, and dropped them into the stick. In his mild, resonant tones he explained that each letter must be picked up unfalteringly in a particular way, so that it would drop face upward into the stick without any intermediate manipulation. And he explained also that the left hand must be held so that the right hand would have to travel to and fro as little as possible. He was revealing the basic mysteries of his craft, and was happy, making the while the broad series of stock pleasantries which have probably been current in composing rooms since printing was invented. Then he was silent, working more and more quickly, till his right hand could scarcely be followed in its twinklings, and the face of the apprentice duly spread in marvel. When the line was finished he drew out the rule, clapped it down on the top of the last row of letters, and gave the composing stick to the apprentice to essay.

The apprentice began to compose with his feet, his shoulders, his mouth, his eyebrows—with all his body except his hands, which nevertheless travelled spaciously far and wide.

'It's not in seven year, nor in seventy, as you'll learn, young sun of a gun!' said Big James.

And, having unsettled the youth to his foundations with a bland thwack across the head, he resumed the

The next morning, in the printing office, Edwin came upon Big James giving a lesson in composing to the younger apprentice, who in theory had 'learned his cases'. Big James held the composing stick in his great left hand, like a match-box, and with his great right thumb and index picked letter after letter from the case, very slowly in order to display the movement, and dropped them into the stick. In his mild, resonant tones he explained that each letter must be picked up unfalteringly in a particular way, so that it would drop face upward into the stick without any intermediate manipulation. And he explained also that the left hand must be held so that the right hand would have to travel to and fro as little as possible. He was revealing the basic mysteries of his craft, and was happy, making the while the broad series of stock pleasantries which have probably been current in composing rooms since printing was invented. Then he was silent, working more and more quickly, till his right hand could scarcely be followed in its twinklings, and the face of the apprentice duly spread in marvel. When the line was finished he drew out the rule, clapped it down on the top of the last row of letters, and gave the composing stick to the apprentice to essay.

The apprentice began to compose with his feet, his shoulders, his mouth, his eyebrows—with all his body except his hands, which nevertheless travelled spaciously far and wide.

'It's not in seven year, nor in seventy, as you'll learn, young sun of a gun!' said Big James.

And, having unsettled the youth to his foundations with a bland thwack across the head, he resumed the

The next morning, in the printing office, Edwin came upon Big James giving a lesson in composing to the younger apprentice, who in theory had 'learned his cases'. Big James held the composing stick in his great left hand, like a match-box, and with his great right thumb and index picked letter after letter from the case, very slowly in order to display the movement, and dropped them into the stick. In his mild, resonant tones he explained that each letter must be picked up unfalteringly in a particular way, so that it would drop face upward into the stick without any intermediate manipulation. And he explained also that the left hand must be held so that the right hand would have to travel to and fro as little as possible. He was revealing the basic mysteries of his craft, and was happy, making the while the broad series of stock pleasantries which have probably been current in composing rooms since printing was invented. Then he was silent, working more and more quickly, till his right hand could scarcely be followed in its twinklings, and the face of the apprentice duly spread in marvel. When the line was finished he drew out the rule, clapped it down on the top of the last row of letters, and gave the composing stick to the apprentice to essay.

The apprentice began to compose with his feet, his shoulders, his mouth, his eyebrows—with all his body except his hands, which nevertheless travelled spaciously far and wide.

'It's not in seven year, nor in seventy, as you'll learn, young sun of a gun!' said Big James.

And, having unsettled the youth to his foundations with a bland thwack across the head, he resumed the composing stick and began again the exposition of the

The next morning, in the printing office, Edwin came upon Big James giving a lesson in composing to the younger apprentice, who in theory had 'learned his cases'. Big James held the composing stick in his great left hand, like a match-box, and with his great right thumb and index picked letter after letter from the case, very slowly in order to display the movement, and dropped them into the stick. In his mild, resonant tones he explained that each letter must be picked up unfalteringly in a particular way, so that it would drop face upward into the stick without any intermediate manipulation. And he explained also that the left hand must be held so that the right hand would have to travel to and fro as little as possible. He was revealing the basic mysteries of his craft, and was happy, making the while the broad series of stock pleasantries which have probably been current in composing rooms since printing was invented. Then he was silent, working more and more quickly, till his right hand could scarcely be followed in its twinklings, and the face of the apprentice duly spread in marvel. When the line was finished he drew out the rule, clapped it down on the top of the last row of letters, and gave the composing stick to the apprentice to essay.

The apprentice began to compose with his feet, his shoulders, his mouth, his eyebrows—with all his body except his hands, which nevertheless travelled spaciously far and wide.

'It's not in seven year, nor in seventy, as you'll learn, young sun of a gun!' said Big James.

And, having unsettled the youth to his foundations with a bland thwack across the head, he resumed the

The next morning, in the printing office, Edwin came upon Big James giving a lesson in composing to the younger apprentice, who in theory had 'learned his cases'. Big James held the composing stick in his great left hand, like a match-box, and with his great right thumb and index picked letter after letter from the case, very slowly in order to display the movement, and dropped them into the stick. In his mild, resonant tones he explained that each letter must be picked up unfalteringly in a particular way, so that it would drop face upward into the stick without any intermediate manipulation. And he explained also that the left hand must be held so that the right hand would have to travel to and fro as little as possible. He was revealing the basic mysteries of his craft, and was happy, making the while the broad series of stock pleasantries which have probably been current in composing rooms since printing was invented. Then he was silent, working more and more quickly, till his right hand could scarcely be followed in its twinklings, and the face of the apprentice duly spread in marvel. When the line was finished he drew out the rule, clapped it down on the top of the last row of letters, and gave the composing stick to the apprentice to essay.

The apprentice began to compose with his feet, his shoulders, his mouth, his eyebrows—with all his body except his hands, which nevertheless travelled spaciously far and wide.

'It's not in seven year, nor in seventy, as you'll learn, young sun of a gun!' said Big James.

And, having unsettled the youth to his foundations with a bland thwack across the head, he resumed the

KERNING A FACE WITH HIGH THICK/THIN CONTRAST

Again the examples show the same sequence of overall kerns, but with a face—Walbaum—that has highly contrasting thicks and thins. The example in 1 is clearly unacceptable. The wide spaces between the letters, combined with the contrast in the stroke weight, create an unreadably active texture. Taking out 3/8 unit, as we've done in 2, begins to help, but the words really don't hang together until 5/8s is removed (3).

Example 4 shows 1/2 unit overall kern with kern pairs again. This time, though, the choice is not preferable. The texture is still too active for extended reading. An overall kern of 7/8, which was clearly too tight for Baskerville and somewhat too tight for American Typewriter is quite acceptable here and, at least to my taste, the best of these settings. Some might prefer the 3/4 unit kern (6 and 7), but not with the bigger word space in 7.

The next morning, in the printing office, Edwin came upon Big James giving a lesson in composing to the younger apprentice, who in theory had 'learned his cases'. Big James held the composing stick in his great left hand, like a match-box, and with his great right thumb and index picked letter after letter from the case, very slowly in order to display the movement, and dropped them into the stick. In his mild, resonant tones he explained that each letter must be picked up unfalteringly in a particular way, so that it would drop face upward into the stick without any intermediate manipulation. And he explained also that the left hand must be held so that the right hand would have to travel to and fro as little as possible. He was revealing the basic mysteries of his craft, and was happy, making the while the broad series of stock pleasantries which have probably been current in composing rooms since printing was invented. Then he was silent, working more and more quickly, till his right hand could scarcely be followed in its twinklings, and the face of the apprentice duly spread in marvel. When the line was finished he drew out the rule, clapped it down on the top of the last row of letters, and gave the composing stick to the apprentice to essay.

The apprentice began to compose with his feet, his shoulders, his mouth, his eyebrows—with all his body except his hands, which nevertheless travelled spaciously far and wide.

'It's not in seven year, nor in seventy, as you'll learn, young sun of a gun!' said Big James.

1 10/12 WALBAUM : NO KERN

The next morning, in the printing office, Edwin came upon Big James giving a lesson in composing to the younger apprentice, who in theory had 'learned his cases'. Big James held the composing stick in his great left hand, like a match-box, and with his great right thumb and index picked letter after letter from the case, very slowly in order to display the movement, and dropped them into the stick. In his mild, resonant tones he explained that each letter must be picked up unfalteringly in a particular way, so that it would drop face upward into the stick without any intermediate manipulation. And he explained also that the left hand must be held so that the right hand would have to travel to and fro as little as possible. He was revealing the basic mysteries of his craft, and was happy, making the while the broad series of stock pleasantries which have probably been current in composing rooms since printing was invented. Then he was silent, working more and more quickly, till his right hand could scarcely be followed in its twinklings, and the face of the apprentice duly spread in marvel. When the line was finished he drew out the rule, clapped it down on the top of the last row of letters, and gave the composing stick to the apprentice to essay.

The apprentice began to compose with his feet, his shoulders, his mouth, his eyebrows—with all his body except his hands, which nevertheless travelled spaciously far and wide.

'It's not in seven year, nor in seventy, as you'll learn, young sun of a gun!' said Big James.

And, having unsettled the youth to his foundations with a bland thwack across the head, he resumed the

The next morning, in the printing office, Edwin came upon Big James giving a lesson in composing to the younger apprentice, who in theory had 'learned his cases'. Big James held the composing stick in his great left hand, like a match-box, and with his great right thumb and index picked letter after letter from the case, very slowly in order to display the movement, and dropped them into the stick. In his mild, resonant tones he explained that each letter must be picked up unfalteringly in a particular way, so that it would drop face upward into the stick without any intermediate manipulation. And he explained also that the left hand must be held so that the right hand would have to travel to and fro as little as possible. He was revealing the basic mysteries of his craft, and was happy, making the while the broad series of stock pleasantries which have probably been current in composing rooms since printing was invented. Then he was silent, working more and more quickly, till his right hand could scarcely be followed in its twinklings, and the face of the apprentice duly spread in marvel. When the line was finished he drew out his rule, clapped it down on the top of the last row of letters, and gave the composing stick to the apprentice to essay.

The apprentice began to compose with his feet, his shoulders, his mouth, his eyebrows—with all his body except his hands, which nevertheless travelled spaciously far and wide.

'It's not in seven year, nor in seventy, as you'll learn, young sun of a gun!' said Big James.

And, having unsettled the youth to his foundations with a bland thwack across the head, he resumed the

The next morning, in the printing office, Edwin came upon Big James giving a lesson in composing to the younger apprentice, who in theory had 'learned his cases'. Big James held the composing stick in his great left hand, like a match-box, and with his great right thumb and index picked letter after letter from the case, very slowly in order to display the movement, and dropped them into the stick. In his mild, resonant tones he explained that each letter must be picked up unfalteringly in a particular way, so that it would drop face upward into the stick without any intermediate manipulation. And he explained also that the left hand must be held so that the right hand would have to travel to and fro as little as possible. He was revealing the basic mysteries of his craft, and was happy, making the while the broad series of stock pleasantries which have probably been current in composing rooms since printing was invented. Then he was silent, working more and more quickly, till his right hand could scarcely be followed in its twinklings, and the face of the apprentice duly spread in marvel. When the line was finished he drew out the rule, clapped it down on the top of the last row of letters, and gave the composing stick to the apprentice to essay.

The apprentice began to compose with his feet, his shoulders, his mouth, his eyebrows—with all his body except his hands, which nevertheless travelled spaciously far and wide.

'It's not in seven year, nor in seventy, as you'll learn, young sun of a gun!' said Big James.

And, having unsettled the youth to his foundations with a bland thwack across the head, he resumed the

The next morning, in the printing office, Edwin came upon Big James giving a lesson in composing to the younger apprentice, who in theory had 'learned his cases'. Big James held the composing stick in his great left hand, like a match-box, and with his great right thumb and index picked letter after letter from the case, very slowly in order to display the movement, and dropped them into the stick. In his mild, resonant tones he explained that each letter must be picked up unfalteringly in a particular way, so that it would drop face upward into the stick without any intermediate manipulation. And he explained also that the left hand must be held so that the right hand would have to travel to and fro as little as possible. He was revealing the basic mysteries of his craft, and was happy, making the while the broad series of stock pleasantries which have probably been current in composing rooms since printing was invented. Then he was silent, working more and more quickly, till his right hand could scarcely be followed in its twinklings, and the face of the apprentice duly spread in marvel. When the line was finished he drew out the rule, clapped it down on the top of the last row of letters, and gave the composing stick to the apprentice to essay.

The apprentice began to compose with his feet, his shoulders, his mouth, his eyebrows—with all his body except his hands, which nevertheless travelled spaciously far and wide.

'It's not in seven year, nor in seventy, as you'll learn, young sun of a gun!' said Big James.

And, having unsettled the youth to his foundations with a bland thwack across the head, he resumed the composing stick and began again the exposition of the unique

The next morning, in the printing office, Edwin came upon Big James giving a lesson in composing to the younger apprentice, who in theory had 'learned his cases'. Big James held the composing stick in his great left hand, like a match-box, and with his great right thumb and index picked letter after letter from the case, very slowly in order to display the movement, and dropped them into the stick. In his mild, resonant tones he explained that each letter must be picked up unfalteringly in a particular way, so that it would drop face upward into the stick without any intermediate manipulation. And he explained also that the left hand must be held so that the right hand would have to travel to and fro as little as possible. He was revealing the basic mysteries of his craft, and was happy, making the while the broad series of stock pleasantries which have probably been current in composing rooms since printing was invented. Then he was silent, working more and more quickly, till his right hand could scarcely be followed in its twinklings, and the face of the apprentice duly spread in marvel. When the line was finished he drew out the rule, clapped it down on the top of the last row of letters, and gave the composing stick to the apprentice to essay.

The apprentice began to compose with his feet, his shoulders, his mouth, his eyebrows—with all his body except his hands, which nevertheless travelled spaciously far and wide.

'It's not in seven year, nor in seventy, as you'll learn, young sun of a gun!' said Big James.

And, having unsettled the youth to his foundations with a bland thwack across the head, he resumed the composing stick and began again the exposition of the unique

The next morning, in the printing office, Edwin came upon Big James giving a lesson in composing to the younger apprentice, who in theory had 'learned his cases'. Big James held the composing stick in his great left hand, like a match-box, and with his great right thumb and index picked letter after letter from the case, very slowly in order to display the movement, and dropped them into the stick. In his mild, resonant tones he explained that each letter must be picked up unfalteringly in a particular way, so that it would drop face upward into the stick without any intermediate manipulation. And he explained also that the left hand must be held so that the right hand would have to travel to and fro as little as possible. He was revealing the basic mysteries of his craft, and was happy, making the while the broad series of stock pleasantries which have probably been current in composing rooms since printing was invented. Then he was silent, working more and more quickly, till his right hand could scarcely be followed in its twinklings, and the face of the apprentice duly spread in marvel. When the line was finished he drew out the rule, clapped it down on the top of the last row of letters, and gave the composing stick to the apprentice to essay.

The apprentice began to compose with his feet, his shoulders, his mouth, his eyebrows—with all his body except his hands, which nevertheless travelled spaciously far and wide.

'It's not in seven year, nor in seventy, as you'll learn, young sun of a gun!' said Big James.

And, having unsettled the youth to his foundations with a bland thwack across the head, he resumed the

Some faces present extraordinarily difficult problems because of the design characteristics of the face itself. Avant Garde combines open, very round characters with very narrow (because it is a sans serif), vertical characters. The round characters contain a great deal of internal space but also create large spaces between them, while the verticals appear to be very close.

Example 1 shows the uneven look these design characteristics create when they are set without modification. Tightening them up, as in example 2, helps the combinations of the round letters but exaggerates the problem of the verticals. When both round groups and straight groups are combined, as in words like *followed* or *with*, the unevenness is emphasized. Note how the overall color is made darker by the overall kern.

Example 3 shows a careful handling—both tightening and opening—of letter pairs throughout. Compare *followed* in the samples. Only very skilled typesetters, with enough time to set the job, can achieve excellent results with faces as difficult as this.

The next morning, in the printing office, Edwin came upon Big James giving a lesson in composing to the younger apprentice, who in theory had 'learned his cases'. Big James held the composing stick in his great left hand, like a match-box, and with his great right thumb and index picked letter after letter from the case, very slowly in order to display the movement, and dropped them into the stick. In his mild, resonant tones he explained that each letter must be picked up unfalteringly in a particular way, so that it would drop face upward into the stick without any intermediate manipulation. And he explained also that the left hand must be held so that the right hand would have to travel to and fro as little as possible. He was revealing the basic mysteries of his craft, and was happy, making the while the broad series of stock pleasantries which have probably been current in composing rooms since printing was invented. Then he was silent, working more and more quickly, till his right hand could scarcely be followed in its twinklings, and the face of the apprentice duly spread in marvel. When the line was finished he drew out the rule, clapped it down on the top of the last row of letters, and gave the composing stick to the apprentice to essay.

The apprentice began to compose with his feet, his shoulders, his mouth, his eyebrows—with all his body except his hands, which nevertheless travelled spaciously far and wide.

'It's not in seven year, nor in seventy, as you'll learn, young sun of a gun!' said Big James.

And, having unsettled the youth to his foundations with a bland thwack across the head, he resumed the

1 10/12 ITC AVANT GARDE: NO MODIFICATION

The next morning, in the printing office, Edwin came upon Big James giving a lesson in composing to the younger apprentice, who in theory had 'learned his cases'. Big James held the composing stick in his great left hand, like a match-box, and with his great right thumb and index picked letter after letter from the case, very slowly in order to display the movement, and dropped them into the stick. In his mild, resonant tones he explained that each letter must be picked up unfalteringly in a particular way, so that it would drop face upward into the stick without any intermediate manipulation. And he explained also that the left hand must be held so that the right hand would have to travel to and fro as little as possible. He was revealing the basic mysteries of his craft, and was happy, making the while the broad series of stock pleasantries which have probably been current in composing rooms since printing was invented. Then he was silent, working more and more quickly, till his right hand could scarcely be followed in its twinklings, and the face of the apprentice duly spread in marvel. When the line was finished he drew out the rule, clapped it down on the top of the last row of letters, and gave the composing stick to the apprentice to essay.

The apprentice began to compose with his feet, his shoulders, his mouth, his eyebrows—with all his body except his hands, which nevertheless travelled spaciously far and wide.

'It's not in seven year, nor in seventy, as you'll learn, young sun of a gun!' said Big James.

And, having unsettled the youth to his foundations with a bland thwack across the head, he resumed the composing stick and began again the exposition of the unique smooth movement which is the root of rapid typesetting.

The next morning, in the printing office, Edwin came upon Big James giving a lesson in composing to the younger apprentice, who in theory had 'learned his cases'. Big James held the composing stick in his great left hand, like a match-box, and with his great right thumb and index picked letter after letter from the case, very slowly in order to display the movement, and dropped them into the stick. In his mild, resonant tones he explained that each letter must be picked up unfalteringly in a particular way, so that it would drop face upward into the stick without any intermediate manipulation. And he explained also that the left hand must be held so that the right hand would have to travel to and fro as little as possible. He was revealing the basic mysteries of his craft, and was happy, making the while the broad series of stock pleasantries which have probably been current in composing rooms since printing was invented. Then he was silent, working more and more quickly, till his right hand could scarcely be followed in its twinklings, and the face of the apprentice duly spread in marvel. When the line was finished he drew out the rule, clapped it down on the top of the last row of letters, and gave the composing stick to the apprentice to essay.

The apprentice began to compose with his feet, his shoulders, his mouth, his eyebrows—with all his body except his hands, which nevertheless travelled spaciously far and wide.

'It's not in seven year, nor in seventy, as you'll learn, young sun of a gun!' said Big James.

And, having unsettled the youth to his foundations with a bland thwack across the head, he resumed the composing stick and began again the exposition of the

Lubalin Graph is essentially Avant Garde with serifs. The serifs however, make all the difference, since they create a natural space between the vertical letters that makes the contrast of the spacing between them and the round letters less extreme. The letterspacing looks extremely open in the unaltered sample (1). Merely tightening the space, however, as in 2, results in some uncomfortably tight pairs and emphasizes the unevenness of the overall color. Still, 2 is a possible setting.

Example 3, in which the pairs are handled individually, is much better. It retains and evens out the light overall color of the face.

The word-spacing parameters here, as in the other samples in this section, are 3-6. Notice that the lines look tight with minimum word space; the internal spaces of the letters are so great that the small word space looks as if it were actually less than the space within the characters. Specify slightly greater word spacing for faces with large internal spaces.

The next morning, in the printing office, Edwin came upon Big James giving a lesson in composing to the younger apprentice, who in theory had 'learned his cases'. Big James held the composing stick in his great left hand, like a match-box, and with his great right thumb and index picked letter after letter from the case, very slowly in order to display the movement, and dropped them into the stick. In his mild, resonant tones he explained that each letter must be picked up unfalteringly in a particular way, so that it would drop face upward into the stick without any intermediate manipulation. And he explained also that the left hand must be held so that the right hand would have to travel to and fro as little as possible. He was revealing the basic mysteries of his craft, and was happy, making the while the broad series of stock pleasantries which have probably been current in composing rooms since printing was invented. Then he was silent, working more and more quickly, till his right hand could scarcely be followed in its twinklings, and the face of the apprentice duly spread in marvel. When the line was finished he drew out the rule, clapped it down on the top of the last row of letters, and gave the composing stick to the apprentice to essay.

The apprentice began to compose with his feet, his shoulders, his mouth, his eyebrows—with all his body except his hands, which nevertheless travelled spaciously far and wide.

'It's not in seven year, nor in seventy, as you'll learn, young sun of a gun!' said Big James.

1 10/12 ITC LUBALIN GRAPH: NO MODIFICATION

The next morning, in the printing office, Edwin came upon Big James giving a lesson in composing to the younger apprentice, who in theory had 'learned his cases'. Big James held the composing stick in his great left hand, like a match-box, and with his great right thumb and index picked letter after letter from the case, very slowly in order to display the movement, and dropped them into the stick. In his mild, resonant tones he explained that each letter must be picked up unfalteringly in a particular way, so that it would drop face upward into the stick without any intermediate manipulation. And he explained also that the left hand must be held so that the right hand would have to travel to and fro as little as possible. He was revealing the basic mysteries of his craft, and was happy, making the while the broad series of stock pleasantries which have probably been current in composing rooms since printing was invented. Then he was silent, working more and more quickly, till his right hand could scarcely be followed in its twinklings, and the face of the apprentice duly spread in marvel. When the line was finished he drew out the rule, clapped it down on the top of the last row of letters, and gave the composing stick to the apprentice to essay.

The apprentice began to compose with his feet, his shoulders, his mouth, his eyebrows—with all his body except his hands, which nevertheless travelled spaciously far and wide.

'It's not in seven year, nor in seventy, as you'll learn, young sun of a gun!' said Big James.

And, having unsettled the youth to his foundations with a bland thwack across the head, he resumed the

The next morning, in the printing office, Edwin came upon Big James giving a lesson in composing to the younger apprentice, who in theory had 'learned his cases'. Big James held the composing stick in his great left hand, like a match-box, and with his great right thumb and index picked letter after letter from the case, very slowly in order to display the movement, and dropped them into the stick. In his mild, resonant tones he explained that each letter must be picked up unfalteringly in a particular way, so that it would drop face upward into the stick without any intermediate manipulation. And he explained also that the left hand must be held so that the right hand would have to travel to and fro as little as possible. He was revealing the basic mysteries of his craft, and was happy, making the while the broad series of stock pleasantries which have probably been current in composing rooms since printing was invented. Then he was silent, working more and more quickly, till his right hand could scarcely be followed in its twinklings, and the face of the apprentice duly spread in marvel. When the line was finished he drew out the rule, clapped it down on the top of the last row of letters, and gave the composing stick to the apprentice to essay.

The apprentice began to compose with his feet, his shoulders, his mouth, his eyebrows—with all his body except his hands, which nevertheless travelled spaciously far and wide.

'It's not in seven year, nor in seventy, as you'll learn, young sun of a gun!' said Big James.

And, having unsettled the youth to his foundations with a bland thwack across the head, he resumed the

Very condensed faces have relatively little internal space and a very pronounced vertical movement. An unaltered setting like 1 looks extremely open because the spaces between the letters are as great as or greater than the spaces within the letters themselves. Tightening improves matters greatly (2), but an overall tightening combined with opening up some vertical pairs results in a pleasing texture (3). Notice that the word spacing, which looks (if anything) a bit too large here, is the same as on the preceding spread, where it looks too small.

To look right, the relation of the space within the words, both between and within the characters, must be proportional to the space between the words.

The next morning, in the printing office, Edwin came upon Big James giving a lesson in composing to the younger apprentice, who in theory had 'learned his cases'. Big James held the composing stick in his great left hand, like a match-box, and with his great right thumb and index picked letter after letter from the case, very slowly in order to display the movement, and dropped them into the stick. In his mild, resonant tones he explained that each letter must be picked up unfalteringly in a particular way, so that it would drop face upward into the stick without any intermediate manipulation. And he explained also that the left hand must be held so that the right hand would have to travel to and fro as little as possible. He was revealing the basic mysteries of his craft, and was happy, making the while the broad series of stock pleasantries which have probably been current in composing rooms since printing was invented. Then he was silent, working more and more quickly, till his right hand could scarcely be followed in its twinklings, and the face of the apprentice duly spread in marvel. When the line was finished he drew out the rule, clapped it down on the top of the last row of letters, and gave the composing stick to the apprentice to essay.

The apprentice began to compose with his feet, his shoulders, his mouth, his eyebrows—with all his body except his hands, which nevertheless travelled spaciously far and wide.

'It's not in seven year, nor in seventy, as you'll learn, young sun of a gun!' said Big James.

And, having unsettled the youth to his foundations with a bland thwack across the head, he resumed the composing stick and began again the exposition of the unique smooth move-

1 11/13 ITC CENTURY CONDENSED: NO MODIFICATION

The next morning, in the printing office, Edwin came upon Big James giving a lesson in composing to the younger apprentice, who in theory had 'learned his cases'. Big James held the composing stick in his great left hand, like a match-box, and with his great right thumb and index picked letter after letter from the case, very slowly in order to display the movement, and dropped them into the stick. In his mild, resonant tones he explained that each letter must be picked up unfalteringly in a particular way, so that it would drop face upward into the stick without any intermediate manipulation. And he explained also that the left hand must be held so that the right hand would have to travel to and fro as little as possible. He was revealing the basic mysteries of his craft, and was happy, making the while the broad series of stock pleasantries which have probably been current in composing rooms since printing was invented. Then he was silent, working more and more quickly, till his right hand could scarcely be followed in its twinklings, and the face of the apprentice duly spread in marvel. When the line was finished he drew out the rule, clapped it down on the top of the last row of letters, and gave the composing stick to the apprentice to essay.

The apprentice began to compose with his feet, his shoulders, his mouth, his eyebrows—with all his body except his hands, which nevertheless travelled spaciously far and wide.

'It's not in seven year, nor in seventy, as you'll learn, young sun of a gun!' said Big James.

And, having unsettled the youth to his foundations with a bland thwack across the head, he resumed the composing stick and began again the exposition of the unique smooth movement which is the root of rapid typesetting.

'Here!' said Big James, when the apprentice had behaved worse

The next morning, in the printing office, Edwin came upon Big James giving a lesson in composing to the younger apprentice, who in theory had 'learned his cases'. Big James held the composing stick in his great left hand, like a match-box, and with his great right thumb and index picked letter after letter from the case, very slowly in order to display the movement, and dropped them into the stick. In his mild, resonant tones he explained that each letter must be picked up unfalteringly in a particular way, so that it would drop face upward into the stick without any intermediate manipulation. And he explained also that the left hand must be held so that the right hand would have to travel to and fro as little as possible. He was revealing the basic mysteries of his craft, and was happy, making the while the broad series of stock pleasantries which have probably been current in composing rooms since printing was invented. Then he was silent, working more and more quickly, till his right hand could scarcely be followed in its twinklings, and the face of the apprentice duly spread in marvel. When the line was finished he drew out the rule, clapped it down on the top of the last row of letters, and gave the composing stick to the apprentice to essay.

The apprentice began to compose with his feet, his shoulders, his mouth, his eyebrows—with all his body except his hands, which nevertheless travelled spaciously far and wide.

'It's not in seven year, nor in seventy, as you'll learn, young sun of a gun!' said Big James.

And, having unsettled the youth to his foundations with a bland thwack across the head, he resumed the composing stick and began again the exposition of the unique smooth movement which is the root of rapid typesetting.

It is impossible to achieve perfectly even word spacing in justified type, although a pretty good illusion of it can be obtained by providing appropriate type specifications to a competent typographer. You can, however, achieve perfectly even word spacing by not using justification. Until the mid-1960s, setting type with an unjustified right margin was almost unknown and would have been considered shocking, a violation of the very nature of typography. Even today, when many magazines and advertisements and more than a few books are set this way, there are some who still feel that ragged-right typesetting somehow looks wrong.

There are several reasons why a designer might prefer to specify unjustified, or ragged-right, type. For one, in the absence of a sophisticated hyphenation-and-justification program to make line-break and word-space decisions, ragged-right type prevents big empty spaces within a line by putting all the extra space at the end. In fact, early computerized typesetting equipment had inadequate hyphenation-and-justification programs with the same limitations seen in many desktop computer systems today.

UNJUSTIFIED SETTING

These inadequacies probably led many designers to start using ragged-right setting. Ragged-right setting remains the best choice for most desktop publishing equipment.

As we have seen in Chapter 5, even with excellent hyphenation-and-justification, very narrow type measures present certain word spacing problems; these can be avoided by using ragged-right setting. In multi-column material, a ragged-right setting often helps to keep the columns visually separated, and it also automatically adds a certain amount of white space to a full page. You may also find the informality of a ragged-right setting appropriate to certain kinds of material.

Setting ragged right, however, is not a way of avoiding typesetting problems. Other decisions have to be made. For example, how much of a ragged edge is desirable? Designers differ in what they consider a good-looking rag. Some prefer a very small amount of variation between line lengths, and others prefer a strongly irregular edge. Achieving the desired result requires some method of controlling the line endings. One method is to specify the rag in minimum and maximum allowable measures. To keep within these limits, some lines may require varying

word space, the use of which defeats, at least to some degree, the ideal of even word space. Another method of controlling the degree of rag is by permitting or forbidding hyphenation. If no hyphenation is permitted, the rag will be rougher than it would be if words could be broken. If hyphenation is not permitted on a narrow measure, the rag will have some lines that are too short, especially in copy containing longish words. On the other hand, if hyphenation is permitted on a wide measure, many lines will look almost justified. There are intermediate positions, such as specifying no two hyphenations in a row, or hyphenation permitted only to avoid lines shorter than the specified minimum.

The appearance of unjustified settings is determined by the relationship of the amount of rag to the length of the lines and to the amount of space between the lines. Control of the shape of the right edge, with the longer and shorter lines varying constantly but unobtrusively, may not be achievable by programming alone. It may require operator intervention. On the following pages we will look at unjustified type set at different measures, with and without hyphenation, with and without variable word space, and with differing amounts of line spacing.

UNJUSTIFIED SETTING AND HYPHENATION

Deciding whether or not to hyphenate words is particularly important when specifying a ragged right on a narrow pica measure. The samples on this page demonstrate the way in which hyphenation affects the rag in a 12-pica measure. In sample 1, no hyphenation was allowed and you can see that the rag is extremely rough, with several very short lines. Example 2 is hyphenated freely, resulting in ten hyphenated lines, two of which are consecutive pairs. This setting has a rather smooth right edge and several groups of lines even seem to be nearly justified. Sample 3 uses moderate hyphenation with no consecutive pairs and no two-character hyphenations allowed. Notice that there are only five hyphenated lines in this sample. This moderate hyphenation avoids the very short lines of 1 and the almost justified groups of lines in 2.

Samples 4 and 5 on the next page show how hyphenation affects the ragged edge of a wider measure. Even though the hyphenated sample (4) contains only three hyphenations, there seems to be too little line variation in general, since the degree of variation is seen in relation to the total line length. With no hyphenation, the right edge in 5 varies nicely in proportion to the line length.

Samples 6 and 7 reveal similar results on an intermediate measure of 18 picas. Neither 6, in which normal hyphenation was allowed, nor 7, in which no hyphenation was allowed, are entirely satisfactory. Some groups of lines in 6 are too close in length and, in 7, a few lines appear short in relation to the measure. One or two judicious hyphenations would improve 7.

The next morning, in the printing office, Edwin came upon Big James giving a lesson in composing to the younger apprentice, who in theory had 'learned his cases'. Big James held the composing stick in his great left hand, like a match-box, and with his great right thumb and index picked letter after letter from the case, very slowly in order to display the movement, and dropped them into the stick. In his mild, resonant tones he explained that each letter must be picked up unfalteringly in a particular way, so that it would drop face upward into the stick without any intermediate manipulation. And he explained also that the left hand must be held so that the right hand would have to travel to and fro as little as possible. He was revealing the basic mysteries of his craft, and was happy, making the while the broad series of stock pleasantries which have probably been current in composing rooms since printing was invented. Then he was silent, working more and more quickly,

1 10/12 HELVETICA: NO HYPHENATION

The next morning, in the printing office, Edwin came upon Big James giving a lesson in composing to the younger apprentice, who in theory had 'learned his cases'. Big James held the composing stick in his great left hand, like a match-box, and with his great right thumb and index picked letter after letter from the case, in order to display movement, and dropped them into the stick. In his mild, resonant tones he explained that each letter must be picked up unfalteringly in a particular way, so that it would drop face upward into the stick without any intermediate manipulation. And he explained also that the left hand must be held so that the right hand would have to travel to and fro as little as possible. He was revealing the basic mysteries of his craft, and was happy, making the while the broad series of stock pleasantries which have probably been current in composing rooms since printing was invented. Then he was silent, working quickly, till his right hand could scarcely be followed in its twinklings, and the face of the appren-

The next morning, in the printing office, Edwin came upon Big James giving a lesson in composing to the younger apprentice, who in theory had 'learned his cases'. Big James held the composing stick in his great left hand, like a match-box, and with his great right thumb and index picked letter after letter from the case, very slowly in order to display the movement, and dropped them into the stick. In his mild, resonant tones he explained that each letter must be picked up unfalteringly in a particular way, so that it would drop face upward into the stick without any intermediate manipulation. And he explained also that the left hand must be held so that the right hand would have to travel to and fro as little as possible. He was revealing the basic mysteries of his craft, and was happy, making the while the broad series of stock pleasantries which have probably been current in composing rooms since printing was invented. Then he was silent, working more and more quickly, till his right hand could scarcely

The next morning, in the printing office, Edwin came upon Big James giving a lesson in composing to the younger apprentice, who in theory had 'learned his cases'. Big James held the composing stick in his great left hand, like a match-box, and with his great right thumb and index picked letter after letter from the case, very slowly in order to display the movement, and dropped them into the stick. In his mild, resonant tones he explained that each letter must be picked up unfalteringly in a particular way, so that it would drop face upward into the stick without any intermediate manipulation. And he explained also that the left hand must be held so that the right hand would have to travel to and fro as little as possible. He was revealing the basic mysteries of his craft, and was happy, making the while the broad series of stock pleasantries which have probably been current in composing rooms since printing was invented. Then he was silent, working more and more quickly, till his right hand could scarcely be followed in its twinklings, and the face of the apprentice duly spread in marvel. When the line was finished he drew out the rule, clapped it down on the top of the last row of letters, and gave the composing stick to the apprentice to essay.

The apprentice began to compose with his feet, his shoulders, his mouth, his eyebrows—with all his body except his hands, which nevertheless travelled spaciously far and wide.

'It's not in seven year, nor in seventy, as you'll learn, young sun of a gun!' said Big James.

And, having unsettled the youth to his foundations with a bland thwack across the head, he resumed the composing stick and began again the exposition of the unique smooth movement which is the root of rapid typesetting.

'Here!' said Big James, when the apprentice had behaved worse than ever. 'Us'll ask Mr Edwin to have a go. 'Us'll see what *he*'ll do.'

And Edwin, sheepish, had to comply. He was in pride bound to

The next morning, in the printing office, Edwin came upon Big James giving a lesson in composing to the younger apprentice, who in theory had 'learned his cases'. Big James held the composing stick in his great left hand, like a match-box, and with his great right thumb and index picked letter after letter from the case, in order to display movement, and dropped them into the stick. In his mild, resonant tones he explained that each letter must be picked up unfalteringly in a particular way, so that it would drop face upward into the stick without any intermediate manipulation. And he explained also that the left hand must be held so that the right hand would have to travel to and fro as little as possible. He was revealing the basic mysteries of his craft, and was happy, making the while the broad series of stock pleasantries which have probably been current in composing rooms since printing was invented. Then he was silent, working quickly, till his right hand could scarcely be followed in its twinklings, and the face of the apprentice duly spread in marvel. When the line was finished he drew out the rule, clapped it down on the top of the last row of letters, and gave the composing stick to the apprentice to essay.

The apprentice began to compose with his feet, his shoulders, his mouth, his eyebrows—with all his body except his hands, which nevertheless travelled spaciously far and wide.

'It's not in seven year, nor in seventy, as you'll learn, young sun of a gun!' said Big James.

And, having unsettled the youth to his foundations with a bland thwack across the head, he resumed the composing stick and began again the exposition of the unique smooth movement which is the root of rapid typesetting.

'Here!' said Big James, when the apprentice had behaved worse than ever. 'Us'll ask Mr Edwin to have a go. 'Us'll see what *he*'ll do.'

The next morning, in the printing office, Edwin came upon Big James giving a lesson in composing to the younger apprentice, who in theory had 'learned his cases'. Big James held the composing stick in his great left hand, like a match-box, and with his great right thumb and index picked letter after letter from the case, very slowly in order to display the movement, and dropped them into the stick. In his mild, resonant tones he explained that each letter must be picked up unfalteringly in a particular way, so that it would drop face upward into the stick without any intermediate manipulation. And he explained also that the left hand must be held so that the right hand would have to travel to and fro as little as possible. He was revealing the basic mysteries of his craft, and was happy, making the while the broad series of stock pleasantries which have probably been current in composing rooms since printing was invented. Then he was silent, working more and more quickly, till his right hand could scarcely be followed in its twinklings, and the face of the apprentice duly spread in marvel. When the line was finished he drew out the rule, clapped it down on the top of the last row of letters, and gave the composing stick to the apprentice to essay.

The apprentice began to compose with his feet, his shoulders, his mouth, his eyebrows—with all his body except his hands, which nevertheless travelled spaciously far and wide.

'It's not in seven year, nor in seventy, as you'll learn, young sun of a gun!' said Big James.

The next morning, in the printing office, Edwin came upon Big James giving a lesson in composing to the younger apprentice, who in theory had 'learned his cases'. Big James held the composing stick in his great left hand, like a match-box, and with his great right thumb and index picked letter after letter from the case, very slowly in order to display the movement, and dropped them into the stick. In his mild, resonant tones he explained that each letter must be picked up unfalteringly in a particular way, so that it would drop face upward into the stick without any intermediate manipulation. And he explained also that the left hand must be held so that the right hand would have to travel to and fro as little as possible. He was revealing the basic mysteries of his craft, and was happy, making the while the broad series of stock pleasantries which have probably been current in composing rooms since printing was invented. Then he was silent, working more and more quickly, till his right hand could scarcely be followed in its twinklings, and the face of the apprentice duly spread in marvel. When the line was finished he drew out the rule, clapped it down on the top of the last row of letters, and gave the composing stick to the apprentice to essay.

The apprentice began to compose with his feet, his shoulders, his mouth, his eyebrows—with all his body except his hands, which nevertheless travelled spaciously far and wide.

'It's not in seven year, nor in seventy, as you'll

The spaces between the lines have as great an effect on the appearance of unjustified settings as the line length. In examples 1 and 2, the type is large, the measure narrow, and the line spacing tight. The texture is very dense. Here the tight rag, achieved by hyphenating freely, looks good in relation to the overall texture. The rough rag of 1 looks even rougher in contrast to the dense texture. It is instructive to compare examples 3 and 4 with 1 and 2. The specifications and line breaks are identical, but 1 and 2 have been set with an overall space reduction (kern) between the characters. This makes the overall texture in 1 and 2 much denser than in 3 and 4. The relation of the rougher rag in 3 to the overall texture is quite different. While I would not recommend the loose settings of 3 and 4, these examples do demonstrate quite clearly the way in which the overall texture of the copy relates to the degree of rag and how much this is changed by altering the character spacing.

Example 5 shows the way greater line spacing affects the rag. The line spacing here is so great that the small differences of line lengths in this hyphenated example are barely perceptible; the effect of the last few lines is that of very poorly set justified copy.

The next morning, in the printing office, Edwin came upon Big James giving a lesson in composing to the younger apprentice, who in theory had 'learned his cases'. Big James held the composing stick in his great left hand, like a match-box, and with his great right thumb and index picked letter after letter from the case, very slowly in order to display the movement, and dropped them into the stick. In his mild, resonant tones he explained that each letter must be picked up unfalteringly in a particular way, so that it would drop face upward into the stick without any intermediate manipulation. And he explained also that the left hand must be held so that the right hand would have to travel to and fro as little as possible. He was revealing the basic mysteries of his craft, and was happy, making the while the broad series of stock pleasantries which have probably been current in composing rooms since

1 **11/11 TIMES ROMAN:**
 NO HYPHENATION, KERNED

The next morning, in the printing office, Edwin came upon Big James giving a lesson in composing to the younger apprentice, who in theory had 'learned his cases'. Big James held the composing stick in his great left hand, like a match-box, and with his great right thumb and index picked letter after letter from the case, very slowly in order to display the movement, and dropped them into the stick. In his mild, resonant tones he explained that each letter must be picked up unfalteringly in a particular way, so that it would drop face upward into the stick without any intermediate manipulation. And he explained also that the left hand must be held so that the right hand would have to travel to and fro as little as possible. He was revealing the basic mysteries of his craft, and was happy, making the while the broad series of stock pleasantries which have probably been current in composing rooms since printing was invented. Then he was silent,

2 **11/11 TIMES ROMAN:**
 HYPHENATION, KERNED

The next morning, in the printing office, Edwin came upon Big James giving a lesson in composing to the younger apprentice, who in theory had 'learned his cases'. Big James held the composing stick in his great left hand, like a match-box, and with his great right thumb and index picked letter after letter from the case, very slowly in order to display the movement, and dropped them into the stick. In his mild, resonant tones he explained that each letter must be picked up unfalteringly in a particular way, so that it would drop face upward into the stick without any intermediate manipulation. And he explained also that the left hand must be held so that the right hand would have to travel to and fro as little as possible. He was revealing the basic mysteries of his craft, and was happy, making the while the broad series of stock pleasantries which have probably been current in composing rooms since

The next morning, in the printing office, Edwin came upon Big James giving a lesson in composing to the younger apprentice, who in theory had 'learned his cases'. Big James held the composing stick in his great left hand, like a match-box, and with his great right thumb and index picked letter after letter from the case, very slowly in order to display the movement, and dropped them into the stick. In his mild, resonant tones he explained that each letter must be picked up unfalteringly in a particular way, so that it would drop face upward into the stick without any intermediate manipulation. And he explained also that the left hand must be held so that the right hand would have to travel to and fro as little as possible. He was revealing the basic mysteries of his craft, and was happy, making the while the broad series of stock pleasantries which have probably been current in composing rooms since printing was invented. Then he was silent,

The next morning, in the printing office, Edwin came upon Big James giving a lesson in composing to the younger apprentice, who in theory had 'learned his cases'. Big James held the composing stick in his great left hand, like a match-box, and with his great right thumb and index picked letter after letter from the case, very slowly in order to display the movement, and dropped them into the stick. In his mild, resonant tones he explained that each letter must be picked up unfalteringly in a particular way, so that it would drop face upward into the stick without any intermediate manipulation. And he explained also that the left hand must be held so that the right hand would have to travel to and fro as little as possible. He

On a wider measure very rough rags can be extremely attractive, but the degree of roughness should be proportional to the line spacing. Example 1 looks too rough in relation to the line space, but adding space, as in examples 2 and 3, creates a pleasing effect.

The next morning, in the printing office, Edwin came upon Big James giving a lesson in composing to the younger apprentice, who in theory had 'learned his cases'. Big James held the composing stick in his great left hand, like a match-box, and with his great right thumb and index picked letter after letter from the case, very slowly in order to display the movement, and dropped them into the stick. In his mild, resonant tones he explained that each letter must be picked up unfalteringly in a particular way, so that it would drop face upward into the stick without any intermediate manipulation. And he explained also that the left hand must be held so that the right hand would have to travel to and fro as little as possible. He was revealing the basic mysteries of his craft, and was happy, making the while the broad series of stock pleasantries which have probably been current in composing rooms since printing was invented. Then he was silent, working more and more quickly, till his right hand could scarcely be followed in its twinklings, and the face of the apprentice spread in marvel. When the line was finished he drew out the rule, clapped it down on top of the last row of letters, and gave the composing stick to the apprentice to essay.

The apprentice began to compose with his feet, his cases'. Big James held the composing stick in his great left hand, like a match-box, and with his great right thumb and index picked letter after letter from the case, very slowly in order to display the movement, and dropped them into the stick. In his mild, resonant tones he explained that each letter must be picked up unfalteringly in a particular way, so that it would drop face upward into the stick without any intermediate manipulation. And he explained also that the left hand must be held so that the right hand would have to travel to and fro as little as possible. He was revealing the basic mysteries of his craft, and was happy, making the

1 10/10 TIMES ROMAN: NO HYPHENATION

The next morning, in the printing office, Edwin came upon Big James giving a lesson in composing to the younger apprentice, who in theory had 'learned his cases'. Big James held the composing stick in his great left hand, like a match-box, and with his great right thumb and index picked letter after letter from the case, very slowly in order to display the movement, and dropped them into the stick. In his mild, resonant tones he explained that each letter must be picked up unfalteringly in a particular way, so that it would drop face upward into the stick without any intermediate manipulation. And he explained also that the left hand must be held so that the right hand would have to travel to and fro as little as possible. He was revealing the basic mysteries of his craft, and was happy, making the while the broad series of stock pleasantries which have probably been current in composing rooms since printing was invented. Then he was silent, working more and more quickly, till his right hand could scarcely be followed in its twinklings, and the face of the apprentice spread in marvel. When the line was finished he drew out the rule, clapped it down on top of the last row of letters, and gave the composing stick to the apprentice to essay.

The apprentice began to compose with his feet, his shoulders, his mouth, his eyebrows—with all his body upon Big James giving a lesson in composing to the younger apprentice, who in theory had 'learned his cases'. Big James held the composing stick in his great left hand, like a match-box, and with his great right thumb and index picked letter after letter from the

The next morning, in the printing office, Edwin came upon Big James giving a lesson in composing to the younger apprentice, who in theory had 'learned his cases'. Big James held the composing stick in his great left hand, like a match-box, and with his great right thumb and index picked letter after letter from the case, very slowly in order to display the movement, and dropped them into the stick. In his mild, resonant tones he explained that each letter must be picked up unfalteringly in a particular way, so that it would drop face upward into the stick without any intermediate manipulation. And he explained also that the left hand must be held so that the right hand would have to travel to and fro as little as possible. He was revealing the basic mysteries of his craft, and was happy, making the while the broad series of stock pleasantries which have probably been current in composing rooms since printing was invented. Then he was silent, working more and more quickly, till his right hand could scarcely be followed in its twinklings, and the face of the apprentice spread in marvel. When the line was finished he drew out the rule, clapped it down on top of the last row of letters, and gave the composing stick to the apprentice to essay.

The apprentice began to compose with his feet, his shoulders, his mouth, his eyebrows—with all his body except his hands, which nevertheless travelled

EVALUATING THE EDGE

Examples 1, 2, and 3 show some rather subtle differences in edge shape and point up some of the hard choices that you might need to make. Squint a bit and concentrate on the shapes of the right edges. You will see that 1 contains some consecutive groups of lines that form regular slopes. It also has a very short line. Example 2 has no hyphenation and so is quite rough, but since the line width and the line spacing are nicely proportioned, some designers might prefer it to 3. However, the second paragraph has all short lines, and it, too, has a very short line. Example 3 solves the widow problem in both paragraphs and eliminates the very short lines. This excellent result was achieved only by manipulating some lines with the addition and removal of small amounts of character space and by a judicious use of hyphenation. Getting results like this rag is time-consuming and expensive.

The next morning, in the printing office, Edwin came upon Big James giving a lesson in composing to the younger apprentice, who in theory had 'learned his cases'. Big James held the composing stick in his great left hand, like a match-box, and with his great right thumb and index picked letter after letter from the case, very slowly in order to display the movement, and dropped them into the stick. In his mild, resonant tones he explained that each letter must be picked up unfalteringly in a particular way, so that it would drop face upward into the stick without any intermediate manipulation. And he explained also that the left hand must be held so that the right hand would have to travel to and fro as little as possible. He was revealing the basic mysteries of his craft, and was happy, making the while the broad series of stock pleasantries which have probably been current in composing rooms since printing was invented. Then he was silent, working more and more quickly, till his right hand could scarcely be followed in its twinklings, and the face of the apprentice spread in marvel. When the line was finished he drew out the rule, clapped it down on top of the last row of letters, and gave the composing stick to the apprentice to essay.

The apprentice began to compose with his feet, his shoulders, his mouth, his eyebrows—with all his body except his hands, which nevertheless travelled spaciously far and wide.

'It's not in seven year, nor in seventy, as you'll learn, young sun of a gun!' said Big James.

And, having unsettled the youth to his foundations with a bland thwack across the head, he resumed the composing stick and

1 10/14 TIMES ROMAN: HYPHENATION ALLOWED

The next morning, in the printing office, Edwin came upon Big James giving a lesson in composing to the younger apprentice, who in theory had 'learned his cases'. Big James held the composing stick in his great left hand, like a match-box, and with his great right thumb and index picked letter after letter from the case, in order to display movement, and dropped them into the stick. In his mild, resonant tones he explained that each letter must be picked up unfalteringly in a particular way, so that it would drop face upward into the stick without any intermediate manipulation. And he explained also that the left hand must be held so that the right hand would have to travel to and fro as little as possible. He was revealing the basic mysteries of his craft, and was happy, making the while the broad series of stock pleasantries which have probably been current in composing rooms since printing was invented. Then he was silent, working quickly, till his right hand could scarcely be followed in its twinklings, and the face of the apprentice duly spread in marvel. When the line was finished he drew out the rule, clapped it down on the top of the last row of letters, and gave the composing stick to the apprentice to essay.

The apprentice began to compose with his two feet, his shoulders, his mouth, his eyebrows—with all his body except his hands, which nevertheless travelled spaciously far and wide.

'It's not in seven year, nor in seventy, as you'll learn, young sun of a gun!' said Big James.

And, having unsettled the youth to his foundations with a bland thwack across the head, he resumed the composing stick and

The next morning, in the printing office, Edwin came upon Big James giving a lesson in composing to the younger apprentice, who in theory had 'learned his cases'. Big James held the composing stick in his great left hand, like a match-box, and with his great right thumb and index picked letter after letter from the case, very slowly in order to display the movement, and dropped them into the stick. In his mild, resonant tones he explained that each letter must be picked up unfalteringly in a particular way, so that it would drop face upward into the stick without any intermediate manipulation. And he explained also that the left hand must be held so that the right hand would have to travel to and fro as little as possible. He was revealing the basic mysteries of his craft, and was happy, making the while the broad series of stock pleasantries which have probably been current in composing rooms since printing was invented. Then he was silent, working more and more quickly, till his right hand could scarcely be followed in its twinklings, and the face of the apprentice duly spread in marvel. When the line was finished he drew out the rule, clapped it down on the top of the last row of letters, and gave the composing stick to the apprentice to essay.

The apprentice began to compose with his feet, his shoulders, his mouth, his eyebrows—with all his body except his hands, which nevertheless travelled spaciously far and wide.

'It's not in seven year, nor in seventy, as you'll learn, young sun of a gun!' said Big James.

And, having unsettled the youth to his foundations with a

UNJUSTIFIED SETTING AND PARAGRAPH INDENTION

Much of the rag's effectiveness lies in the contrast between the rigid left edge with the ragged right edge. This is particularly evident in multi-column material. Compare examples 1 and 2. The proportionally deep paragraph indent (2 ems) in 1 causes the second column to appear ragged both left and right. The rag in 2 is more effective because the paragraph indent is only 1 en.

An elegant way of setting rag copy is with paragraph openings set flush left, with a bit of added space between the paragraphs to signal breaks. In multi-column material, however, this method means that lines across the columns will not align, nor will the columns align at the foot without hand manipulation of the spaces between the paragraphs (see example 3). You can solve this, of course, by inserting a full line of space between paragraphs. On a narrow measure, however, inserting a full line creates a space that will look too large. Another solution, which is not always appropriate, is to deliberately vary the column length at the foot.

The next morning, in the printing office, Edwin came upon Big James giving a lesson in composing to the younger apprentice, who in theory had 'learned his cases'. Big James held the composing stick in his great left hand, like a matchbox, and with his great right thumb and index picked letter after letter from the case, very slowly in order to display the movement, and dropped them into the stick.

In his mild, resonant tones he explained that each letter must be picked up unfalteringly in a particular way, so that it would drop face upward into the stick without any intermediate manipulation. And he explained also that the left hand must be held so that the right hand would have to travel to and fro as little as possible. He was revealing the basic mysteries of his craft, and was happy, making the while the broad series of stock pleasantries which have probably been current in composing rooms since printing was invented.

Then he was silent, working more and more quickly, till his right hand could scarcely be followed in its twinklings, and the face of the apprentice spread in marvel. When the line was finished he drew out the rule, clapped it down on the top of the last row of letters, and gave the composing stick to the apprentice to essay. When the line was finished he drew out the rule, clapped it down on top of the last row of letters, and gave the composing stick to the apprentice to essay.

The apprentice began to compose with his feet, his shoulders, his mouth, his eyebrows —with all his body except his hands, which nevertheless travelled spaciously far and wide.

'It's not in seven year, nor in seventy, as you'll learn, young sun of a gun!' said Big James.

And, having unsettled the youth to his foundations with a bland thwack across the head, he resumed the composing stick and began again the exposition of the unique smooth movement which is the root of rapid typesetting.

'Here!' said Big James, when the apprentice had behaved worse than ever. 'Us'll ask Mr Edwin to have a go. 'Us'll see what *he*'ll do.

And Edwin, sheepish, had to comply. He was in pride bound to surpass the apprentice, and did so.

'There!' said Big James. 'What did I tell ye?' He seemed to imply a prophecy that, because Edwin

1 9/11 GILL SANS LIGHT : 2 EM PARAGRAPH INDENT

The next morning, in the printing office, Edwin came upon Big James giving a lesson in composing to the younger apprentice, who in theory had 'learned his cases'. Big James held the composing stick in his great left hand, like a matchbox, and with his great right thumb and index picked letter after letter from the case, very slowly in order to display movement, and dropped them into the stick.

In his mild, resonant tones he explained that each letter must be picked up unfalteringly in a particular way, so that it would drop face upward into the stick without any intermediate manipulation. And he explained also that the left hand must be held so that the right hand would have to travel to and fro as little as possible. He was revealing the basic mysteries of his craft, and was happy, making the while the broad series of stock pleasantries which have probably been current in composing rooms since printing was invented.

Then he was silent, working quickly, till his right hand could scarcely be followed in its twinklings, and the face of the apprentice duly spread in marvel. When the line was finished he drew out the rule, clapped it down on the top of the last row of letters, and gave the composing stick to the apprentice to essay.

The apprentice began to compose with his feet, his shoulders, his mouth, his eyebrows—with all his body except his hands, which nevertheless travelled spaciously far and wide.

'It's not in seven year, nor in seventy, as you'll learn, young sun of a gun!' said Big James.

And, having unsettled the youth to his foundations with a bland thwack across the head, he resumed the composing stick and began again the exposition of the unique smooth movement which is the root of rapid typesetting.

'Here!' said Big James, when the apprentice had behaved worse than ever. 'Us'll ask Mr Edwin to have a go. 'Us'll see what *he*'ll do.

And Edwin, sheepish, had to comply. He was in pride bound to surpass the apprentice, and did so.

'There!' said Big James. 'What did I tell ye?' He seemed to imply a prophecy that, because Edwin had saved the printing office from destruction two days previously, he would prove to be a born compositor.

The next morning, in the printing

The next morning, in the printing office, Edwin came upon Big James giving a lesson in composing to the younger apprentice, who in theory had 'learned his cases'. Big James held the composing stick in his great left hand, like a matchbox, and with his great right thumb and index picked letter after letter from the case, very slowly in order to display the movement, and dropped them into the stick.

In his mild, resonant tones he explained that each letter must be picked up unfalteringly in a particular way, so that it would drop face upward into the stick without any intermediate manipulation. And he explained also that the left hand must be held so that the right hand would have to travel to and fro as little as possible. He was revealing the basic mysteries of his craft, and was happy, making the while the broad series of stock pleasantries which have probably been current in composing rooms since printing was invented.

Then he was silent, working more and more quickly, till his right hand could scarcely be followed in its twinklings, and the face of the apprentice duly spread in marvel. When the line was finished he drew out the rule, clapped it down on the top of the last row of letters, and gave the composing stick to the apprentice to essay.

The apprentice began to compose with his feet, his shoulders, his mouth, his eyebrows—with all his body except his hands, which nevertheless travelled spaciously far and wide.

'It's not in seven year, nor in seventy, as you'll learn, young sun of a gun!' said Big James.

And, having unsettled the youth to his foundations with a bland thwack across the head, he resumed the composing stick and began again the exposition of the unique smooth movement which is the root of rapid typesetting.

'Here!' said Big James, when the apprentice had behaved worse than ever. 'Us'll ask Mr Edwin to have a go. 'Us'll see what *he*'ll do.

And Edwin, sheepish, had to comply. He was in pride bound to surpass the apprentice, and did so.

'There!' said Big James. 'What did I tell ye?' He seemed to imply a prophecy that, because Edwin had saved the printing office from destruction two days previously, he would prove to be a born

UNJUSTIFIED SETTING AND LINE SPACING, MEASURE, AND DEGREE OF RAG

The appearance of a rag is affected by all the spacing elements in setting. Examples 1 and 2 have identical line breaks but different line spacing. While 1 appears much too jagged, example 2 looks acceptable because it has 3 more points of space between the lines. If your preference is for rough rags, you may find 2 ideal. Set on a wider measure, example 3 has the same line spacing as 2, with about the same degree of roughness in the rag. On this measure and with this spacing, any less roughness would appear disproportionate.

The next morning, in the printing office, Edwin came upon Big James giving a lesson in composing to the younger apprentice, who in theory had 'learned his cases'. Big James held the composing stick in his great left hand, like a match-box, and with his great right thumb and index picked letter after letter from the case, very slowly in order to display the movement, and dropped them into the stick. In his mild, resonant tones he explained that each letter must be picked up unfalteringly in a particular way, so that it would drop face upward into the stick without any intermediate manipulation. And he explained also that the left hand must be held so that the right hand would have to travel to and fro as little as possible. He was revealing the basic mysteries of his craft, and was happy, making the while the broad series of stock pleasantries which have probably been current in composing rooms since printing was invented. Then he was silent, working more and more quickly, till his right hand could scarcely be followed in its twinklings, and the face of the apprentice duly spread in marvel. When the line was finished he drew out the rule, clapped it down on the top of the last row of letters, and gave the composing stick to the apprentice to essay.

The apprentice began to compose with his feet, his shoulders, his mouth, his eyebrows—with all his body except his hands, which nevertheless travelled spaciously far and wide.

'It's not in seven year, nor in seventy, as

1 10/11 GILL SANS LIGHT : NO HYPHENATION ALLOWED

The next morning, in the printing office, Edwin came upon Big James giving a lesson in composing to the younger apprentice, who in theory had 'learned his cases'. Big James held the composing stick in his great left hand, like a match-box, and with his great right thumb and index picked letter after letter from the case, very slowly in order to display the movement, and dropped them into the stick. In his mild, resonant tones he explained that each letter must be picked up unfalteringly in a particular way, so that it would drop face upward into the stick without any intermediate manipulation. And he explained also that the left hand must be held so that the right hand would have to travel to and fro as little as possible. He was revealing the basic mysteries of his craft, and was happy, making the while the broad series of stock pleasantries which have probably been current in composing rooms since printing was invented. Then he was silent, working more and more quickly, till his right hand could scarcely be followed in its twinklings, and the face of the apprentice duly spread in marvel. When the line was finished he drew out the rule, clapped it down on the

The next morning, in the printing office, Edwin came upon Big James giving a lesson in composing to the younger apprentice, who in theory had 'learned his cases'. Big James held the composing stick in his great left hand, like a match-box, and with his great right thumb and index picked letter after letter from the case, very slowly in order to display the movement, and dropped them into the stick. In his mild, resonant tones he explained that each letter must be picked up unfalteringly in a particular way, so that it would drop face upward into the stick without any intermediate manipulation. And he explained also that the left hand must be held so that the right hand would have to travel to and fro as little as possible. He was revealing the basic mysteries of his craft, and was happy, making the while the broad series of stock pleasantries which have probably been current in composing rooms since printing was invented. Then he was silent, working more and more quickly, till his right hand could scarcely be followed in its twinklings, and the face of the apprentice duly spread in marvel. When the line was finished he drew out the rule, clapped it down on the top of the last row of letters, and gave the composing stick to the apprentice to essay.

The apprentice began to compose with his feet, his shoulders, his mouth, his eyebrows—with all his body except his hands, which nevertheless travelled spaciously far and wide.

'It's not in seven year, nor in seventy, as you'll learn, young sun of a gun!' said Big James.

And, having unsettled the youth to his foundations with a bland thwack across the head, he resumed the composing stick and began again the exposition of the unique smooth movement which is the root of rapid typesetting.

CHARACTER ALTERATION

Advanced technology brings some ambiguous blessings, among them the ability of typesetting systems to alter the proportion and slope of characters. Many systems can set characters to the width of one size and to the height of another (called "changing the set width"). These systems can also slope characters, usually about 14 degrees, producing a sloped version of a roman face, which is sometimes miscalled an italic.

A face can be condensed by specifying that it be set with the character width of a smaller size; for example, you can specify 10-point characters to be set with the width of the same face in 9 point. The same 10-point face could be expanded by having it set to the width of 11 point. Varying the width-height proportions of a face can be a useful device for a designer looking for a specific effect, but you should use extreme caution when changing the set width. More than a slight change tends to distort the characters, producing an unreadable and often ugly result. Some faces work better than others for either condensing or expanding, as we will see in the following pages.

Sloping a roman face is another technique to be used cautiously. Some faces, mostly sans serifs, use as their italic the same character design as the roman in a sloped form. For faces like these, a machine-sloped roman looks fine and can be used if no italic is available. However, most serif faces have italics that are quite different in letterform from their romans; for these faces, sloping the roman results in something quite different from the italic.

There may be times when you prefer to change the set width or to machine-slope a roman face. Even a half-point alteration in set width can solve problems of copyfitting, character design, or overall color that cannot be solved simply by selecting another face. And there may be some uses for which a sloped roman is preferable. It's important to know when character alteration is advisable and when it produces undesirable results.

In this chapter we will look at set-width alterations of various degrees on faces of different characteristics, and also at some sloped romans, comparing them to true italics.

ALTERING A FACE WITH NORMAL PROPORTIONS AND THICK/THIN RELATIONSHIPS

These examples demonstrate what happens with computer-generated character alteration of a normal font. Example 1 shows Baskerville set normally; 2 shows it set to the width of 9½ point, and 3 shows it set to the width of 9 point. You can see that even the ½-point reduction makes a perceptible difference in both the overall color and the proportion of letters, and a full point of reduction creates a letterform that is definitely condensed.

The equivalent amounts of expansion are shown on the next spread in 4 and 5. A full point of change in the set width in either direction creates what is essentially a new face. In the full-point expansion, not only do the letter proportions change, but the thick/thin relationships change as well.

Example 6 shows Baskerville roman artificially sloped. Compare it to 7, the true italic. Clearly, in a serif typeface like Baskerville, a machine-sloped roman and a true italic are entirely unrelated faces.

The next morning, in the printing office, Edwin came upon Big James giving a lesson in composing to the younger apprentice, who in theory had 'learned his cases'. Big James held the composing stick in his great left hand, like a match-box, and with his great right thumb and index picked letter after letter from the case, very slowly in order to display the movement, and dropped them into the stick. In his mild, resonant tones he explained that each letter must be picked up unfalteringly in a particular way, so that it would drop face upward into the stick without any intermediate manipulation. And he explained also that the left hand must be held so that the right hand would have to travel to and fro as little as possible. He was revealing the basic mysteries of his craft, and was happy, making the while the broad series of stock pleasantries which have probably been current in composing rooms since printing was invented. Then he was silent, working more and more quickly, till his right hand could scarcely be followed in its twinklings, and the face of the apprentice duly spread in marvel. When the line was finished he drew out the rule, clapped it down on the top of the last row of letters, and gave the composing stick to the apprentice to essay.

The apprentice began to compose with his feet, his shoulders, his mouth, his eyebrows—with all his body except his hands, which nevertheless travelled spaciously far and wide.

'It's not in seven year, nor in seventy, as you'll learn, young sun of a gun!' said Big James.

And, having unsettled the youth to his foundations with a bland thwack across the head, he resumed the

1 10/12 BASKERVILLE: NORMAL SET WIDTH

The next morning, in the printing office, Edwin came upon Big James giving a lesson in composing to the younger apprentice, who in theory had 'learned his cases'. Big James held the composing stick in his great left hand, like a match-box, and with his great right thumb and index picked letter after letter from the case, in order to display movement, and dropped them into the stick. In his mild, resonant tones he explained that each letter must be picked up unfalteringly in a particular way, so that it would drop face upward into the stick without any intermediate manipulation. And he explained also that the left hand must be held so that the right hand would have to travel to and fro as little as possible. He was revealing the basic mysteries of his craft, and was happy, making the while the broad series of stock pleasantries which have probably been current in composing rooms since printing was invented. Then he was silent, working quickly, till his right hand could scarcely be followed in its twinklings, and the face of the apprentice duly spread in marvel. When the line was finished he drew out the rule, clapped it down on the top of the last row of letters, and gave the composing stick to the apprentice to essay.

The apprentice began to compose with his feet, his shoulders, his mouth, his eyebrows—with all his body except his hands, which nevertheless travelled spaciously far and wide.

'It's not in seven year, nor in seventy, as you'll learn, young sun of a gun!' said Big James.

And, having unsettled the youth to his foundations with a bland thwack across the head, he resumed the composing stick and began again the exposition of the unique smooth movement which is the root of rapid typesetting.

The next morning, in the printing office, Edwin came upon Big James giving a lesson in composing to the younger apprentice, who in theory had 'learned his cases'. Big James held the composing stick in his great left hand, like a match-box, and with his great right thumb and index picked letter after letter from the case, very slowly in order to display the movement, and dropped them into the stick. In his mild, resonant tones he explained that each letter must be picked up unfalteringly in a particular way, so that it would drop face upward into the stick without any intermediate manipulation. And he explained also that the left hand must be held so that the right hand would have to travel to and fro as little as possible. He was revealing the basic mysteries of his craft, and was happy, making the while the broad series of stock pleasantries which have probably been current in composing rooms since printing was invented. Then he was silent, working more and more quickly, till his right hand could scarcely be followed in its twinklings, and the face of the apprentice duly spread in marvel. When the line was finished he drew out the rule, clapped it down on the top of the last row of letters, and gave the composing stick to the apprentice to essay.

The apprentice began to compose with his feet, his shoulders, his mouth, his eyebrows—with all his body except his hands, which nevertheless travelled spaciously far and wide.

'It's not in seven year, nor in seventy, as you'll learn, young sun of a gun!' said Big James.

And, having unsettled the youth to his foundations with a bland thwack across the head, he resumed the composing stick and began again the exposition of the unique smooth movement which is the root of rapid typesetting.

'It's not in seven year, nor in seventy, as you'll learn, young

The next morning, in the printing office, Edwin came upon Big James giving a lesson in composing to the younger apprentice, who in theory had 'learned his cases'. Big James held the composing stick in his great left hand, like a match-box, and with his great right thumb and index picked letter after letter from the case, very slowly in order to display the movement, and dropped them into the stick. In his mild, resonant tones he explained that each letter must be picked up unfalteringly in a particular way, so that it would drop face upward into the stick without any intermediate manipulation. And he explained also that the left hand must be held so that the right hand would have to travel to and fro as little as possible. He was revealing the basic mysteries of his craft, and was happy, making the while the broad series of stock pleasantries which have probably been current in composing rooms since printing was invented. Then he was silent, working more and more quickly, till his right hand could scarcely be followed in its twinklings, and the face of the apprentice duly spread in marvel. When the line was finished he drew out the rule, clapped it down on the top of the last row of letters, and gave the composing stick to the apprentice to essay.

The apprentice began to compose with his feet, his shoulders, his mouth, his eyebrows—with all his body except his hands, which nevertheless travelled spaciously far and wide.

'It's not in seven year, nor in seventy, as you'll learn, young sun of a gun!' said Big James.

And, having unsettled the youth to his founda-

The next morning, in the printing office, Edwin came upon Big James giving a lesson in composing to the younger apprentice, who in theory had 'learned his cases'. Big James held the composing stick in his great left hand, like a match-box, and with his great right thumb and index picked letter after letter from the case, in order to display movement, and dropped them into the stick. In his mild, resonant tones he explained that each letter must be picked up unfalteringly in a particular way, so that it would drop face upward into the stick without any intermediate manipulation. And he explained also that the left hand must be held so that the right hand would have to travel to and fro as little as possible. He was revealing the basic mysteries of his craft, and was happy, making the while the broad series of stock pleasantries which have probably been current in composing rooms since printing was invented. Then he was silent, working quickly, till his right hand could scarcely be followed in its twinklings, and the face of the apprentice duly spread in marvel. When the line was finished he drew out the rule, clapped it down on the top of the last row of letters, and gave the composing stick to the apprentice to essay.

The apprentice began to compose with his feet, his shoulders, his mouth, his eyebrows—with all his body except his hands, which nevertheless travelled spaciously far and wide.

'It's not in seven year, nor in seventy, as you'll learn, young sun of a gun!' said Big James.

The next morning, in the printing office, Edwin came upon Big James giving a lesson in composing to the younger apprentice, who in theory had 'learned his cases'. Big James held the composing stick in his great left hand, like a match-box, and with his great right thumb and index picked letter after letter from the case, very slowly in order to display the movement, and dropped them into the stick. In his mild, resonant tones he explained that each letter must be picked up unfalteringly in a particular way, so that it would drop face upward into the stick without any intermediate manipulation. And he explained also that the left hand must be held so that the right hand would have to travel to and fro as little as possible. He was revealing the basic mysteries of his craft, and was happy, making the while the broad series of stock pleasantries which have probably been current in composing rooms since printing was invented. Then he was silent, working more and more quickly, till his right hand could scarcely be followed in its twinklings, and the face of the apprentice duly spread in marvel. When the line was finished he drew out the rule, clapped it down on the top of the last row of letters, and gave the composing stick to the apprentice to essay.

The apprentice began to compose with his feet, his shoulders, his mouth, his eyebrows—with all his body except his hands, which nevertheless travelled spaciously far and wide.

'It's not in seven year, nor in seventy, as you'll learn, young sun of a gun!' said Big James.

And, having unsettled the youth to his foundations with a bland thwack across the head, he resumed the

The next morning, in the printing office, Edwin came upon Big James giving a lesson in composing to the younger apprentice, who in theory had 'learned his cases'. Big James held the composing stick in his great left hand, like a match-box, and with his great right thumb and index picked letter after letter from the case, very slowly in order to display the movement, and dropped them into the stick. In his mild, resonant tones he explained that each letter must be picked up unfalteringly in a particular way, so that it would drop face upward into the stick without any intermediate manipulation. And he explained also that the left hand must be held so that the right hand would have to travel to and fro as little as possible. He was revealing the basic mysteries of his craft, and was happy, making the while the broad series of stock pleasantries which have probably been current in composing rooms since printing was invented. Then he was silent, working more and more quickly, till his right hand could scarcely be followed in its twinklings, and the face of the apprentice duly spread in marvel. When the line was finished he drew out the rule, clapped it down on the top of the last row of letters, and gave the composing stick to the apprentice to essay.

The apprentice began to compose with his feet, his shoulders, his mouth, his eyebrows—with all his body except his hands, which nevertheless travelled spaciously far and wide.

'It's not in seven year, nor in seventy, as you'll learn, young sun of a gun!' said Big James.

And, having unsettled the youth to his foundations with a bland thwack across the head, he resumed the composing stick and began again the exposition of the unique smooth movement which is the root of rapid typesetting.

'Here!' said Big James, when the apprentice had behaved worse than ever. 'Us'll ask Mr Edwin to have a go. 'Us'll see

ALTERING A FACE WITH EXTREME THICK/THIN CONTRAST

In these examples, Bodoni Book is set normally, condensed, and expanded by a full point. You will notice that even though the change is only in the width of the letter, the x-height appears to have changed as well.

The next morning, in the printing office, Edwin came upon Big James giving a lesson in composing to the younger apprentice, who in theory had 'learned his cases'. Big James held the composing stick in his great left hand, like a match-box, and with his great right thumb and index picked letter after letter from the case, very slowly in order to display the movement, and dropped them into the stick. In his mild, resonant tones he explained that each letter must be picked up unfalteringly in a particular way, so that it would drop face upward into the stick without any intermediate manipulation. And he explained also that the left hand must be held so that the right hand would have to travel to and fro as little as possible. He was revealing the basic mysteries of his craft, and was happy, making the while the broad series of stock pleasantries which have probably been current in composing rooms since printing was invented. Then he was silent, working more and more quickly, till his right hand could scarcely be followed in its twinklings, and the face of the apprentice duly spread in marvel. When the line was finished he drew out the rule, clapped it down on the top of the last row of letters, and gave the composing stick to the apprentice to essay.

The apprentice began to compose with his feet, his shoulders, his mouth, his eyebrows—with all his body except his hands, which nevertheless travelled spaciously far and wide.

1 11/14 BODONI BOOK: NORMAL SET WIDTH

The next morning, in the printing office, Edwin came upon Big James giving a lesson in composing to the younger apprentice, who in theory had 'learned his cases'. Big James held the composing stick in his great left hand, like a match-box, and with his great right thumb and index picked letter after letter from the case, in order to display movement, and dropped them into the stick. In his mild, resonant tones he explained that each letter must be picked up unfalteringly in a particular way, so that it would drop face upward into the stick without any intermediate manipulation. And he explained also that the left hand must be held so that the right hand would have to travel to and fro as little as possible. He was revealing the basic mysteries of his craft, and was happy, making the while the broad series of stock pleasantries which have probably been current in composing rooms since printing was invented. Then he was silent, working quickly, till his right hand could scarcely be followed in its twinklings, and the face of the apprentice duly spread in marvel. When the line was finished he drew out the rule, clapped it down on the top of the last row of letters, and gave the composing stick to the apprentice to essay.

The apprentice began to compose with his feet, his shoulders, his mouth, his eyebrows—with all his body except his hands, which nevertheless travelled spaciously far and wide.

'It's not in seven year, nor in seventy, as you'll learn, young sun of a gun!' said Big James.

And, having unsettled the youth to his foundations with a bland thwack across the head, he resumed the composing stick

The next morning, in the printing office, Edwin came upon Big James giving a lesson in composing to the younger apprentice, who in theory had 'learned his cases'. Big James held the composing stick in his great left hand, like a match-box, and with his great right thumb and index picked letter after letter from the case, very slowly in order to display the movement, and dropped them into the stick. In his mild, resonant tones he explained that each letter must be picked up unfalteringly in a particular way, so that it would drop face upward into the stick without any intermediate manipulation. And he explained also that the left hand must be held so that the right hand would have to travel to and fro as little as possible. He was revealing the basic mysteries of his craft, and was happy, making the while the broad series of stock pleasantries which have probably been current in composing rooms since printing was invented. Then he was silent, working more and more quickly, till his right hand could scarcely be followed in its twinklings, and the face of the apprentice duly spread in marvel. When the line was finished he drew out the rule, clapped it down on the top of the last row of letters, and gave the composing stick to the apprentice to essay.

The apprentice began to compose with his feet, his shoulders, his mouth, his eyebrows—with all

ALTERING A FACE OF EVEN STROKE WEIGHT

Century Schoolbook, which has a relatively even stroke weight, is shown here expanded by both a half point and a full point. As the face is expanded, the overall texture becomes more active—even in an even-colored face like this—because of the greater amount of white space within the letters.

The next morning, in the printing office, Edwin came upon Big James giving a lesson in composing to the younger apprentice, who in theory had 'learned his cases'. Big James held the composing stick in his great left hand, like a match-box, and with his great right thumb and index picked letter after letter from the case, very slowly in order to display the movement, and dropped them into the stick. In his mild, resonant tones he explained that each letter must be picked up unfalteringly in a particular way, so that it would drop face upward into the stick without any intermediate manipulation. And he explained also that the left hand must be held so that the right hand would have to travel to and fro as little as possible. He was revealing the basic mysteries of his craft, and was happy, making the while the broad series of stock pleasantries which have probably been current in composing rooms since printing was invented. Then he was silent, working more and more quickly, till his right hand could scarcely be followed in its twinklings, and the face of the apprentice duly spread in marvel. When the line was finished he drew out the rule, clapped it down on the top of the last row of letters, and gave the composing stick to the apprentice to essay.

The apprentice began to compose with his feet, his shoulders, his mouth, his eyebrows—with all his body except his hands, which travelled spaciously far and wide.

'It's not in seven year, nor in seventy, as you'll learn, young sun of a gun!' said Big James.

And, having unsettled the youth to his foundations with a bland thwack across the head, he resumed the composing stick and began again the exposition of the unique smooth movement which is the root of rapid typesetting.

'Here!' said Big James, when the apprentice had behaved

The next morning, in the printing office, Edwin came upon Big James giving a lesson in composing to the younger apprentice, who in theory had 'learned his cases'. Big James held the composing stick in his great left hand, like a match-box, and with his great right thumb and index picked letter after letter from the case, in order to display movement, and dropped them into the stick. In his mild, resonant tones he explained that each letter must be picked up unfalteringly in a particular way, so that it would drop face upward into the stick without any intermediate manipulation. And he explained also that the left hand must be held so that the right hand would have to travel to and fro as little as possible. He was revealing the basic mysteries of his craft, and was happy, making the while the broad series of stock pleasantries which have probably been current in composing rooms since printing was invented. Then he was silent, working quickly, till his right hand could scarcely be followed in its twinklings, and the face of the apprentice duly spread in marvel. When the line was finished he drew out the rule, clapped it down on the top of the last row of letters, and gave the composing stick to the apprentice to essay.

The apprentice began to compose with his feet, his shoulders, his mouth, his eyebrows—with all his body except his hands, which nevertheless travelled spaciously far and wide.

'It's not in seven year, nor in seventy, as you'll learn, young sun of a gun!' said Big James.

And, having unsettled the youth to his foundations with a bland thwack across the head, he resumed the composing stick and began again the exposition of the

The next morning, in the printing office, Edwin came upon Big James giving a lesson in composing to the younger apprentice, who in theory had 'learned his cases'. Big James held the composing stick in his great left hand, like a match-box, and with his great right thumb and index picked letter after letter from the case, very slowly in order to display the movement, and dropped them into the stick. In his mild, resonant tones he explained that each letter must be picked up unfalteringly in a particular way, so that it would drop face upward into the stick without any intermediate manipulation. And he explained also that the left hand must be held so that the right hand would have to travel to and fro as little as possible. He was revealing the basic mysteries of his craft, and was happy, making the while the broad series of stock pleasantries which have probably been current in composing rooms since printing was invented. Then he was silent, working more and more quickly, till his right hand could scarcely be followed in its twinklings, and the face of the apprentice spread in marvel. When the line was finished he drew out the rule, clapped it down on top of the last row of letters, and gave the composing stick to the apprentice to essay.

The apprentice began to compose with his feet, his shoulders, his mouth, his eyebrows—with all his body except his hands, which nevertheless travelled spaciously far and wide.

'It's not in seven year, nor in seventy, as you'll learn, young sun of a gun!' said Big James.

And, having unsettled the youth to his foundations with a bland thwack across the head, he resumed the

CONDENSED FACES

Some faces are designed in a condensed form, as the Gill Sans in example 1. It is possible to create an artificially condensed Gill Sans by changing the set width of the normal width (2). The effect is quite different. Example 3 shows Gill Sans Condensed condensed even further.

The next morning, in the printing office, Edwin came upon Big James giving a lesson in composing to the younger apprentice, who in theory had 'learned his cases'. Big James held the composing stick in his great left hand, like a match-box, and with his great right thumb and index picked letter after letter from the case, very slowly in order to display the movement, and dropped them into the stick. In his mild, resonant tones he explained that each letter must be picked up unfalteringly in a particular way, so that it would drop face upward into the stick without any intermediate manipulation. And he explained also that the left hand must be held so that the right hand would have to travel to and fro as little as possible. He was revealing the basic mysteries of his craft, and was happy, making the while the broad series of stock pleasantries which have probably been current in composing rooms since printing was invented. Then he was silent, working more and more quickly, till his right hand could scarcely be followed in its twinklings, and the face of the apprentice duly spread in marvel. When the line was finished he drew out the rule, clapped it down on the top of the last row of letters, and gave the composing stick to the apprentice to essay.

The apprentice began to compose with his feet, his shoulders, his mouth, his eyebrows—with all his body except his hands, which nevertheless travelled spaciously far and wide.

'It's not in seven year, nor in seventy, as you'll learn, young sun of a gun!' said Big James.

And, having unsettled the youth to his foundations with a bland thwack across the head, he resumed the composing stick and began again the exposition of the unique smooth movement which is the root of rapid typesetting.

'Here!' said Big James, when the apprentice had behaved worse than ever. 'Us'll ask Mr Edwin to have a go. 'Us'll see what *he*'ll do.'

And Edwin, sheepish, had to comply. He was in pride bound to surpass the apprentice, and did so.

'There!' said Big James. 'What did I tell ye?' He seemed to imply a prophecy that, because Edwin had saved the printing office from destruction two days previously, he would prove to be a born compositor.

The next morning, in the printing office, Edwin came upon Big James giving a

The next morning, in the printing office, Edwin came upon Big James giving a lesson in composing to the younger apprentice, who in theory had 'learned his cases'. Big James held the composing stick in his great left hand, like a match-box, and with his great right thumb and index picked letter after letter from the case, very slowly in order to display the movement, and dropped them into the stick. In his mild, resonant tones he explained that each letter must be picked up unfalteringly in a particular way, so that it would drop face upward into the stick without any intermediate manipulation. And he explained also that the left hand must be held so that the right hand would have to travel to and fro as little as possible. He was revealing the basic mysteries of his craft, and was happy, making the while the broad series of stock pleasantries which have probably been current in composing rooms since printing was invented. Then he was silent, working more and more quickly, till his right hand could scarcely be followed in its twinklings, and the face of the apprentice duly spread in marvel. When the line was finished he drew out the rule, clapped it down on the top of the last row of letters, and gave the composing stick to the apprentice to essay.

The apprentice began to compose with his feet, his shoulders, mouth, eyebrows—with all his body except his hands, which nevertheless travelled spaciously far and wide.

'It's not in seven year, nor in seventy, as you'll learn, young sun of a gun!' said Big James.

And, having unsettled the youth to his foundations with a bland thwack across the head, he resumed the composing stick and began again the exposition of the unique smooth movement which is the root of rapid typesetting.

'Here!' said Big James, when the apprentice had behaved worse than ever. 'Us'll ask Mr Edwin to have a go. 'Us'll see what *he*'ll do.'

And Edwin, sheepish, had to comply. He was in pride bound to surpass the apprentice, and did so.

'There!' said Big James. 'What did I tell ye?' He seemed to imply a prophecy that, because Edwin had saved the printing office from destruction two days previously, he would prove to be a born compositor.

The next morning, in the printing office, Edwin came upon Big James giving a lesson in composing to the younger apprentice, who in theory had 'learned his cases'. Big James held the composing stick in his great left hand, like a match-box, and with his great right thumb and index picked letter after letter from the case, very slowly in order to display the movement, and dropped them into the stick. In his mild, resonant tones he explained that

The next morning, in the printing office, Edwin came upon Big James giving a lesson in composing to the younger apprentice, who in theory had 'learned his cases'. Big James held the composing stick in his great left hand, like a match-box, and with his great right thumb and index picked letter after letter from the case, in order to display movement, and dropped them into the stick. In his mild, resonant tones he explained that each letter must be picked up unfalteringly in a particular way, so that it would drop face upward into the stick without any intermediate manipulation. And he explained also that the left hand must be held so that the right hand would have to travel to and fro as little as possible. He was revealing the basic mysteries of his craft, and was happy, making the while the broad series of stock pleasantries which have probably been current in composing rooms since printing was invented. Then he was silent, working quickly, till his right hand could scarcely be followed in its twinklings, and the face of the apprentice duly spread in marvel. When the line was finished he drew out the rule, clapped it down on the top of the last row of letters, and gave the composing stick to the apprentice to essay.

The apprentice began to compose with his feet, his shoulders, mouth, eyebrows—with all his body except his hands, which travelled spaciously far and wide.

'It's not in seven year, nor in seventy, as you'll learn, young sun of a gun!' said Big James.

And, having unsettled the youth to his foundations with a bland thwack across the head, he resumed the composing stick and began again the exposition of the unique smooth movement which is the root of rapid typesetting.

'Here!' said Big James, when the apprentice had behaved worse than ever. 'Us'll ask Mr Edwin to have a go. 'Us'll see what *he*'ll do.'

And Edwin, sheepish, had to comply. He was in pride bound to surpass the apprentice, and did so.

'There!' said Big James. 'What did I tell ye?' He seemed to imply a prophecy that, because Edwin had saved the printing office from destruction two days previously, he would prove to be a born compositor.

The next morning, in the printing office, Edwin came upon Big James giving a lesson in composing to the younger apprentice, who in theory had 'learned his cases'. Big James held the composing stick in his great left hand, like a match-box, and with his

TRUE ITALICS AND MACHINE-SLOPED ROMANS

As we saw with the examples of Baskerville, machine-sloped roman and true italic are very dissimilar in most serif typefaces. The differences are much less apparent in sans serif and square serif types. Some sans serifs, like Gill Sans, have true italics in which both the letterforms and letter proportions differ from the roman. Compare examples 1 and 2 for overall appearance and color as well as letter by letter. Note particularly letters like *p* and *f*. Many square serif types, like Memphis, were not originally designed with italics, and the so-called italic form is actually a sloped roman. This is also true for many sans serifs. Notice the difference between the true italic and the machine-sloped italic in examples 3 and 4. Many typesetters routinely set machine-sloped Helvetica when italic is specified, and very few designers find it unacceptable.

The next morning, in the printing office, Edwin came upon Big James giving a lesson in composing to the younger apprentice, who in theory had 'learned his cases'. Big James held the composing stick in his great left hand, like a match-box, and with his great right thumb and index picked letter after letter from the case, very slowly in order to display the movement, and dropped them into the stick. In his mild, resonant tones he explained that each letter must be picked up unfalteringly in a particular way, so that it would drop face upward into the stick without any intermediate manipulation. And he explained also that the left hand must be held so that the right hand would have to travel to and fro as little as possible. He was revealing the basic mysteries of his craft, and was happy, making the while the broad series of stock pleasantries which have probably been current in composing rooms since printing was invented. Then he was silent, working more and more quickly, till his right hand could scarcely be followed in its twinklings, and the face of the apprentice duly spread in marvel. When the line was finished he drew out the rule, clapped it down on the top of the last row of letters, and gave the composing stick to the apprentice to essay.

The apprentice began to compose with his feet, his shoulders, his mouth, his eyebrows—with all his body except his hands, which nevertheless travelled spaciously far and wide.

'It's not in seven year, nor in seventy, as you'll learn, young sun of a gun!' said Big James.

And, having unsettled the youth to his foundations with a bland thwack across the head, he resumed the composing stick and began again the exposition of the unique smooth movement which is the root of rapid typesetting.

'Here!' said Big James, when the apprentice had behaved worse than ever. 'Us'll ask Mr Edwin to have a go. 'Us'll see just what he'll do.'

1 10/12 GILL SANS ITALIC: TRUE CUT

The next morning, in the printing office, Edwin came upon Big James giving a lesson in composing to the younger apprentice, who in theory had 'learned his cases'. Big James held the composing stick in his great left hand, like a match-box, and with his great right thumb and index picked letter after letter from the case, very slowly in order to display movement, and dropped them into the stick. In his mild, resonant tones he explained that each letter must be picked up unfalteringly in a particular way, so that it would drop face upward into the stick without any intermediate manipulation. And he explained also that the left hand must be held so that the right hand would have to travel to and fro as little as possible. He was revealing the basic mysteries of his craft, and was happy, making the while the broad series of stock pleasantries which have probably been current in composing rooms since printing was invented. Then he was silent, working quickly, till his right hand could scarcely be followed in its twinklings, and the face of the apprentice duly spread in marvel. When the line was finished he drew out the rule, clapped it down on the top of the last row of letters, and gave the composing stick to the apprentice to essay.

The apprentice began to compose with his feet, his shoulders, his mouth, his eyebrows—with all his body except his hands, which nevertheless travelled spaciously far and wide.

'It's not in seven year, nor in seventy, as you'll learn, young sun of a gun!' said Big James.

And, having unsettled the youth to his foundations with a bland thwack across the head, he resumed the composing stick and began again the exposition of the unique smooth movement which is the root of rapid typesetting.

'Here!' said Big James, when the apprentice had behaved worse than ever. 'Us'll ask Mr Edwin to have a go. 'Us'll see

2 10/12 GILL SANS: MACHINE-SLOPED

The next morning, in the printing office, Edwin came upon Big James giving a lesson in composing to the younger apprentice, who in theory had 'learned his cases'. Big James held the composing stick in his great left hand, like a match-box, and with his great right thumb and index picked letter after letter from the case, very slowly in order to display the movement, and dropped them into the stick. In his mild, resonant tones he explained that each letter must be picked up unfalteringly in a particular way, so that it would drop face upward into the stick without any intermediate manipulation. And he explained also that the left hand must be held so that the right hand would have to travel to and fro as little as possible.

3 10/12 HELVETICA ITALIC: TRUE CUT

The next morning, in the printing office, Edwin came upon Big James giving a lesson in composing to the younger apprentice, who in theory had 'learned his cases'. Big James held the composing stick in his great left hand, like a match-box, and with his great right thumb and index picked letter after letter from the case, very slowly in order to display the movement, and dropped them into the stick. In his mild, resonant tones he explained that each letter must be picked up unfalteringly in a particular way, so that it would drop face upward into the stick without any intermediate manipulation. And he explained also that the left hand must be held so that the right hand would have to travel to and fro as little as possible.

4 10/12 HELVETICA: MACHINE-SLOPED

CAUTIONS

All machine alterations should be used with prudence. Although there are circumstances and faces for which small alterations can be useful, extreme changes, especially in faces that are extreme to begin with, will bring about unreadable results. For example, notice what happens when Americana (1), a face that is extremely expanded and has exaggerated thicks and thins, is expanded even further. Also notice what happens when Helvetica Light Condensed (2) is much further condensed. Neither setting works as a readable text mass.

Example 3 shows City Medium, a face designed without an italic, given a machine slope. The effect (at least to me) seems to fight with the upright structure of the letter design. It is a little like colorizing movies; possible, but slightly suspect.

The next morning, in the printing office, Edwin came upon Big James giving a lesson in composing to the younger apprentice, who in theory had 'learned his cases'. Big James held the composing stick in his great left hand, like a match-box, and with his great right thumb and index picked letter after letter from the case, very slowly in order to display the movement, and dropped them into the stick. In his mild, resonant tones he explained that each letter must be picked up unfalteringly in a particular way, so that it would drop face upward into the stick without any intermediate manipulation. And he explained also that the left hand must be held so that the right hand would have to travel to and fro as little as possible. He was revealing the basic mysteries of his craft, and was happy, making the while the broad series of stock pleasantries which have probably been current in composing rooms since printing was invented. Then he was silent, working more and more quickly, till his right hand could scarcely be followed in its twinklings, and the face of the apprentice duly spread in marvel. When the line was finished he drew out the rule, clapped it down on the top of the last row of letters, and gave the composing stick to the apprentice to essay.

The apprentice began to compose with his feet, his shoulders, his mouth, his eyebrows —with all his body except his hands, which

1 9/12 AMERICANA: 11 SET WIDTH

The next morning, in the printing office, Edwin came upon Big James giving a lesson in composing to the younger apprentice, who in theory had 'learned his cases'. Big James held the composing stick in his great left hand, like a match-box, and with his great right thumb and index picked letter after letter from the case, in order to display movement, and dropped them into the stick. In his mild, resonant tones he explained that each letter must be picked up unfalteringly in a particular way, so that it would drop face upward into the stick without any intermediate manipulation. And he explained also that the left hand must be held so that the right hand would have to travel to and fro as little as possible. He was revealing the basic mysteries of his craft, and was happy, making the while the broad series of stock pleasantries which have probably been current in composing rooms since printing was invented. Then he was silent, working quickly, till his right hand could scarcely be followed in its twinklings, and the face of the apprentice duly spread in marvel. When the line was finished he drew out the rule, clapped it down on the top of the last row of letters, and gave the composing stick to the apprentice to essay.

The apprentice began to compose with his feet, his shoulders, his mouth, his eyebrows—with all his body except his hands, which nevertheless travelled spaciously far and wide.

'It's not in seven year, nor in seventy, as you'll learn, young sun of a gun!' said Big James impatiently.

And, having unsettled the youth to his foundations with a bland thwack across the head, he resumed the composing stick and began again the exposition of the unique smooth movement which is the root of rapid typesetting.

'Here!' said Big James, when the apprentice had behaved worse than ever. 'Us'll ask Mr Edwin to have a go. 'Us'll see what *he*'ll do.'

And Edwin, sheepish, had to comply. He was in pride bound to surpass the apprentice, and did so.

'There!' said Big James. 'What did I tell ye?' He seemed to imply a prophecy that, because Edwin had saved the printing office from destruction two days previously, he would prove to be a born compositor.

The next morning, in the printing office, Edwin came upon Big James giving a lesson in composing to the younger apprentice, who in theory had 'learned his cases'.

The next morning, in the printing office, Edwin came upon Big James giving a lesson in composing to the younger apprentice, who in theory had 'learned his cases'. Big James held the composing stick in his great left hand, like a match-box, and with his great right thumb and index picked letter after letter from the case, very slowly in order to display the movement, and dropped them into the stick. In his mild, resonant tones he explained that each letter must be picked up unfalteringly in a particular way, so that it would drop face upward into the stick without any intermediate manipulation. And he explained also that the left hand must be held so that the right hand would have to travel to and fro as little as possible. He was revealing the basic mysteries of his craft, and was happy, making the while the broad series of stock pleasantries which have probably been current in composing rooms since printing was invented. Then he was silent, working more and more quickly, till his right hand could scarcely be followed in its twinklings, and the face of the apprentice duly spread in marvel. When the line was finished he drew out the rule, clapped it down on the top of the last row of letters, and gave the composing stick to the apprentice to essay.

The apprentice began to compose with his feet, his shoulders, his mouth, his eyebrows—with all his body except his hands, which nevertheless travelled spaciously far and wide.

'It's not in seven year, nor in seventy, as you'll learn, young sun of a gun!' said Big James.

And, having unsettled the youth to his foundations with a bland thwack across the head, he resumed the composing stick and began again the exposition of the unique smooth movement which is the root of rapid typesetting.

'Here!' said Big James, when the apprentice had behaved worse than ever. 'Us'll ask Mr Edwin to have a go. 'Us'll see just what

DETAILS

The architect Mies van der Rohe is supposed to have said, "God is in the details." If this is true for architecture, as it surely is, it is especially true for typography, where the details are finer and more finicky. Even after you are pleased with your selection of type style, measure, size, word and character spacing, and line spacing you still have many decisions to make. Ignoring these details can undermine the best set of specs because most of them have to do with preserving the overall texture and color of the type page. Different kinds of copy present different problems, so the designer must always anticipate what might happen when a given piece of copy is set.

There are many factors in copy that affect typesetting: very long or very short paragraphs; lots of em dashes and exclamation points; frequent quotation marks, parentheses, and brackets; superior numbers for footnote references; dates and numbers of all kinds, especially in ranges; frequent italics used for foreign words or titles; and displayed equations. Most of these details are the responsibility of the typesetter, but it is important that designers be aware of them so they can correct what displeases them.

PARAGRAPHS AND INDENTATION

In general, paragraph indentation should be in proportion to the width of the type line. An indent of 1 em or 1½ ems is considered normal, but this may be too much space on narrow measures, especially if the paragraphs are short. For long, dense paragraphs of text, deeper paragraph indentations tend to lighten the texture somewhat. Also consider the line spacing. A deep paragraph indent in tightly spaced text creates a conspicuous hole, while a small one in an open setting may be too inconspicuous.

Another factor that may affect your choice of indentation is whether or not other material, such as lists or long quotations, will be indented as well. A neater and more elegant page is created when all additional indentations align with the paragraph indents.

Big James held the composing stick in his great left hand, like a match-box, and with his great right thumb and index picked letter after letter from the case, very slowly in order to display the movement, and dropped them into the stick.

In his mild, resonant tones he explained that each letter must be picked up unfalteringly in a particular way, so that it would drop face upward into the stick without any intermediate manipulation. And he explained also that the left hand must be held so that the right hand would have to travel to and fro as little as possible.

He was revealing the basic mysteries of his craft, and was happy, making the while the broad series of stock pleasantries which have probably been current in composing rooms since printing was invented. Then he was silent, working more and more quickly, till his right hand could scarcely be followed in its twinklings, and the face of the apprentice duly spread in marvel.

When the line was finished he drew out the rule, clapped it down on the top of the last row of letters, and gave the composing stick to the apprentice to essay.

The apprentice began to compose with his feet, his shoulders, his mouth, his eyebrows—with all his body except

1 8/10 TIMES ROMAN: 2 EM INDENT

Big James held the composing stick in his great left hand, like a match-box, and with his great right thumb and index picked letter after letter from the case, very slowly in order to display the movement, and dropped them into the stick.

In his mild, resonant tones he explained that each letter must be picked up unfalteringly in a particular way, so that it would drop face upward into the stick without any intermediate manipulation. And he explained also that the left hand must be held so that the right hand would have to travel to and fro as little as possible.

He was revealing the basic mysteries of his craft, and was happy, making the while the broad series of stock pleasantries which have probably been current in composing rooms since printing was invented. Then he was silent, working more and more quickly, till his right hand could scarcely be followed in its twinklings, and the face of the apprentice duly spread in marvel.

When the line was finished he drew out the rule, clapped it down on the top of the last row of letters, and gave the composing stick to the apprentice to essay.

The apprentice began to compose with his feet, his shoulders, his mouth, his eyebrows—with all his body except

2 8/10 TIMES ROMAN: 1 EM INDENT

The next morning, in the printing office, Edwin came upon Big James giving a lesson in composing to the younger apprentice, who in theory had 'learned his cases'. Big James held the composing stick in his great left hand, like a match-box, and with his great right thumb and index picked letter after letter from the case, very slowly in order to display the movement, and dropped them into the stick. In his mild, resonant tones he explained that each letter must be picked up unfalteringly in a particular way, so that it would drop face up into the stick without any intermediate manipulation.

And he explained also that the left hand must be held so that the right hand would have to travel to and fro as little as possible. He was revealing the basic mysteries of his craft, and was happy, making the while the broad series of stock pleasantries which have probably been current in composing rooms since printing was invented. Then he was silent, working more and more quickly, till his right hand could scarcely be followed in its twinklings, and the face of the apprentice duly spread in marvel. When the line was finished he drew out the rule, clapped it down on the top of the last row of letters, and gave the composing stick to the apprentice to essay. The apprentice began to compose with his feet, his shoulders, his mouth, his eyebrows—with all his body except his hands, which nevertheless travelled spaciously far and wide.

'It's not in seven year, nor in seventy, as you'll learn, young sun of a gun!' said Big James impatiently. And, having unsettled the youth to his foundations with a bland thwack across the head, he resumed the composing stick and began again the exposition of the unique smooth movement which is the root of rapid typesetting. 'Here!' said Big James, when the apprentice had behaved worse than ever. 'Us'll ask Mr Edwin to have a go. 'Us'll see what *he*'ll do.'

The next morning, in the printing office, Edwin came upon Big James giving a lesson in composing to the younger apprentice, who in theory had 'learned his cases'.

Big James held the composing stick in his great left hand, like a match-box, and with his great right thumb and index picked letter after letter from the case, very slowly in order to display the movement, and dropped them into the stick.

In his mild, resonant tones he explained that each letter must be picked up unfalteringly in a particular way, so that it would drop face upward into the stick without any intermediate manipulation. And he explained also that the left hand must be held so that the right hand would have to travel to and fro as little as possible.

He was revealing the basic mysteries of his craft, and was happy, making the while the broad series of stock pleasantries which have probably been current in composing rooms since printing was invented. Then he was silent, working more and more quickly, till his right hand could scarcely be followed in its twinklings, and the face of the apprentice duly spread in marvel.

When the line was finished he drew out the rule, clapped it down on the top of the last row of letters, and gave the composing stick to the apprentice to essay.

The apprentice began to compose with his feet, his shoulders, his mouth, his eyebrows—with all his body except his hands, which nevertheless travelled spaciously far and wide.

'It's not in seven year, nor in seventy, as you'll learn, young sun of a gun!' said Big James impatiently.

And, having unsettled the youth to his foundations with a bland thwack across the head, he resumed the composing stick and began again the exposition of the unique smooth movement which is the root of rapid typesetting.

'Here!' said Big James, when the apprentice had be-

NUMBERED AND BULLETED LISTS

There are a number of details to consider in specifying lists. If the list is numbered, will the numbers exceed 10, and if so, how should the single digits align with the multiple digits? What space should follow the number or the bullet? What device follows the number: a period? a centered dot? a space? Where should turnover lines align? Is space needed between items, and if so, how much? Should the type size be the same as the surrounding text or should it be smaller? Should lists be indented or set flush with the surrounding text? There are no right or wrong choices for any of these. Your decision on each should be consistent with the typographic style you have established elsewhere.

Rather than develop a single list of objectives for all of its diverse subsidiaries, top management at the company singled out ten key result areas that are considered essential to the continued vitality of the corporation. These areas are:

1. Profitability defined in terms of both percentage of sales and return on investment funds
2. Market position
3. Productivity
4. Leadership in both fundamental and technological research in all areas
5. Personnel development
6. Employees attitudes and relations
7. Public attitudes and responsibility including participation in areas of local interest
8. Balance between short-range and long-range plans
9. Development of new products to meet perceived market opportunities
10. Introduction of new technology into manufacturing processes to reduce costs

Once these areas were defined, managers were given the responsibility for establishing specific objectives in each area and implementing those plans.

Rather than develop a single list of objectives for all of its diverse subsidiaries, top management at the company singled out ten key result areas that are considered essential to the continued vitality of the corporation. These areas are:

1 Profitability defined in terms of both percentage of sales and return on investment funds
2 Market position
3 Productivity
4 Leadership in both fundamental and technological research in all areas
5 Personnel development
6 Employees attitudes and relations
7 Public attitudes and responsibility including participation in areas of local interest
8 Balance between short-range and long-range plans
9 Development of new products to meet perceived market opportunities
10 Introduction of new technology into manufacturing processes to reduce costs

Once these areas were defined, managers were given the responsibility for establishing specific objectives in each area and implementing those plans.

1 INCORRECTLY ALIGNED HUNG NUMBERS

2 CORRECTLY ALIGNED HUNG NUMBERS

Rather than develop a single list of objectives for all of its diverse subsidiaries, top management at the company singled out ten key result areas that are considered essential to the continued vitality of the corporation. These areas are:

- Profitability defined in terms of both percentage of sales and return on investment funds

- Market position

- Productivity

- Leadership in both fundamental and technological research in all areas

- Personnel development

- Employees attitudes and relations

- Public attitudes and responsibility including participation in areas of local interest

- Balance between short-range and long-range plans

- Development of new products to meet perceived market opportunities

- Introduction of new technology into manufacturing processes to reduce costs

Once these areas were defined, managers were given the responsibility for establishing specific objectives in each area and implementing those plans.

Rather than develop a single list of objectives for all of its diverse subsidiaries, top management at the company singled out ten key result areas that are considered essential to the continued vitality of the corporation. These areas are:

1. Profitability defined in terms of both percentage of sales and return on investment funds

2. Market position

3. Productivity

4. Leadership in both fundamental and technological research in all areas

5. Personnel development

6. Employees attitudes and relations

7. Public attitudes and responsibility including participation in areas of local interest

8. Balance between short-range and long-range plans

9. Development of new products to meet perceived market opportunities

10. Introduction of new technology into manufacturing processes to reduce costs

Once these areas were defined, managers were given the responsibility for establishing specific objectives in each area and implementing those plans.

Rather than develop a single list of objectives for all of its diverse subsidiaries, top management at the company singled out ten key result areas that are considered essential to the continued vitality of the corporation. These areas are:

1 Profitability defined in terms of both percentage of sales and return on investment funds

2 Market position

3 Productivity

4 Leadership in both fundamental and technological research in all areas

5 Personnel development

6 Employees attitudes and relations

7 Public attitudes and responsibility including participation in areas of local interest

8 Balance between short-range and long-range plans

9 Development of new products to meet perceived market opportunities

10 Introduction of new technology into manufacturing processes to reduce costs

Once these areas were defined, managers were given the responsibility for establishing specific objectives in each area and implementing those plans.

3 INDENTED BULLETED LIST

4 BOLD NUMBERED LIST WITH PERIODS

5 BOLD NUMBERED LIST WITH EN SPACE

EM DASHES, EN DASHES, AND HYPHENS

An em dash is a dash that is nominally the length of the em of a particular font. An en dash is half that, and a hyphen is less than an en dash. (In practice, many fonts contain em dashes considerably longer than an em.)

The conventional use of these marks is as follows: em dashes are marks of punctuation similar to but more emphatic than commas, often used in pairs to frame a thought; en dashes are used in numerical ranges, such as 1987–88; hyphens are used in compound words and words broken between two lines and are also sometimes mistakenly used in ranges.

Em and en dashes and hyphens are often badly spaced and sometimes set touching the characters on one side or the other. Space on either side of the dash should be equal but very small. In general, em dashes create large gaps in the texture of a page and, if they appear frequently in the copy, will affect the overall look, especially in those faces that have abnormally long dashes. If you have a cooperative typesetter, you can specify ¾ em dashes (which are actually two overlapped en dashes) or use an em dash from a smaller size programmed to center vertically. Be careful, too, of copy that is full of numerical ranges, since some faces have very long en dashes. These, too, can be shortened by using them from a smaller font.

As I went to the office —my office in town, that is, not the one in the suburbs —I talked to myself the entire way. How were my children —to say nothing of all their pets —going to manage living in such small quarters? The magnitude of this problem —and all its ancillary consequences —preoccupied me until I arrived at my destination

1 POORLY SPACED EM DASHES

During the years 1851–1888 the number of people attending the Salon had nearly doubled compared to the years 1830–1851. The stultifying years of the Third Empire, 1851–1870, represented the period of the most remarkable growth.

2 EN DASHES USED IN NUMERICAL RANGES

During the years 1851–1888 the number of people attending the Salon had nearly doubled compared to the years 1830–1851. The stultifying years of the Third Empire, 1851–1870, represented the period of the most remarkable growth.

3 SHORTENED EN DASH USED IN NUMERICAL RANGES

During the years 1851-1888 the number of people attending the Salon had nearly doubled compared to the years 1830-1851. The stultifying years of the Third Empire, 1851-1870, represented the period of the most remarkable growth.

4 HYPHEN USED IN NUMERICAL RANGES

10/12 JOANNA

LINING AND OLD-STYLE FIGURES

There are two basic styles of numbers: those that align top and bottom and are cap height or a little less (called lining figures), and those that are irregular in height, with some portion hanging below the baseline (called old-style or hanging figures). All fonts have lining figures but in some fonts old-style figures are available as an alternative. In general, the fonts based on early typeface designs have old-style figures, while sans serif types never do.

Lining figures, because they are cap height, become very prominent in text that contains many numbers. Still, lining figures tend to be much less fussy than old styles and are appropriate for all scientific, statistical, and tabular uses, and for displayed equations. Old-style figures work best in literary and historical contexts. Much depends, of course, on the surrounding material. With even small caps, which you might want to use in a bibliography, for example, lining figures can look awkward. In text that contains many figures but for which lining figures look inappropriate, you might want to consider using figures in a smaller size.

Because admission was free on Sundays, there might be 6,000 people who would attend the exhibition. One Sunday the officials tabulated 6,179 visitors. During the course of the month more than 82,500 people came through the doors, which meant that over a ten-year period between 850,000 and 1,000,000 people might visit the great Palace where the exhibition was held. Meanwhile, an exhibition of the Impressionists managed to attract only 1,432 people in three weeks, with 829 attending the final week. Considering that the population of the city was 821,037, this figure was insignificant.

1 10/12 BEMBO: LINING FIGURES

Because admission was free on Sundays, there might be 6,000 people who would attend the exhibition. One Sunday the officials tabulated 6,179 visitors. During the course of the month more than 82,500 people came through the doors, which meant that over a ten-year period between 850,000 and 1,000,000 people might visit the great Palace where the exhibition was held. Meanwhile, an exhibition of the Impressionists managed to attract only 1,432 people in three weeks, with 829 attending the final week. Considering that the population of the city was 821,037, this figure was insignificant.

2 10/12 BEMBO: OLD-STYLE FIGURES

Because admission was free on Sundays, there might be 6,000 people who would attend the exhibition. One Sunday the officials tabulated 6,179 visitors. During the course of the month more than 82,500 people came through the doors, which meant that over a ten-year period between 850,000 and 1,000,000 people might visit the great Palace where the exhibition was held. Meanwhile, an exhibition of the Impressionists managed to attract only 1,432 people in three weeks, with 829 attending the

3 10/12 GARAMOND #3: OLD-STYLE FIGURES

MORE ABOUT NUMBERS

Dimensions, often with fractions, commonly appear in text. Occasionally, full-size figures separated by a solidus or shilling bar (/) are used for fractions. This can look clumsy and can be confusing when the fraction is combined with whole numbers (17 7/16, for example) but rather nice when the fraction appears alone on the line (7/16). Most faces are supplied with two kinds of fractions in the font: those with a horizontal bar (—) and those with a shilling bar (/).

The space between a fraction and its whole number should be small enough so that the number and fraction appear as a unit, but they should not touch or be so close as to be illegible. Often a bit more space is needed in front of fractions with denominators other than 1. The same spacing detail requires attention when numbers are used as superscripts for referencing footnotes or as subscripts in technical composition, especially when very small numbers are used.

Multiple dimensions are commonly given with a multiplication sign (x) between them. Theoretically, the mathematical symbol \times is correct, but many designers use a lowercase x, either in the roman or italic of the font. Depending on the context, any of these can work. However, if other mathematical symbols appear, such as a division sign, the mathematical form \times should be used for consistency. There is usually at least a word space on either side of any mathematical sign of operation.

The many rules and considerations for mathematical settings are too complex and require more examination than this book can provide. If you need to specify displayed mathematical or numerical titles, you should con-sult the specialized style guides that exist for many scientific disciplines, some of which are listed in the bibliography of this book. It is also wise to work with a typesetter who has experience in this kind of setting, if at all possible.

Example 1 shows the mathematical multiplication sign used in text with minimum space on each side. It also shows a full-size shilling-bar fraction set on the line. Example 2 shows more space around the multiplication sign and a built-up shilling-bar fraction on the line. Example 3 shows the x of the font used in place of the multiplication sign and a horizontal-bar built-up fraction. Example 4 shows the x of the font with a bit more space around it and full-size shilling-bar fraction. The use of the multiplication sign, especially with extra space around it, looks far more technical than the x of the font.

The formula in example 5 is set correctly using the multiplication sign and centering the horizontal bar of the fraction. In example 6 the horizontal bar is aligned incorrectly and not centered between the numerator and denominator.

Examples 7–12 show variations in the space around the multiplication sign in a display context, as they might appear in a catalog. Notice that the greater line spacing in examples 10–12 affects the appearance of the spaces around the multiplication sign.

We went to see Allison's newest painting. The canvas was large, $58\frac{7}{8}'' \times 32\frac{1}{2}''$, and was oddly framed with a narrow white strip only 15/16″ of an inch wide. It seemed to fill the $8' \times 10'$ room, and we all felt dwarfed by it.

1

We went to see Allison's newest painting. The canvas was large, $58\frac{7}{8}'' \times 32\frac{1}{2}''$, and was oddly framed with a narrow white strip only $\frac{15}{16}''$ of an inch wide. It seemed to fill the $8' \times 10'$ room, and we all felt dwarfed by it.

2

We went to see Allison's newest painting. The canvas was large, $58\frac{7}{8}'' \times 32\frac{1}{2}''$, and was oddly framed with a narrow white strip only $\frac{15}{16}''$ of an inch wide. It seemed to fill the $8' \times 10'$ room, and we all felt dwarfed by it.

3

We went to see Allison's newest painting. The canvas was large, $58\frac{7}{8}''$ x $32\frac{1}{2}''$, and was oddly framed with a narrow white strip only 15/16″ of an inch wide. It seemed to fill the $8'$ x $10'$ room, and we all felt dwarfed by it.

4

FRACTIONS AND MULTIPLICATION SIGNS IN TEXT

To figure out how much lumber you will need to construct a wooden deck in the shape of a right triangle, you need to measure the two sides and calculate:

$$\text{area} = \text{side } 1 \times \frac{\text{side } 2}{2}$$

5

To figure out how much lumber you will need to construct a wooden deck in the shape of a right triangle, you need to measure the two sides and calculate:

$$\text{area } = \text{side } 1 \text{ x } \underline{\text{side } 2}$$
$$2$$

6

DISPLAYED EQUATIONS

Sunset at Antibes
$48\frac{3}{8} \times 22$ in. (123×56 cm)
Oil on canvas

7

Sunset at Antibes
$48\frac{3}{8} \times 22$ in. (123×56 cm)
Oil on canvas

8

Sunset at Antibes
$48\frac{3}{8}$ x 22 in. (123 x 56 cm)
Oil on canvas

9

Sunset at Antibes
$48\frac{3}{8} \times 22$ in. (123×56 cm)
Oil on canvas

10

Sunset at Antibes
$48\frac{3}{8} \times 22$ in. (123×56 cm)
Oil on canvas

11

Sunset at Antibes
$48\frac{3}{8}$ x 22 in. (123 x 56 cm)
Oil on canvas

12

DIMENSIONS IN CAPTIONS

BIBLIOGRAPHY

This is a brief list of some seminal books in typography, letter design, and graphic design.

Arnheim, Rudolf. *The Power of the Center: A Study of Composition in the Visual Arts*. Berkeley, CA: University of California Press, 1982.

Burns, Aaron. *Typography*. New York: Van Nostrand Reinhold, 1961.

Carter, Rob, Ben Day and Philip Meggs. *Typographic Design: Form and Communication*. New York: Van Nostrand Reinhold, 1985.

Gerstner, Karl. *Compendium for Literates: A System of Writing*. Translated by Dennis Q. Stephenson. Cambridge, MA: MIT Press, 1974.

Goudy, Frederic W. *Typologia: Studies in Type Design and Type-making*. Berkeley, CA: University of California Press, 1940.

Hofmann, Armin. *Graphic Design Manual: Principle and Practice*. New York: Van Nostrand Reinhold, 1965.

Hurlburt, Allen. *The Grid System*. New York: Van Nostrand Reinhold, 1978.

Kepes, Gyorgy. *Sign, Image, Symbol*. New York: George Braziller, 1966.

Morison, Stanley. *First Principles of Typography*. Cambridge: Cambridge University Press, 1936.

Morison, Stanley and Kenneth Day. *The Typographic Book, 1450–1935*. Chicago: University of Chicago Press, 1964.

Sutnar, Ladislav. *Visual Design in Action—Principles, Purposes*. New York: Hastings House, 1961.

Tschichold, Jan. *Designing Books*. English ed. New York: Wittenborn, Schulz, Inc., 1951.

Tschichold, Jan. *Treasury of Alphabets and Lettering*. New York: Van Nostrand Reinhold, 1966.

Updike, Daniel Berkely. *Printing Types: Their History, Forms and Use* (2 vols.). Cambridge, MA: The Belknap Press of Harvard University Press, 1937.

Zapf, Hermann. *Manuale Typographicum*. Cambridge, MA: MIT Press, 1970.

These are some of the reference works that can be consulted for guidance in the editorial/typographic conventions in use both generally and in specific fields.

American Institute of Physics. *Style Manual for Guidance in the Preparation of Papers*. 3d rev. ed. New York: American Institute of Physics, 1978.

Chicago Manual of Style. Chicago: University of Chicago Press, 1982.

Council of Biology Editors. *Council of Biology Editors Style Manual*. 4th ed. Washington, DC: American Institute of Biological Sciences, 1978.

Swanson, Ellen. *Mathematics into Type: Copyediting and Proofreading of Mathematics for Editorial Assistants and Authors*. Rev. ed. Providence, RI: American Mathematical Society, 1979.

Words into Type. Based on studies by Marjorie E. Skillin, Robert M. Gay, and other authorities. 3rd ed. Englewood Cliffs, NJ: Prentice-Hall, 1974.

INDEX

Americana
 altering, 176–77
 and type color, 40–41
American Typewriter
 kerning, 132–35
Ascenders, 49
 defined, 10
Aster Medium
 line spacing, 86–87
Avant Garde, 127
 and type color, 42–43
 kerning, 127, 140–41

Baseline
 defined, 10
Baseline to baseline (b/b)
 defined, 13–48
Baskerville
 altering set width of, 164–67
 kerning, 128–31
 line spacing, 102–03, 104–05
Bauer Bodoni
 and type color, 36–37
 Medium, and type color, 39
Berkeley Old Style Medium
 line spacing, 94–95
Bernhard Modern
 and type color, 46–47
Bodoni
 size of compared to Helvetica, 13
Bodoni Book
 altering set width of, 168–69

line spacing, 96–97
Bookman Light
 line spacing, 62–73, 98–99, 100–01
Bowl
 defined, 10
Brackets
 defined, 10
Bulleted lists, 182–83

Caslon, 11
Caslon #2
 line spacing, 74–85, 98–99, 100–01
Century Condensed
 word spacing, 122–23
Century Schoolbook
 altering set width of, 170–71
Changing set width, 163
Character alteration
 italic vs. machine-sloped romans, 174–75
 of condensed faces, 172–73
 of faces with even stroke weights, 170–71
 of faces with extreme thick/thin contrasts, 168–69
 of faces with normal proportions, 164–67
 of faces with normal thick/thin relationships, 164–67
Character design, see Letter design
Character spacing, 126–144; see also Kerning

Characters per pica (cpp)
 defined, 13
City Medium
 altering, 176–77
Clarendon
 word spacing, 116–17, 122–23
Color, see Type color
Condensed faces
 altering, 172–73
 defined, 12
 word spacing, 114–15
Copy
 defined, 15
Counter
 defined, 10

Descenders, 49
 defined, 10
Details, 179–87

Egyptian 505
 and type color, 34–35
Em
 dash, 184–85
 indent, 180–81
Em space
 defined, 13–14
En
 dash, 184–85
 indent, 180–81
En space
 defined, 13–14

Expanded faces
 defined, 12
 kerning, 132–35
 word spacing, 116–17
Extended faces
 defined, 12; see also Expanded faces
External space, 33

Figures, 185–86
Font
 defined, 10
Font design, see Letter design
Fractions, 186–87

Garamond, 11–12
 and type color, 44–45
Gill Sans
 altering set width of, 172–73
Gill Sans Light
 line spacing, 92–93
Gill Sans Medium
 and type color, 44–45

H-and-j, see Hyphenation-and-justification
Helvetica
 altering, 174–75
 and type color, 42–43
 size of compared to Bodoni, 13
 word spacing, 114–15, 122–23
Helvetica Heavy
 and unjustified setting, 148–51
 line spacing, 90–91

Helvetica Light Condensed
altering, 176–77
Helvetica Thin
line spacing, 102–03, 104–05
Hyphenation-and-justification, 110-11
and unjustified setting, 146–47,
148–51
Hyphens, 184–85

Indentation
and line length, 180–81
paragraph, 180–81
Input
defined, 15
Interlinear spacing, see Line spacing
Internal space, 33, 42–45

Kerning, 127
defined, 14
difficult faces, 140–45
expanded faces of even stroke weight,
132–35
faces with extreme thick/thin contrasts,
136–39
faces with normal thick/thin contrasts,
128–31
overall, 127
pair, 127

Leading, see Line spacing
Legibility, 16–32
and caps, 17
and justification, 17

and line spacing, 17, 18–31, 48
and line width, 16–17, 18–31
and sans serifs, 17
and type size, 16–17
defined, 16
Letter design
and even stroke weights, 34–35
and internal spaces, 42–45
and highly contrasting stroke weights,
36–37
and letter proportions, 46–47
and similar color with differing
textures, 38–41
Letter proportions, 46–47
altering faces with normal, 164–67
line spacing for a face with normal,
50–61
word spacing a face with normal,
112–13
Letter spacing, see Character spacing;
Kerning
Line length
and legibility, 49
Line spacing, 48–109
and color, 49
and legibility, 48
and stroke weight, 86–97
and unjustified setting, 154–57,
160–61
different x-heights with 2 points,
98–99
different x-heights with 4 points,
100–01
faces with large x-heights, 49, 62–73

faces with normal proportions and
x-heights, 50–61
faces with small x-heights, 49,
74–85
Lining figures, 184–85
Lists
numbered and bulleted, 182–83
Lubalin Graph, 127
and type color, 46–47
kerning, 127, 142–43

Machine sloping, 162–63
Measure
and readability, 16–31
defined, 12; see also Type measure
Mies van der Rohe, 179
Multiplication sign, 186–87

Numbered lists, 182–83
Numbers, 184–85, 186–87

Old-style figures, 184–85
Overall kerning, 127

Pair kerning, 127
Palatino Bold
line spacing, 88–89, 102–03, 104–05
Paragraph indentation, 180–83
and unjustified setting, 158–59
Pica
defined, 12
Point
defined, 12

Raleigh Medium
and type color, 38–39
Readability, 16–32
and caps, 17
and justification, 17
and line spacing, 17, 18–31, 48
and line width, 16-l7, 18–31
and sans serifs, 17
and type size, 16-l7, 18–31
defined, 16

Saccadic movement, 16–17
Sans serif
defined, 10
Serif
defined, 10
Set width
changing, 162–63
Shilling bar, 186
Solidus, 186
Souvenir
and type color, 40–41
line spacing, 106–07, 108–09
Spacebands, see Spacing defines
Spacing defines, 111
excessively wide, 118–19
Spacing parameters, see Spacing
defines
Stem
defined, 10
Stroke
defined, 10
Stroke weights, 33

altering a face of even, 170–71
and line spacing, 86–97
and line spacing of different, 102–07
defined, 10
even, 34–35
highly contrasting, 36–37
kerning an expanded face with even,
132–35

Texture, 33
different 38–41
Thicks
defined, 10
Thick/thin contrasts, 33
altering faces with extreme, 168–69
altering faces with normal, 164–67
defined, 10
kerning faces with extreme, 136–39
kerning faces with normal, 128–31
line spacing faces of different, 108–09
Thins
defined, 10
Thin space
defined, 14
Times Roman
and type color, 38–39, 40–41, 42–43,
44–45, 46–47
and unjustified setting, 154–55
line spacing, 50–61, 98–99, 100–01
word spacing, 112–13, 118–19, 120–21,
124–25
Type color
and character spacing, 126–44

and line spacing, 48–109
and word spacing, 110–23
defined, 33
Typeface design, see Letter design
Type family, 12
Type measure
and unjustified setting, 160–61
and word spacing, 122–23
Type size
and line spacing, 50–85
and word spacing, 112–123
defined, 13

Units
defined, 14
Unjustified setting, 146–47
and hyphenation, 148–51
and line spacing, 152–55, 160–61
and paragraph indentation, 158–59,
160–61
and rag, 156–57, 160–61

Vocabulary, 10–14

Walbaum
kerning, 136–39
Word spacing, 110–23
and units, 110–11
condensed faces, 114–15
expanded faces, 116–17
faces of normal proportions, 112–13
standards, 120–21

type size, and measure, 122–23
with excessively wide spacing defines,
118–19
Word spacing defines, see Spacing
defines

X-heights, 33
defined, 10
faces with small, 49
line spacing different, 98–101
line spacing for faces with large, 62–73
line spacing for faces with normal,
50–61
line spacing for faces with small, 74–85

The text of this book is set in Frutiger, designed by
Adrian Frutiger, who is also the designer of the better-
known Univers.

The incessantly repeated example is from *Clayhanger* by
Arnold Bennett.

The book was printed and bound by Horowitz/Rae.